ARABIC
GEOMETRICAL
PATTERN AND DESIGN

ARABIC
GEOMETRICAL
PATTERN AND DESIGN

J. Bourgoin

Dover Publications, Inc., New York

Published in Canada by General Publishing Company, Ltd.,
30 Lesmill Road, Don Mills, Toronto, Ontario.
Published in the United Kingdom by Constable and Company,
Ltd., 10 Orange Street, London WC 2.

This Dover edition, first published in 1973, contains all the
plates from the work *Les Eléments de l'art arabe: le trait des
entrelacs,* by J. Bourgoin, originally published by the Librairie de
Firmin-Didot et Cie, Paris, in 1879. Plates I through X originally
appeared in color. The text of the original edition has been
replaced here by a Publisher's Note.

DOVER *Pictorial Archive* SERIES

International Standard Book Number: 0-486-22924-6
Library of Congress Catalog Card Number: 72-90630

Manufactured in the United States of America
Dover Publications, Inc.
31 East 2nd Street
Mineola, N.Y. 11501

PUBLISHER'S NOTE

The 190 linear plates in this book constitute an unusually complete collection of the basic patterns underlying the geometrical art of the Arabs. These were the designs that Arabic architects, decorators and craftsmen executed in metal, wood, stucco, mosaic and paint during their finest creative eras. The modern designer will find these plates immediately useful just as they are (infinite variations on each plate can be achieved with a little ingenuity—by varying the color emphases, changing straight lines to curves, and so on), and they will also suggest many more related patterns.

Readers who would like to try their hand at drawing these designs themselves can be guided by the dotted construction lines on every plate.

The patterns are divided into eight categories according to the fundamental geometric figures from which they spring: hexagon designs (Plates 1–41), octagon designs (42–67), dodecagon designs (68–105), combinations of stars or rosettes having two different numbers of points (106–142), combinations of squares and octagons (143–153), combinations of stars or rosettes of three or four types (154–163), heptagon designs (164–170) and pentagon designs (171–190). The first plate in each category has construction lines covering the whole page.

The ten plates I through X contain 28 examples of the use of these and similar patterns in actual works of art from Cairo and Damascus dating from the fourteenth through the eighteenth centuries: sanctuary doors, openwork windows, inlaid marble pavements, ceilings.

The present edition of this book omits the text of the original French edition (*Les Eléments de l'art arabe: le trait des entrelacs,* Firmin-Didot et Cie, Paris, 1879), which consisted of an art-historical statement of no particular value today, and of incomplete instructions on drawing the patterns. In view of the shortcomings of this text, it seemed best to let the magnificent plates speak for themselves.

THE PLATES

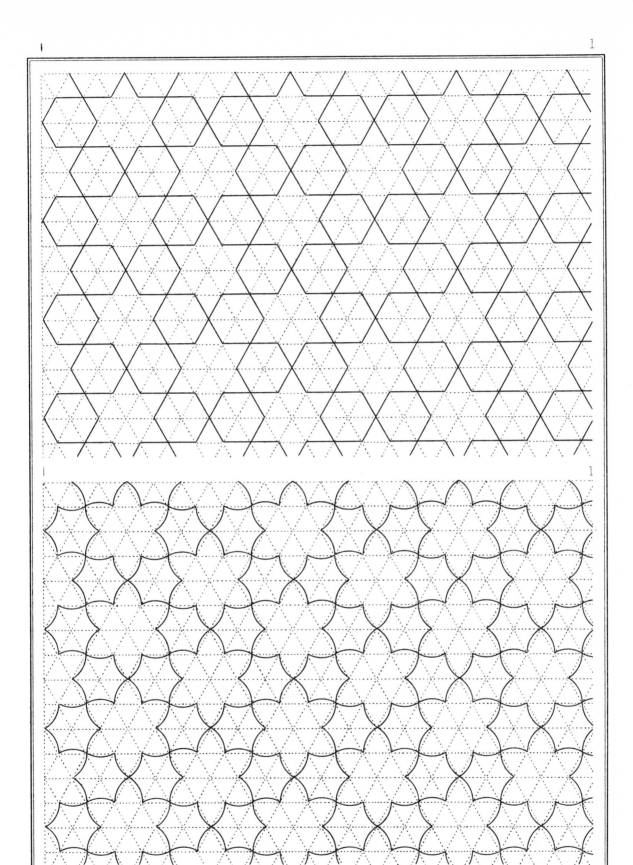

Imp F Didot et Cie Paris

J Sulpis sc

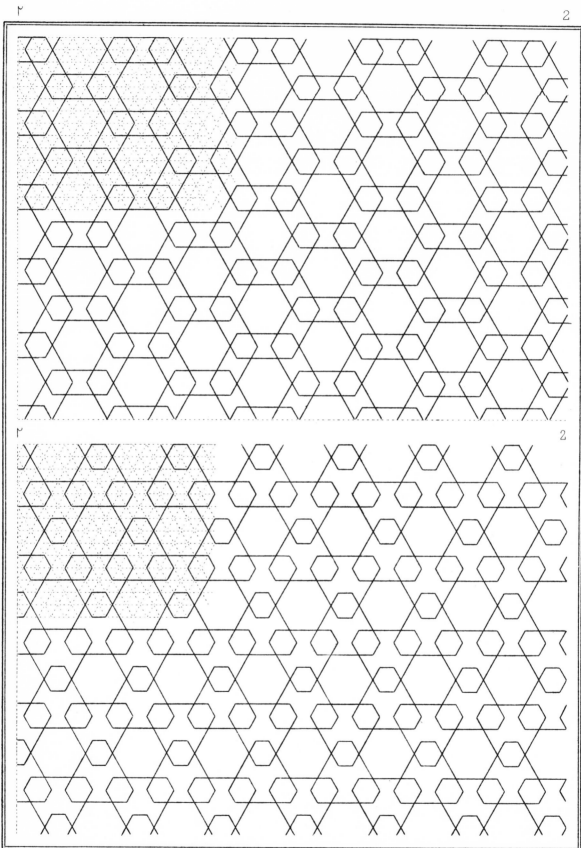

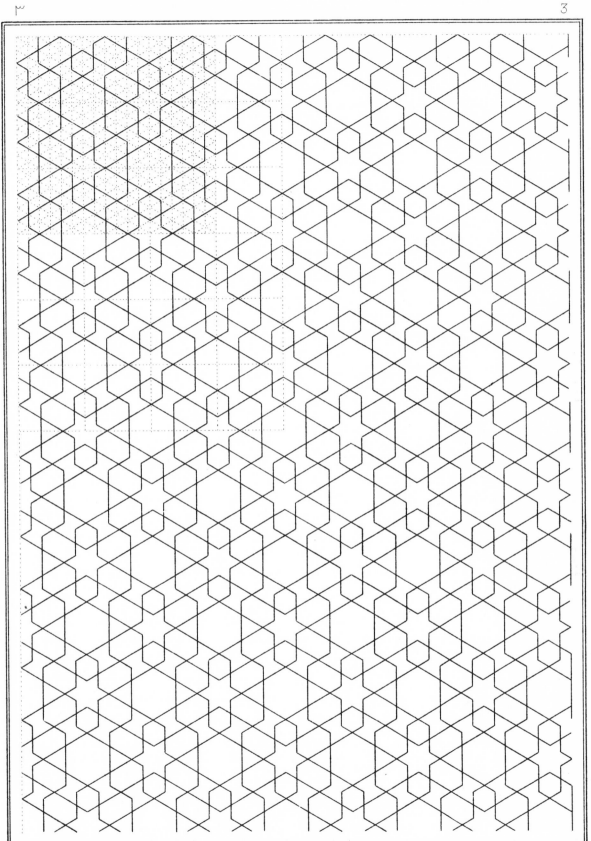

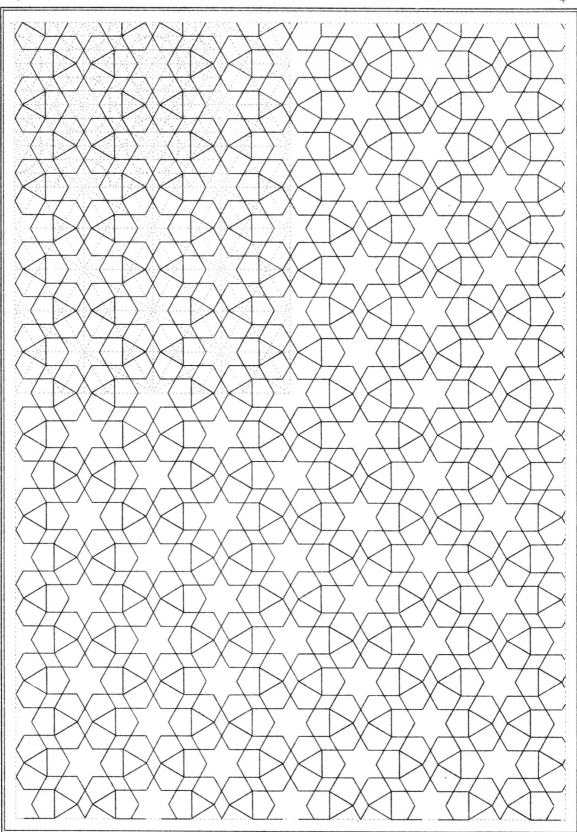

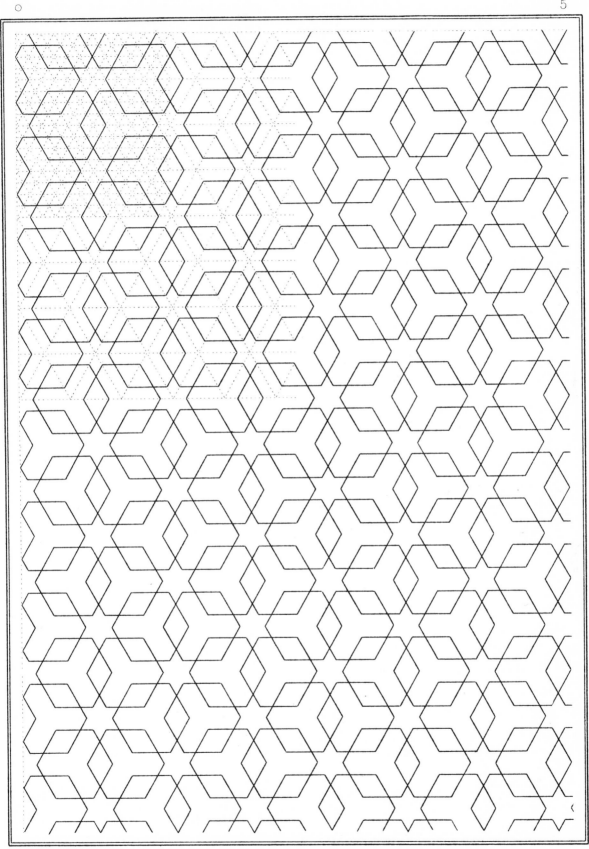

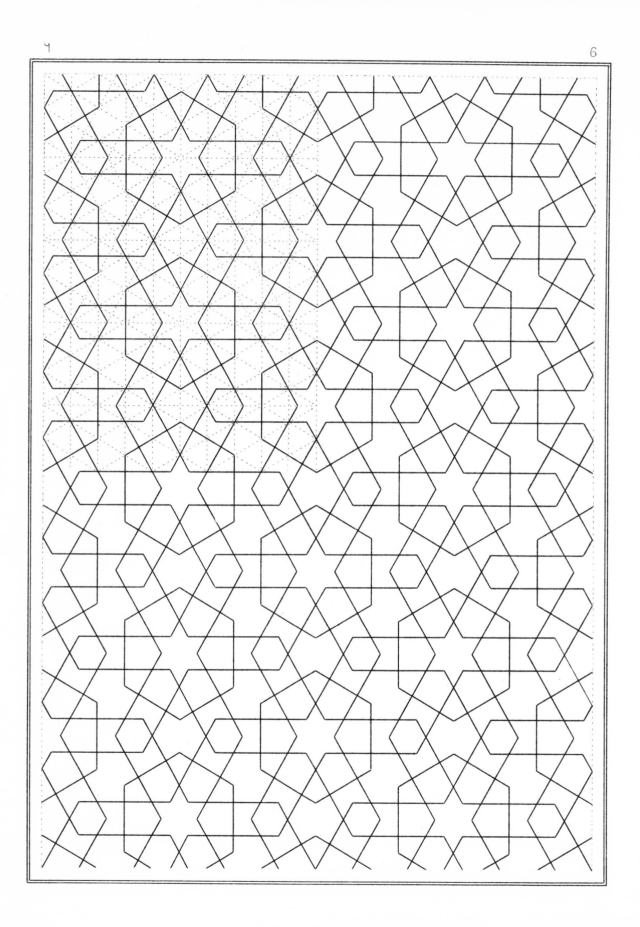

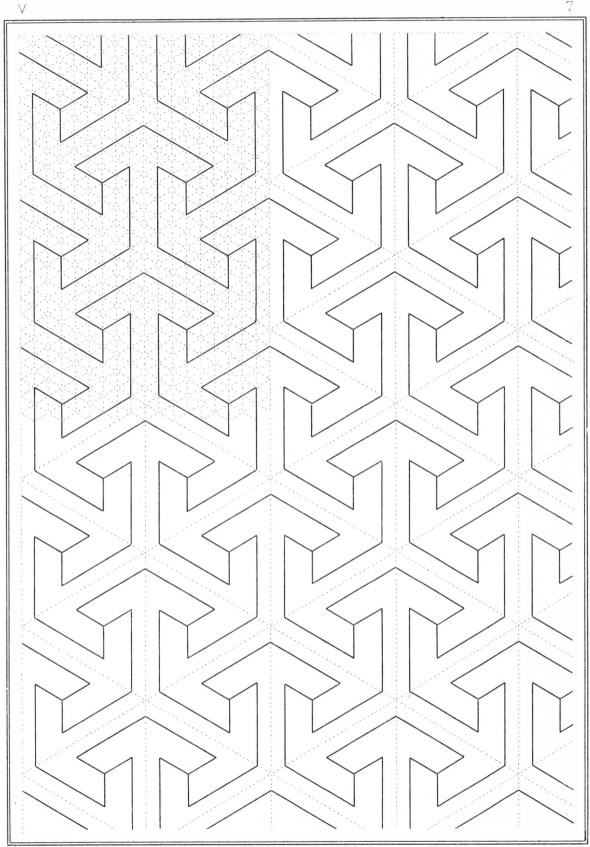

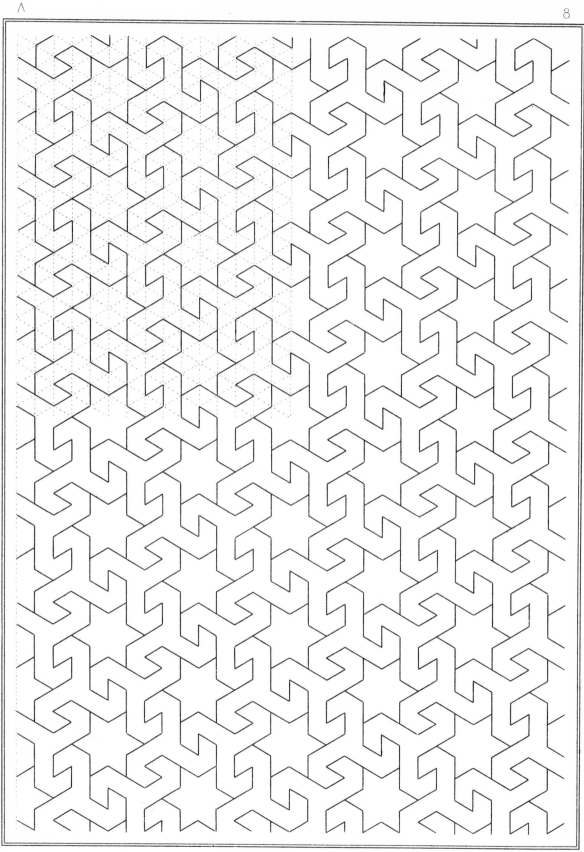

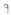

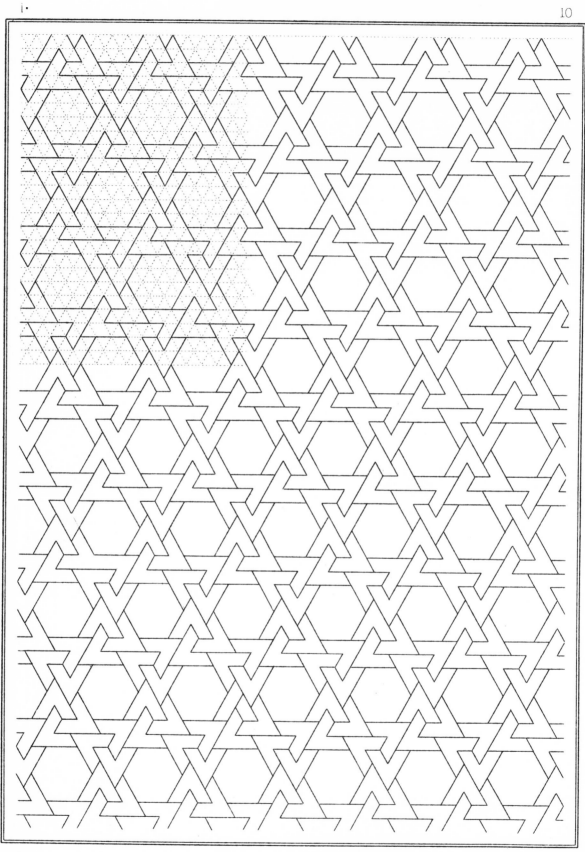

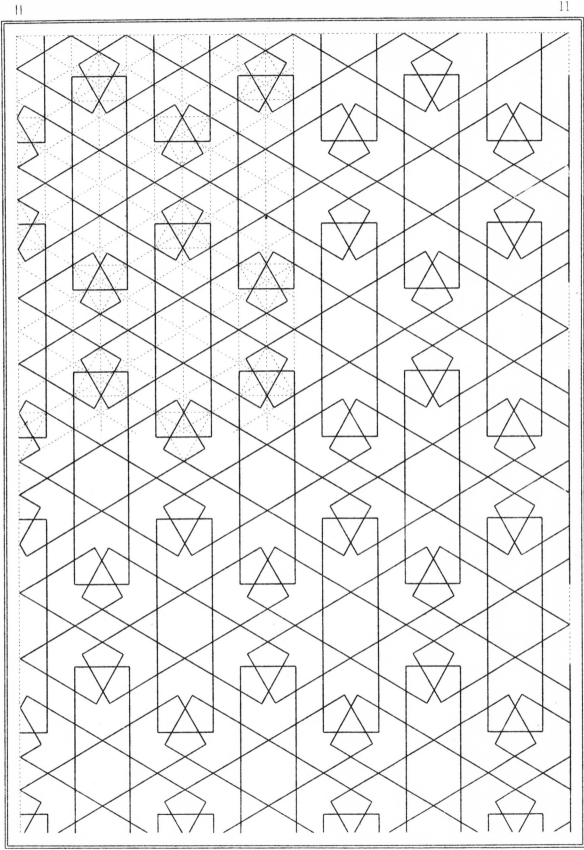

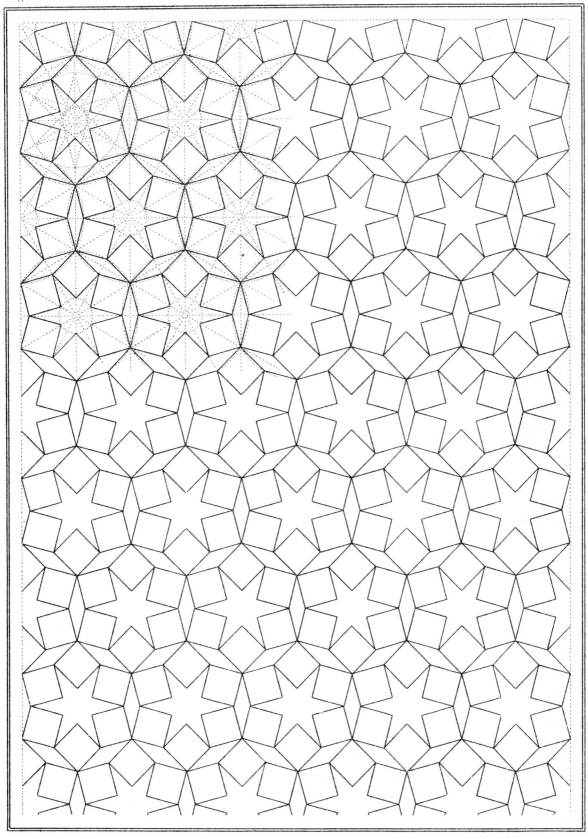

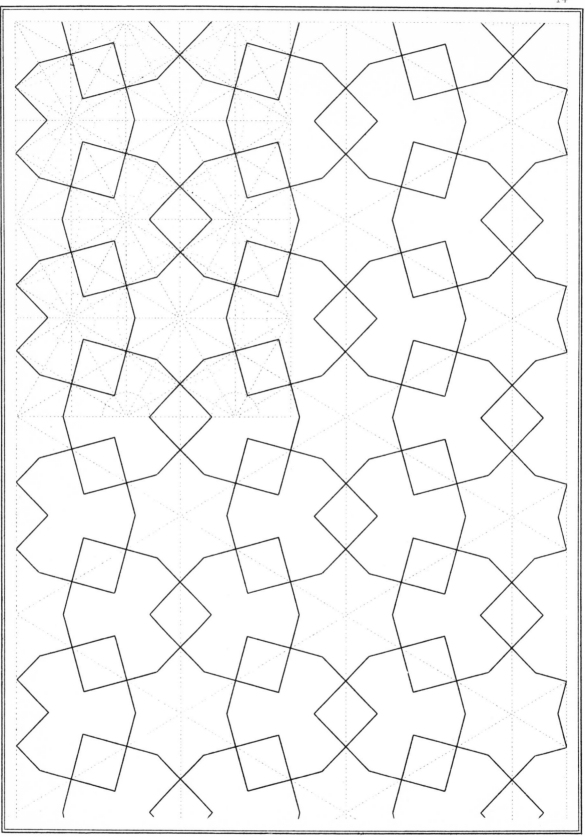

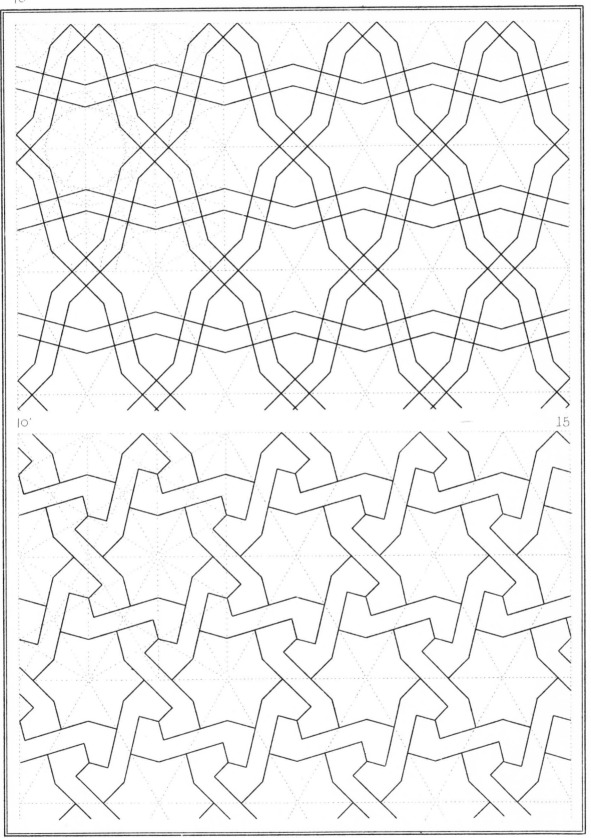

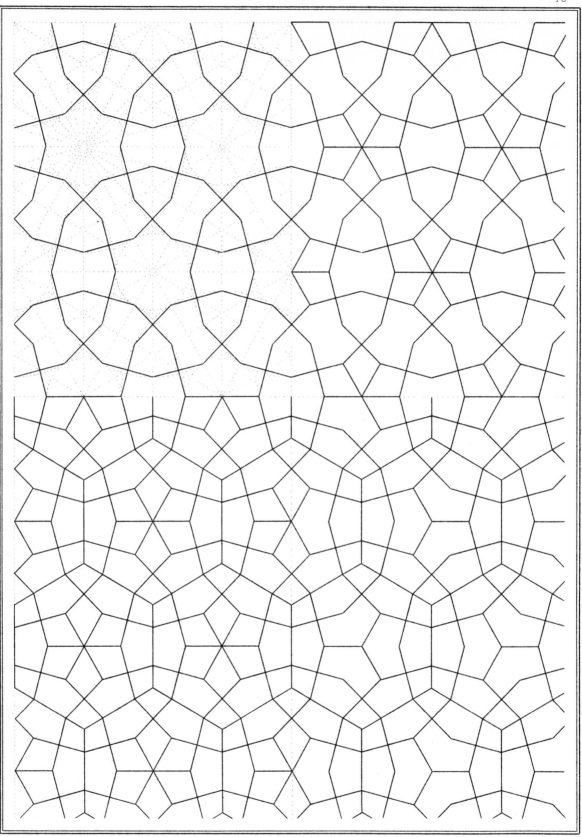

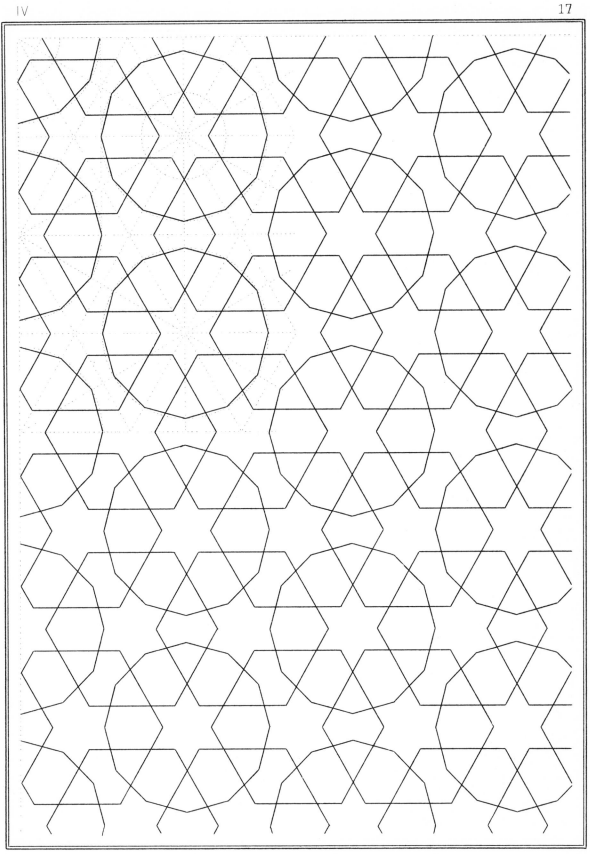

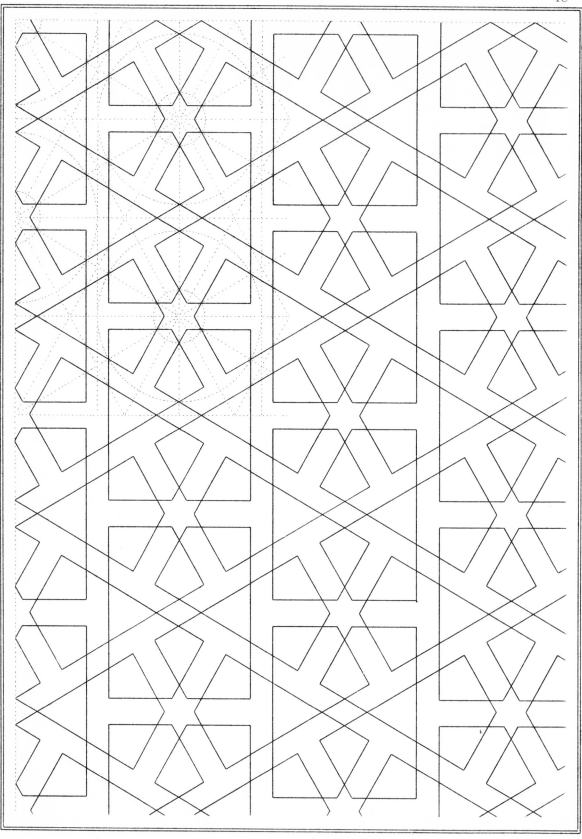

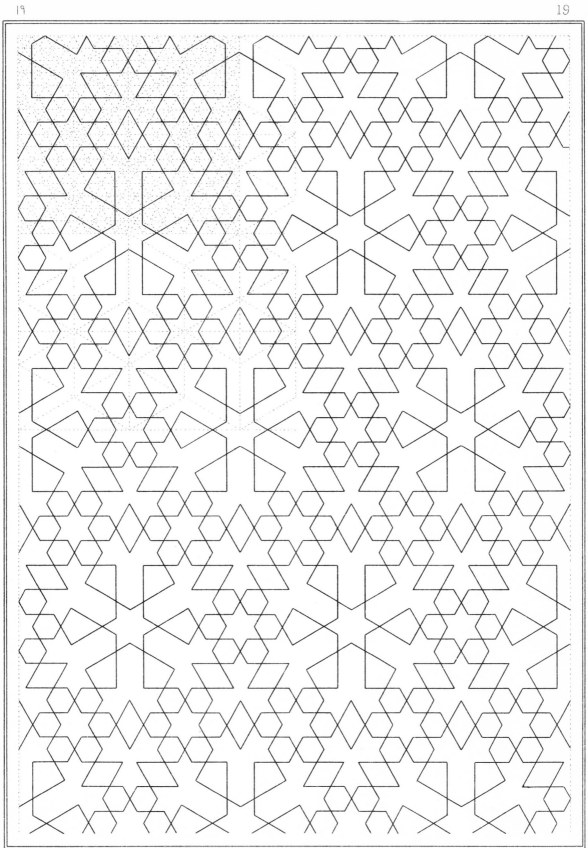

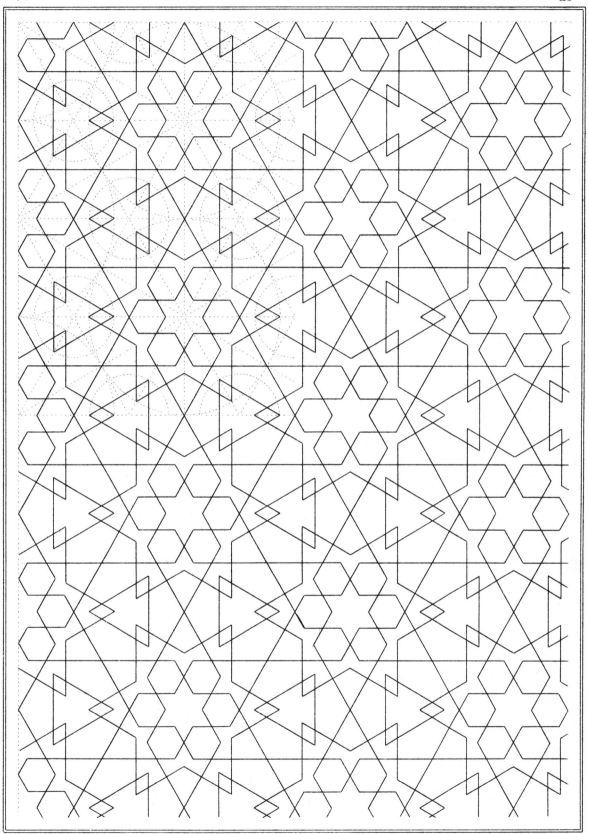

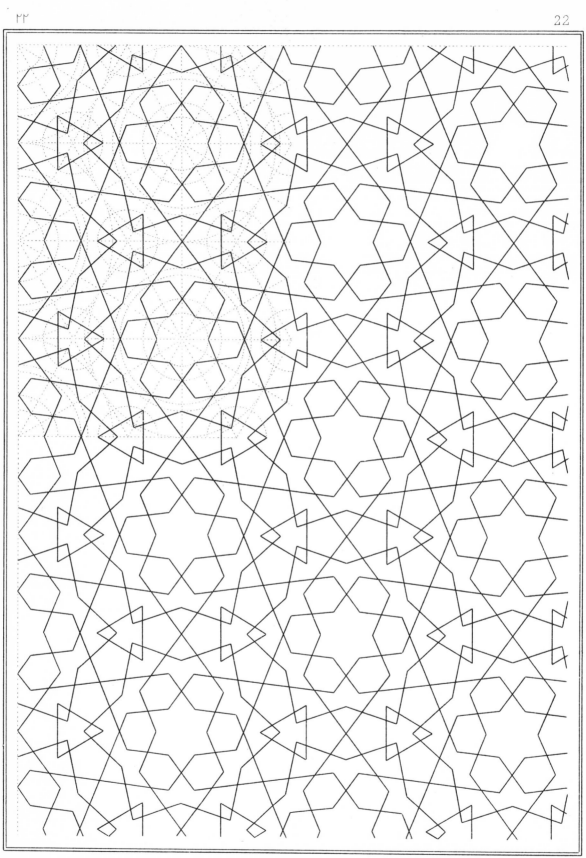

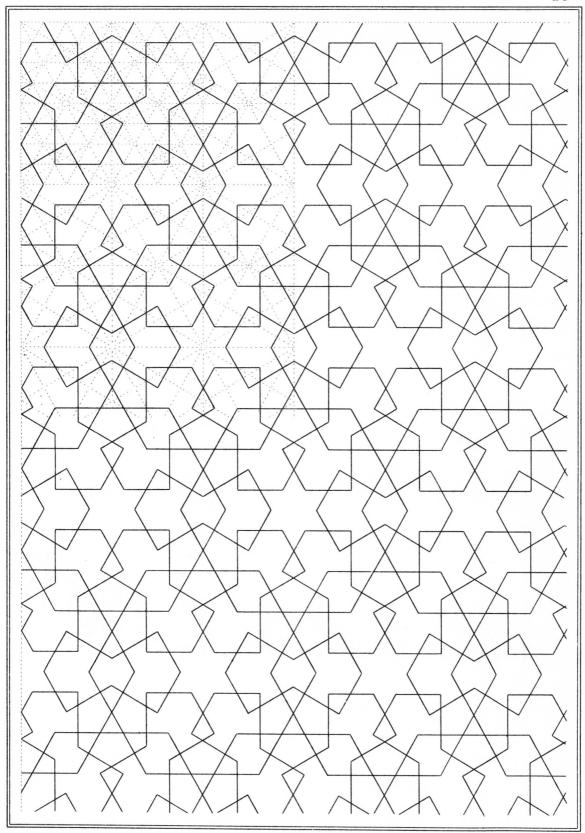

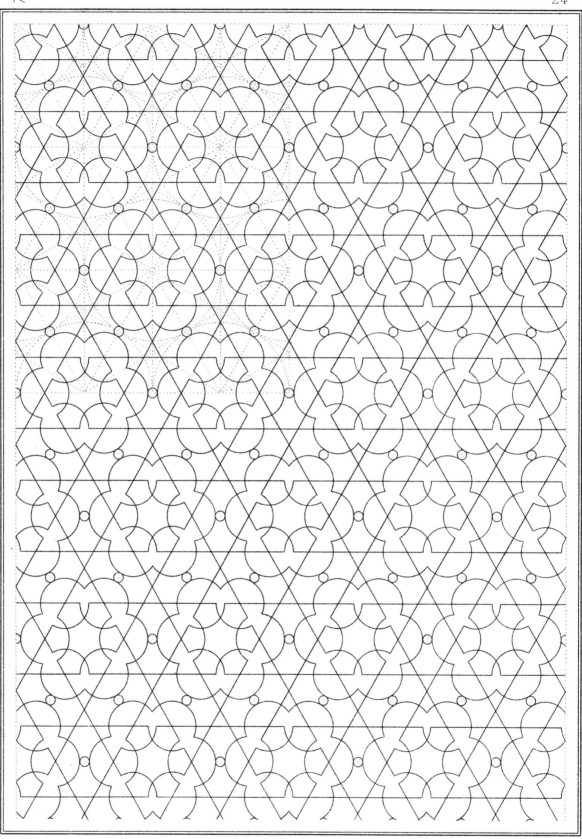

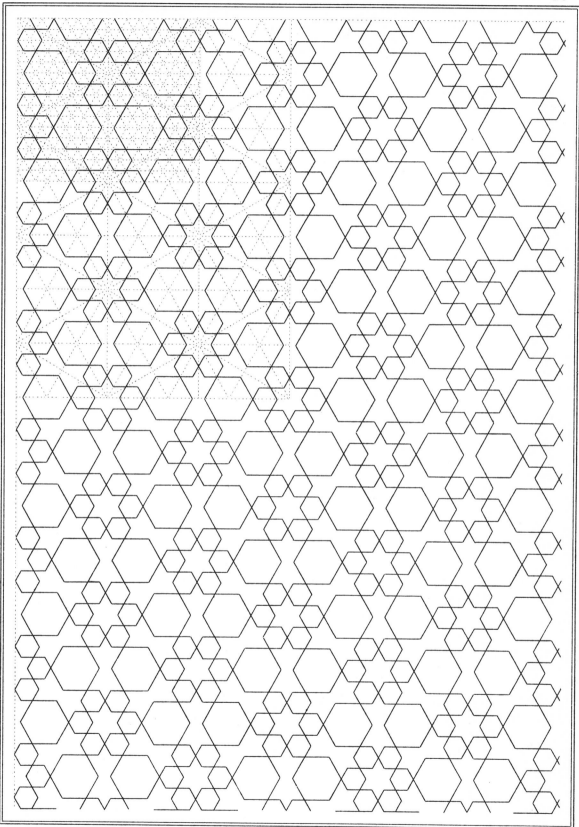

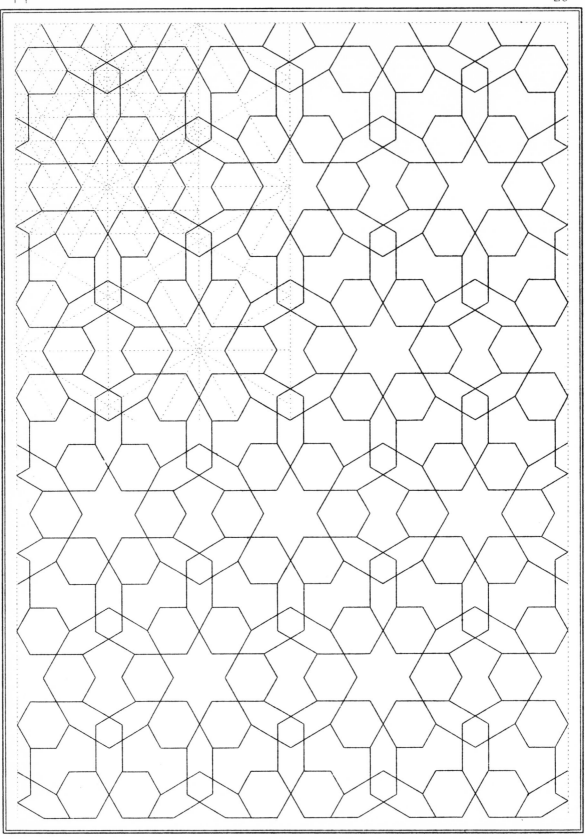

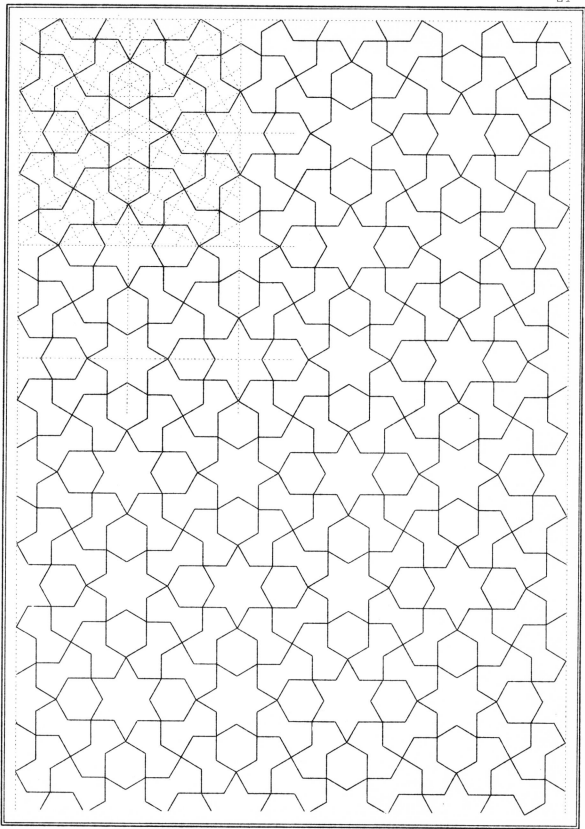

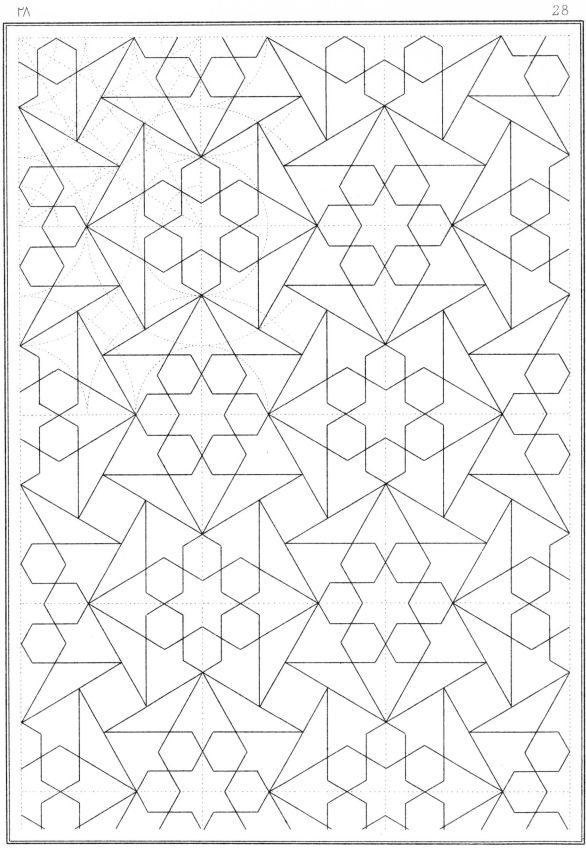

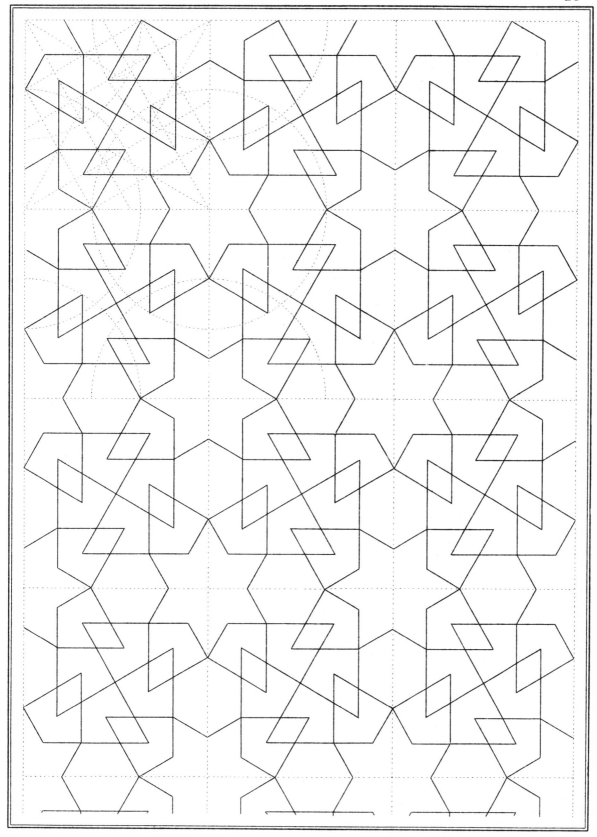

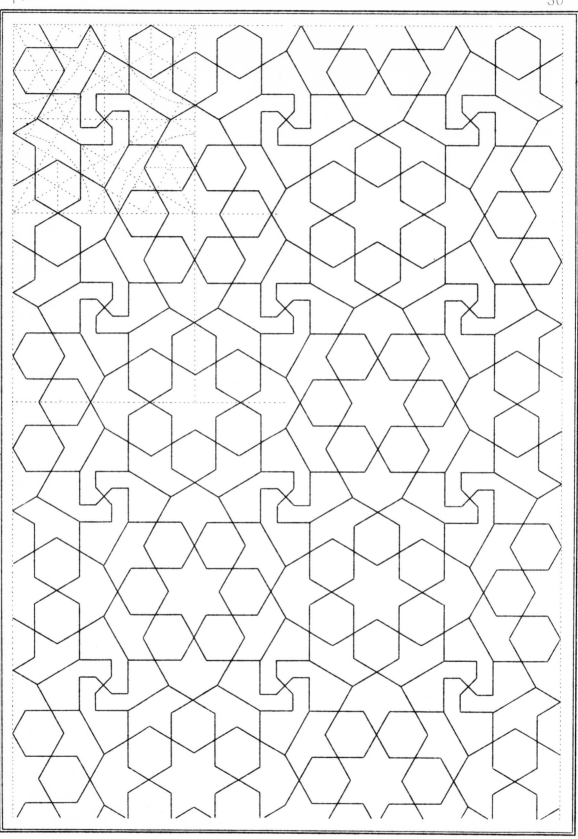

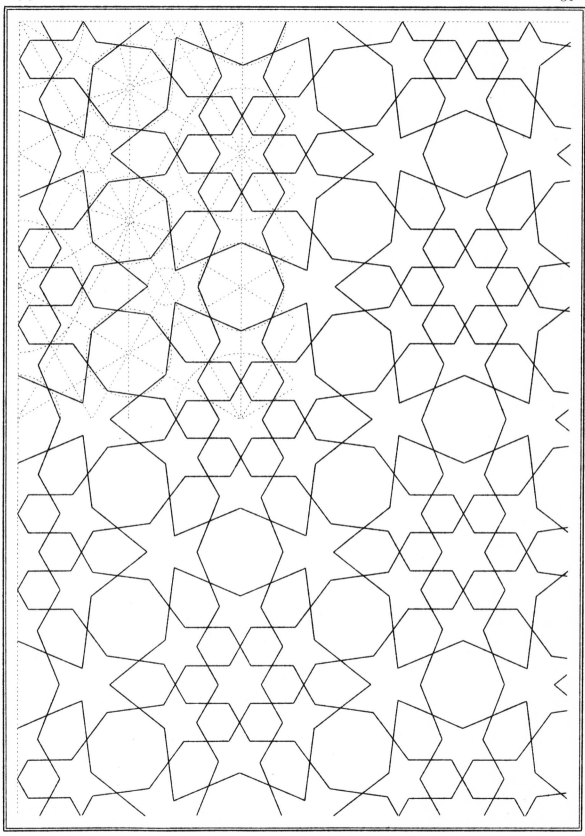

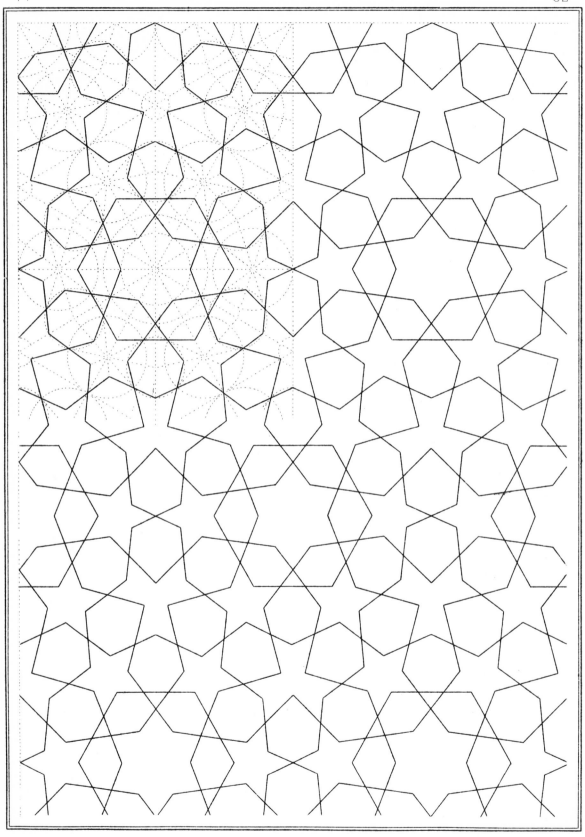

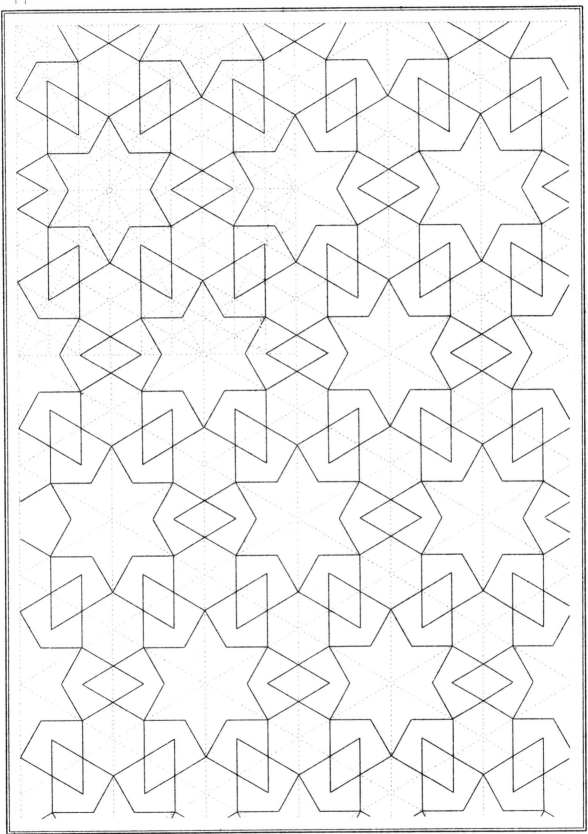

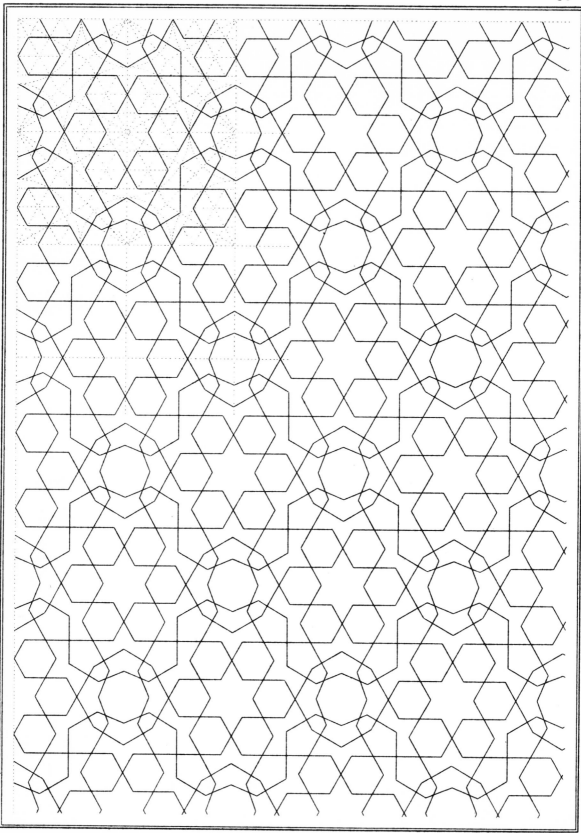

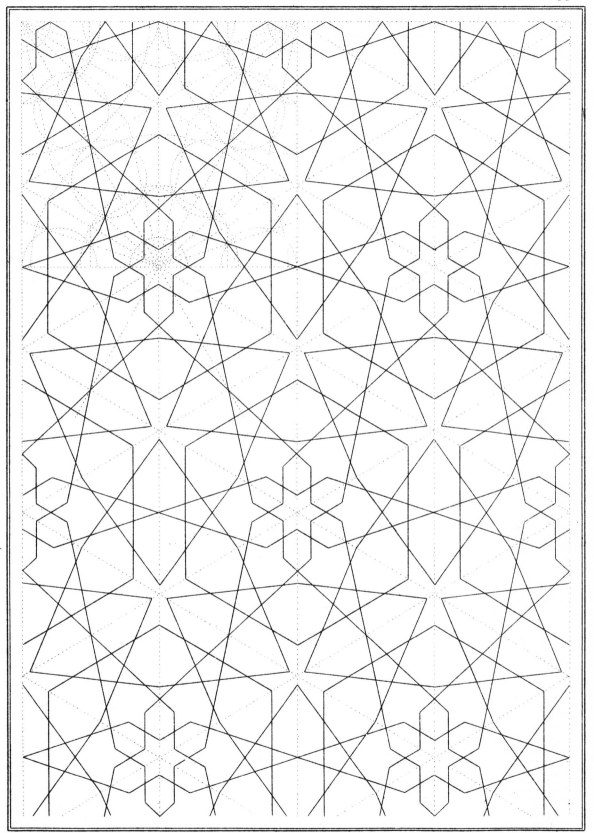

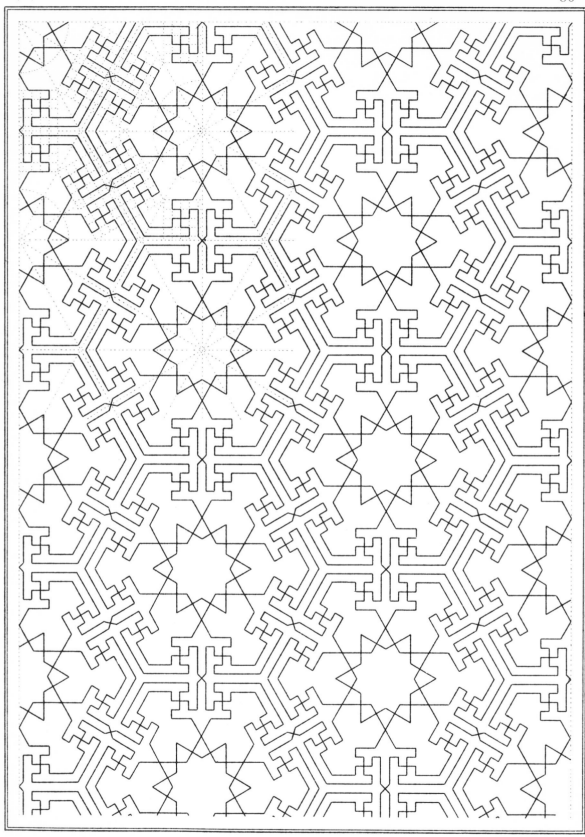

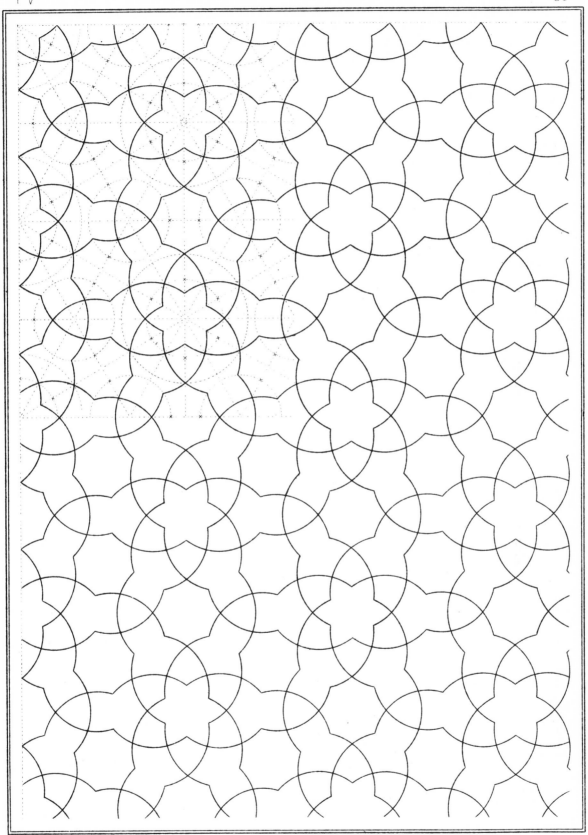

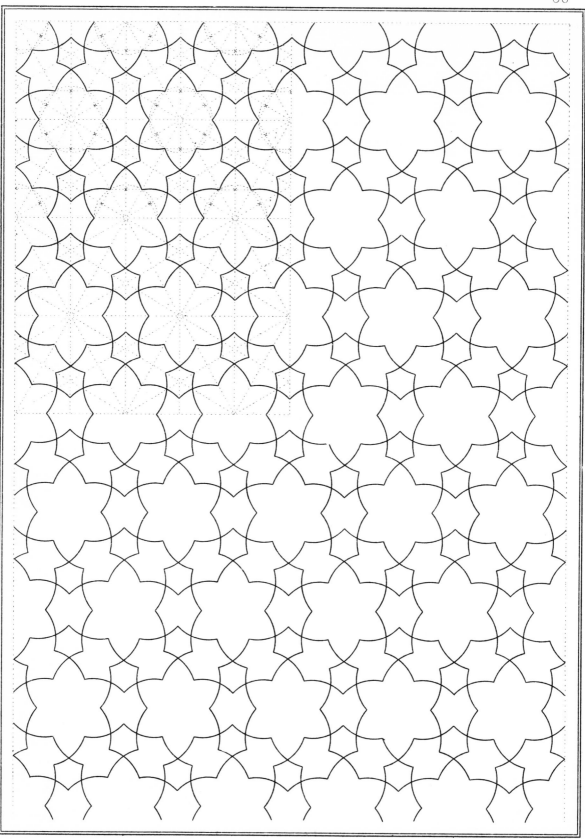

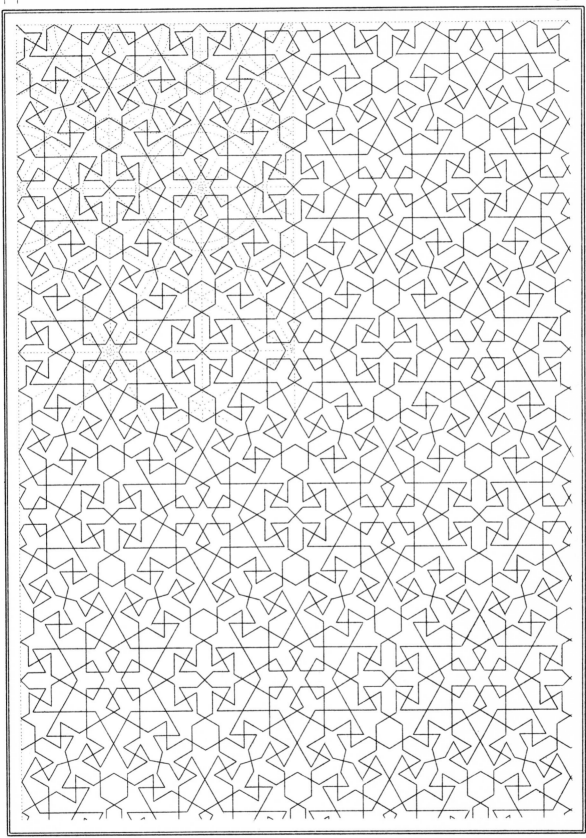

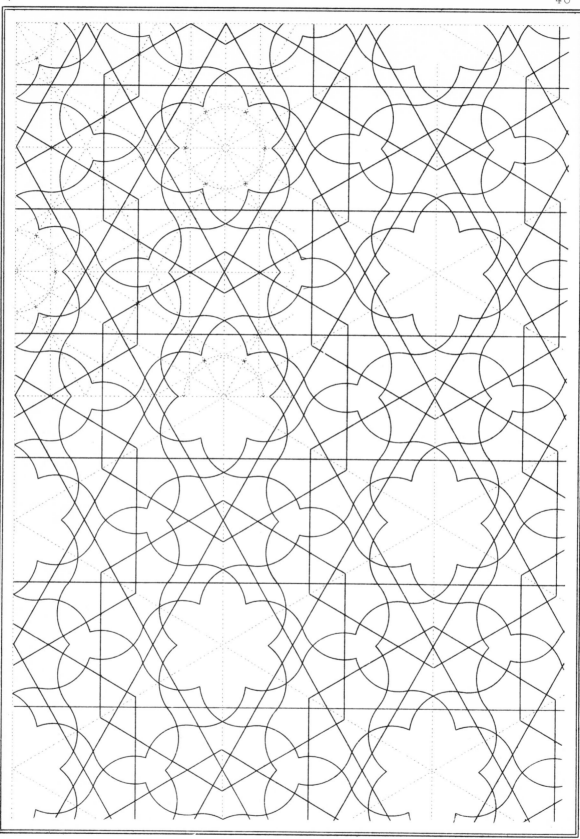

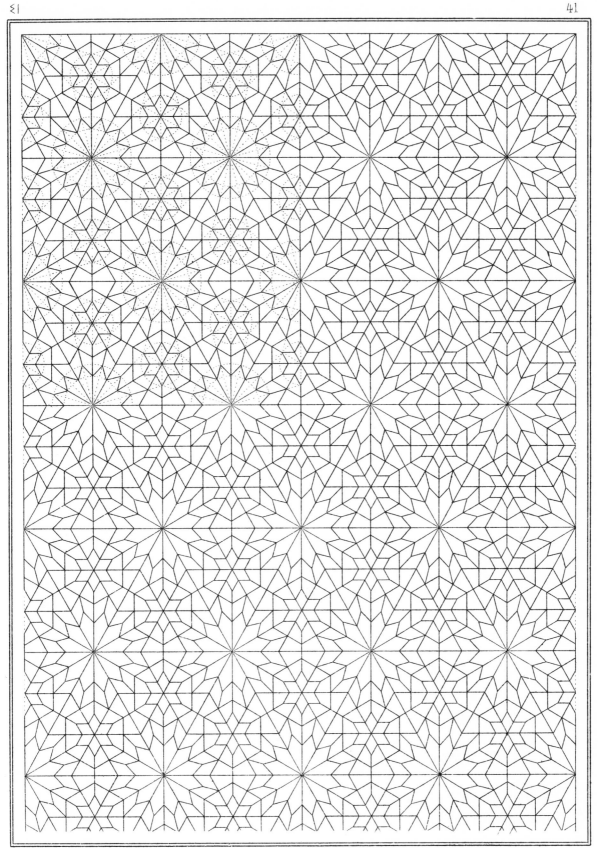

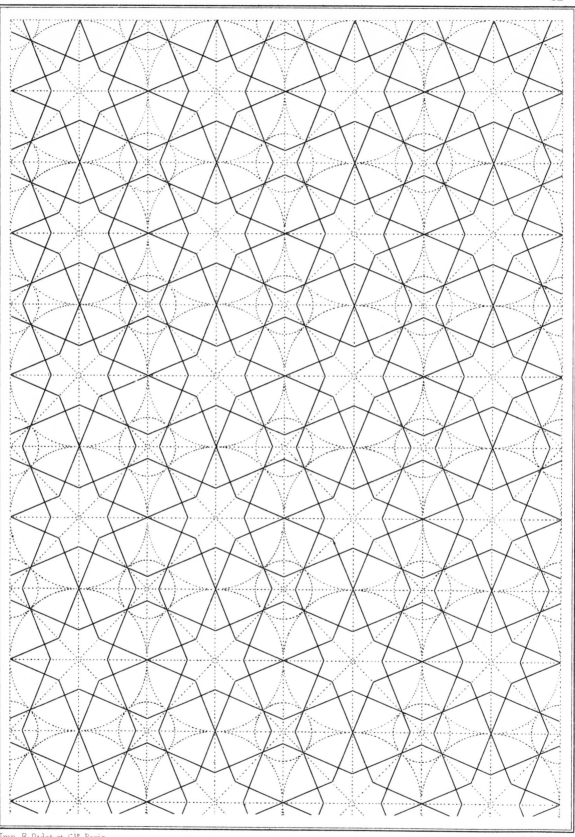

Imp. F. Didot et Cie Paris

J. Sulpis sc

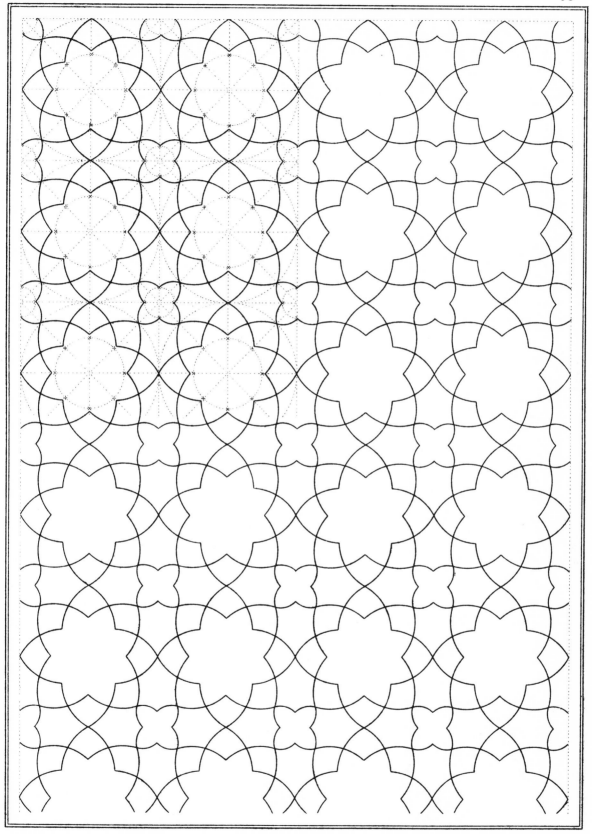

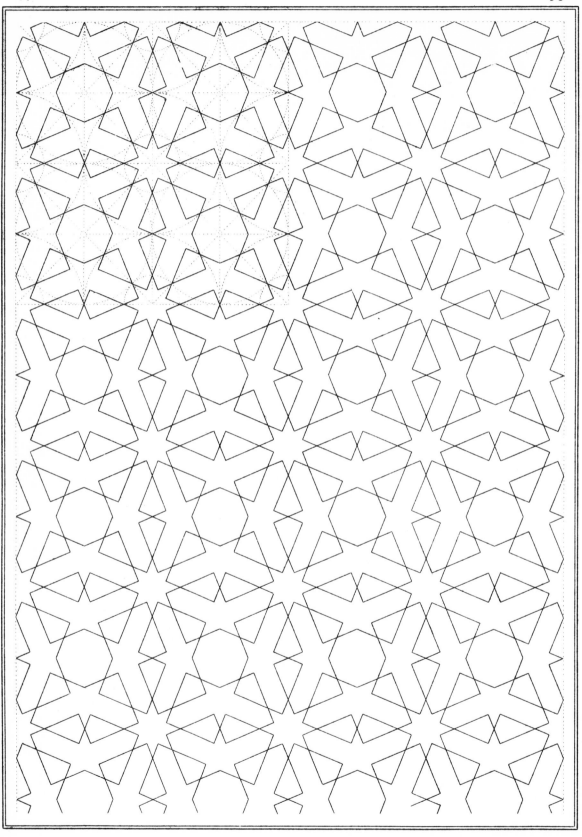

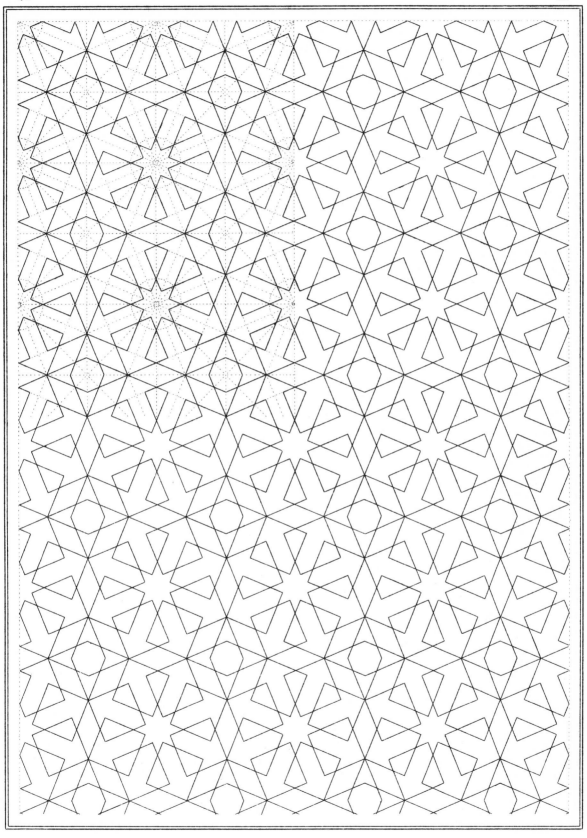

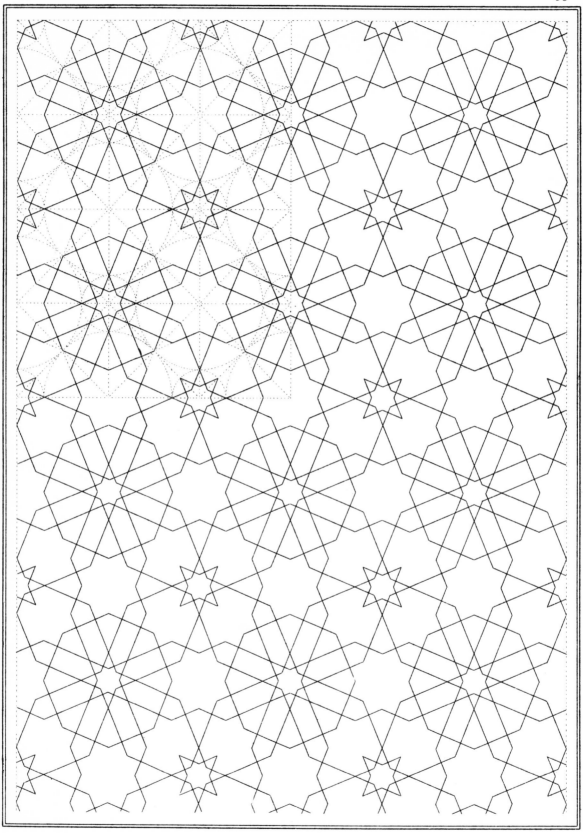

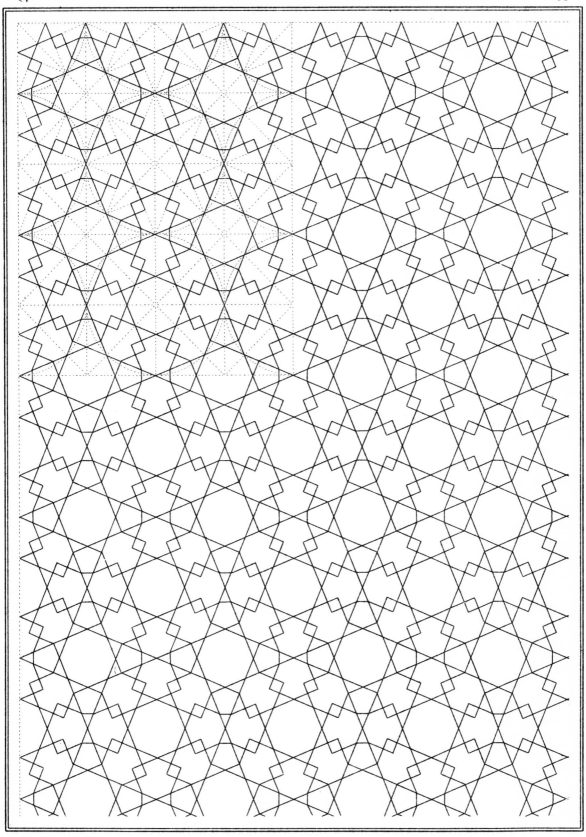

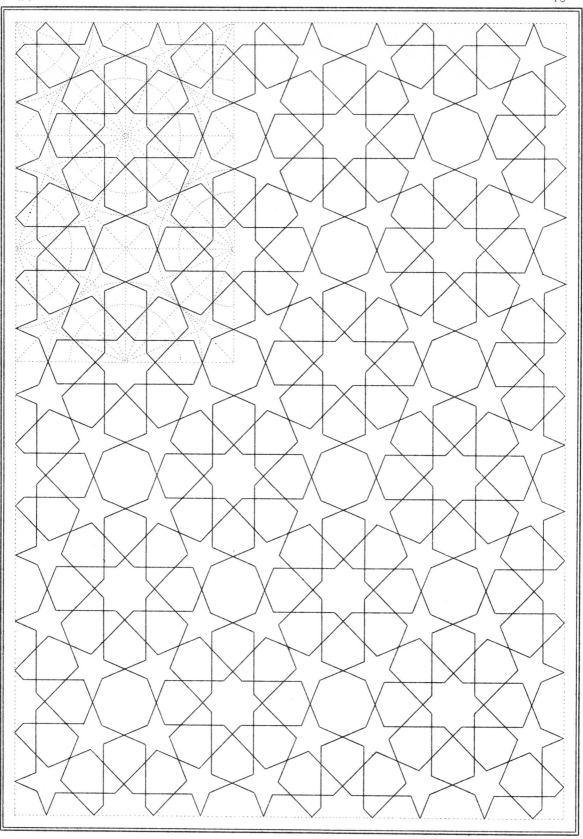

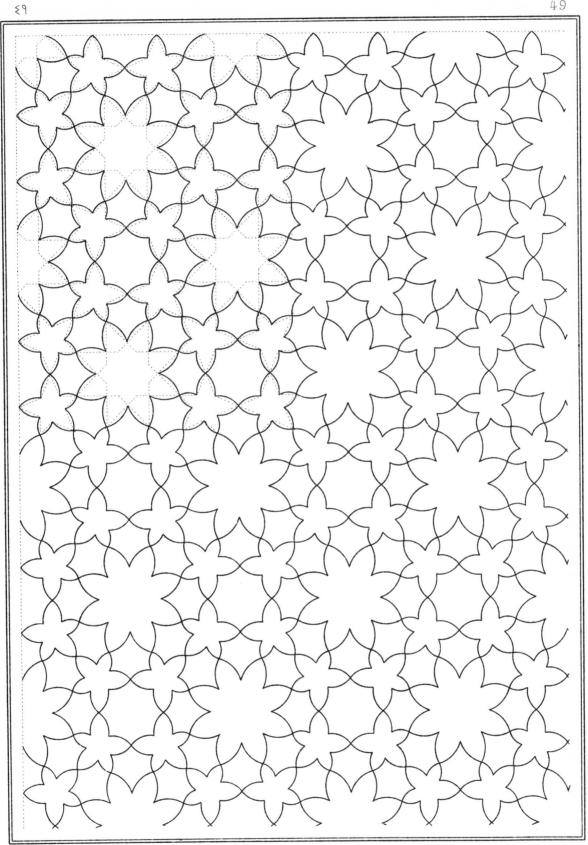

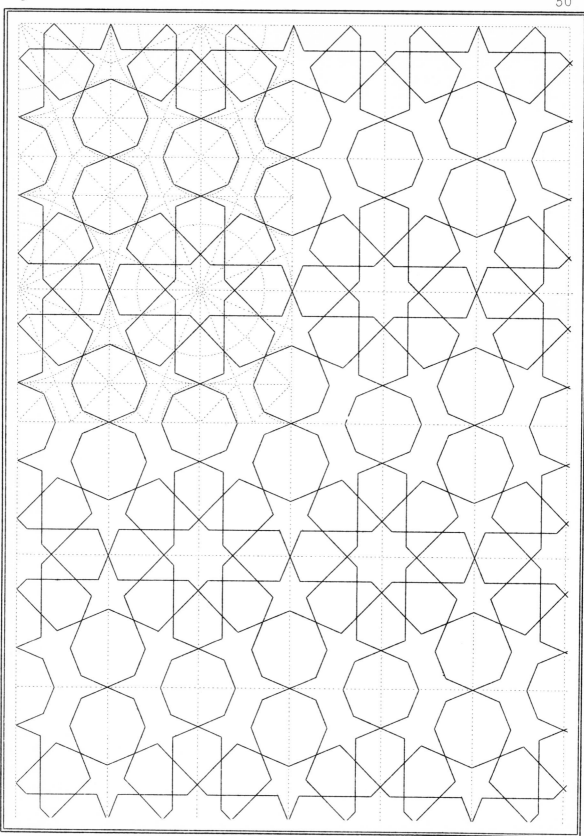

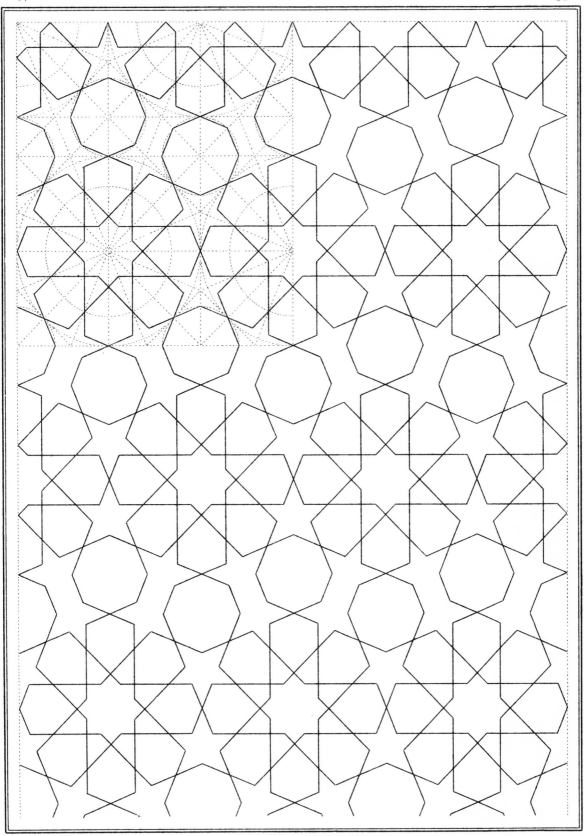

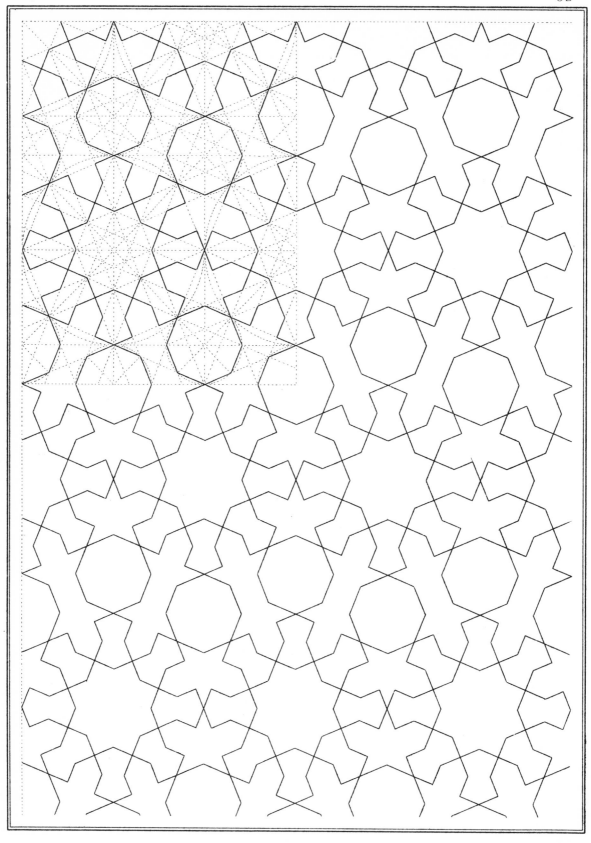

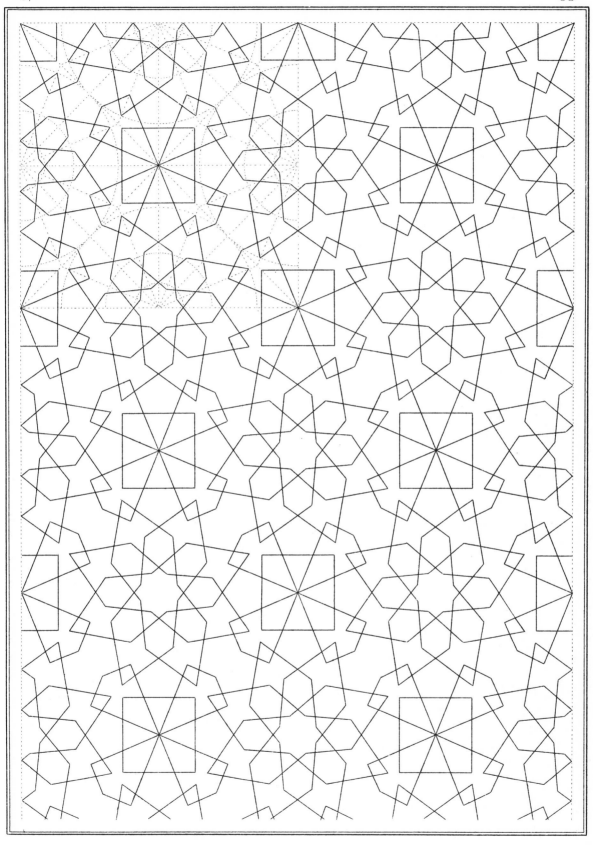

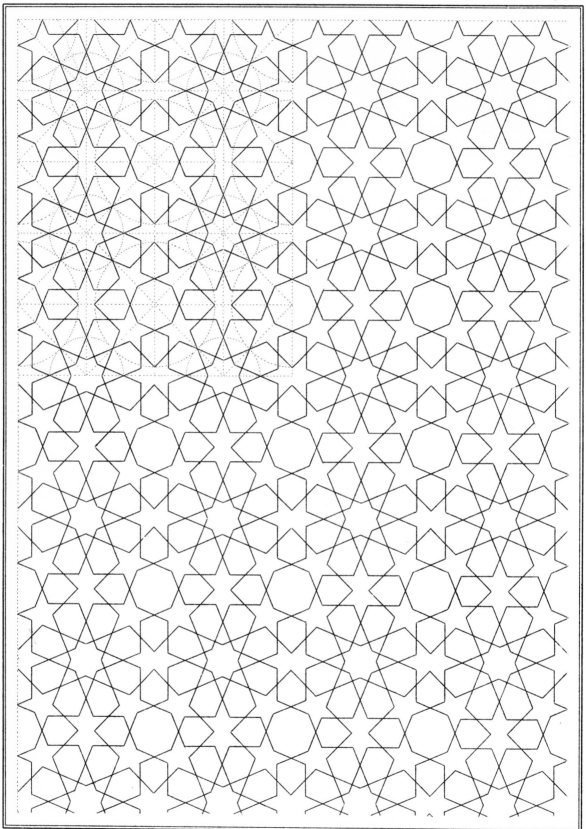

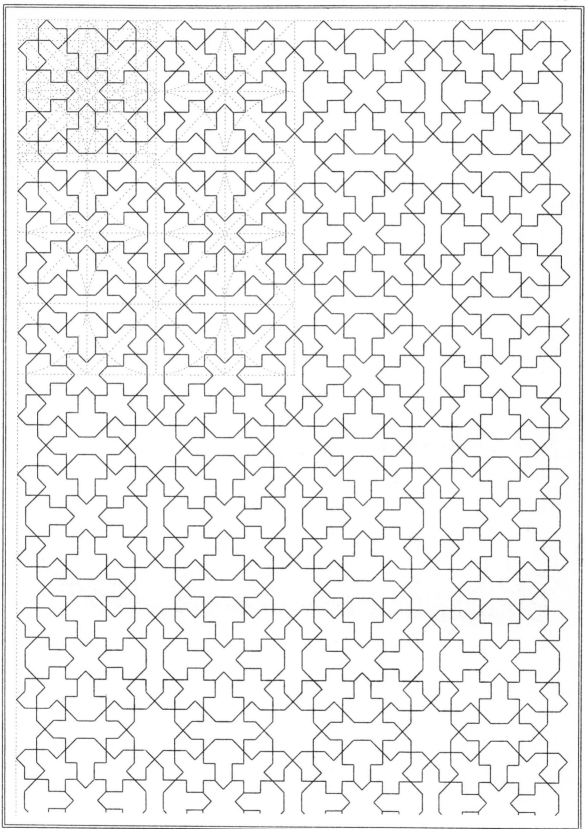

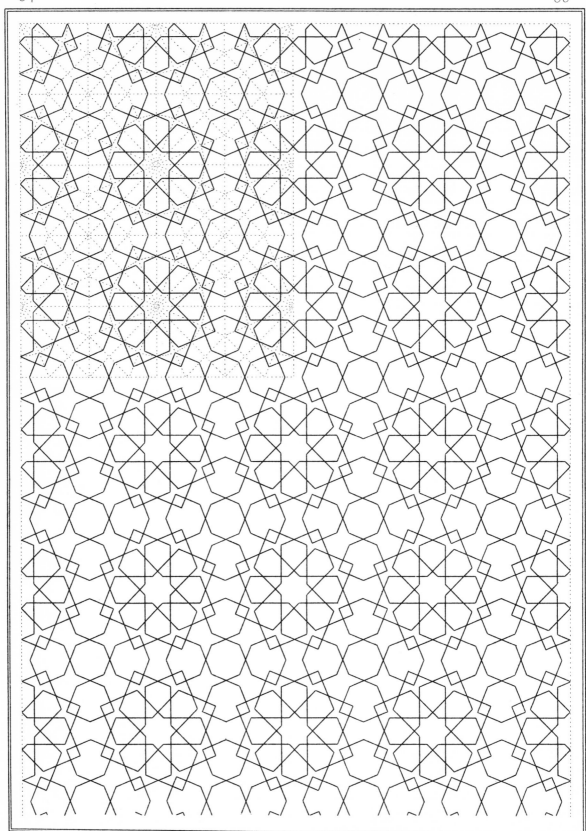

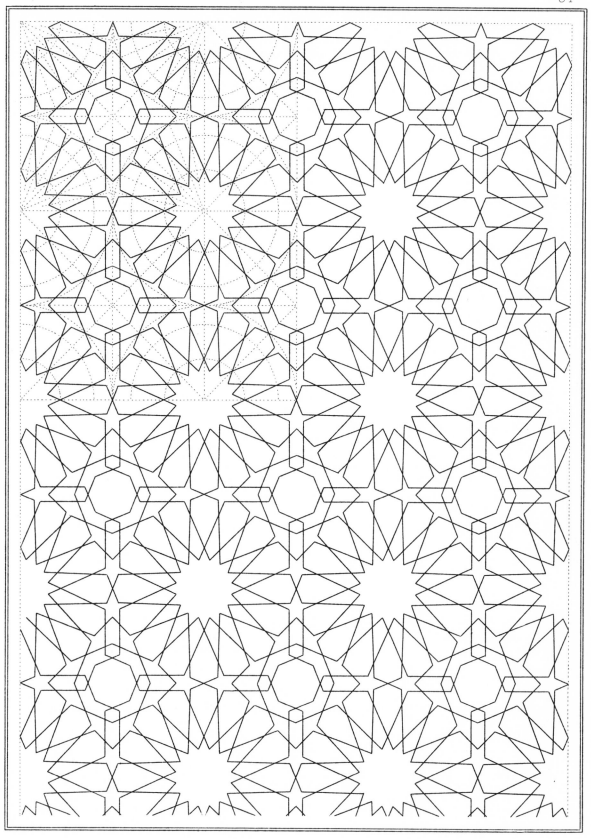

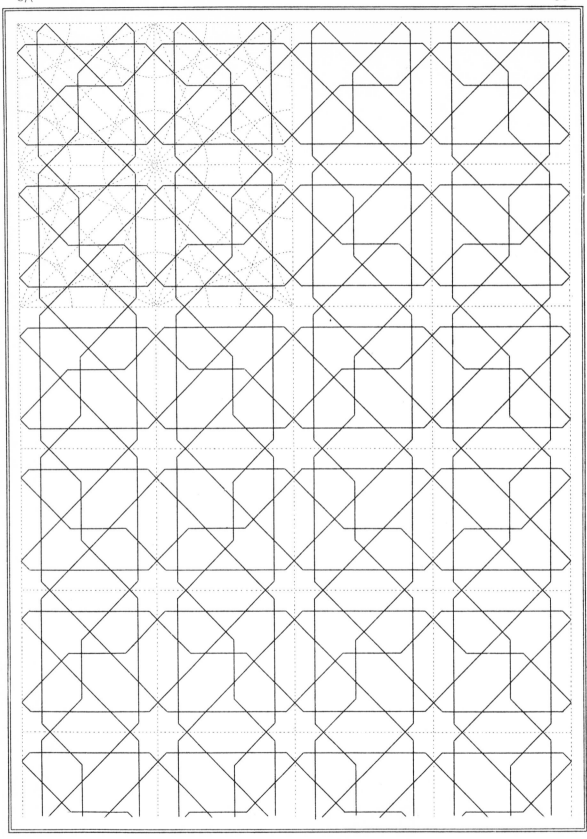

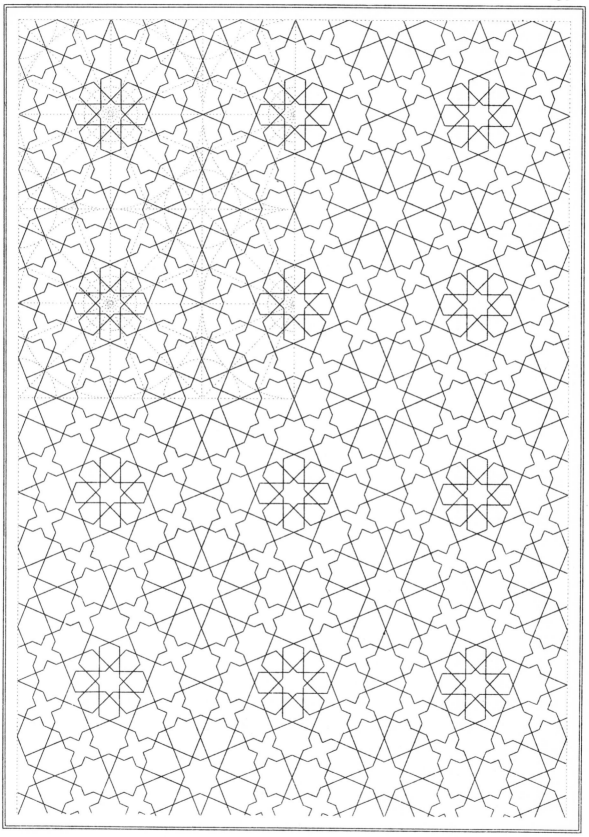

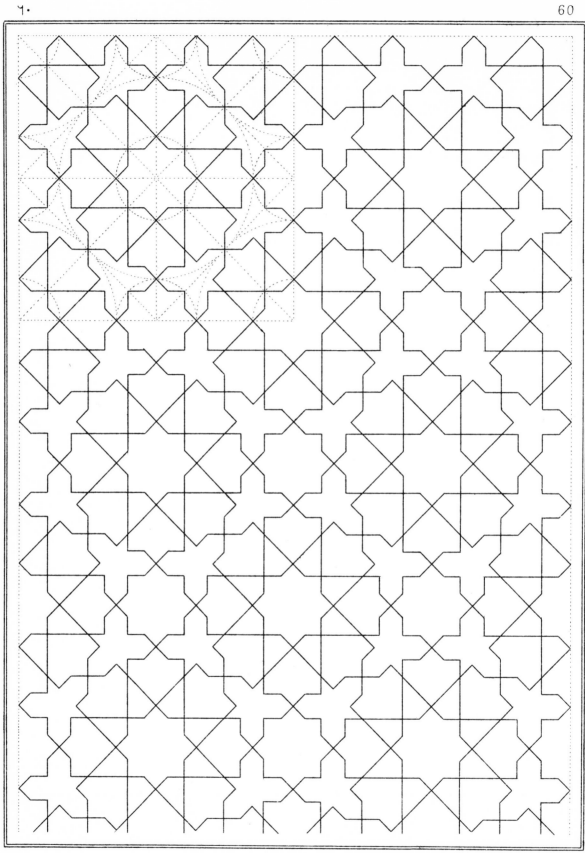

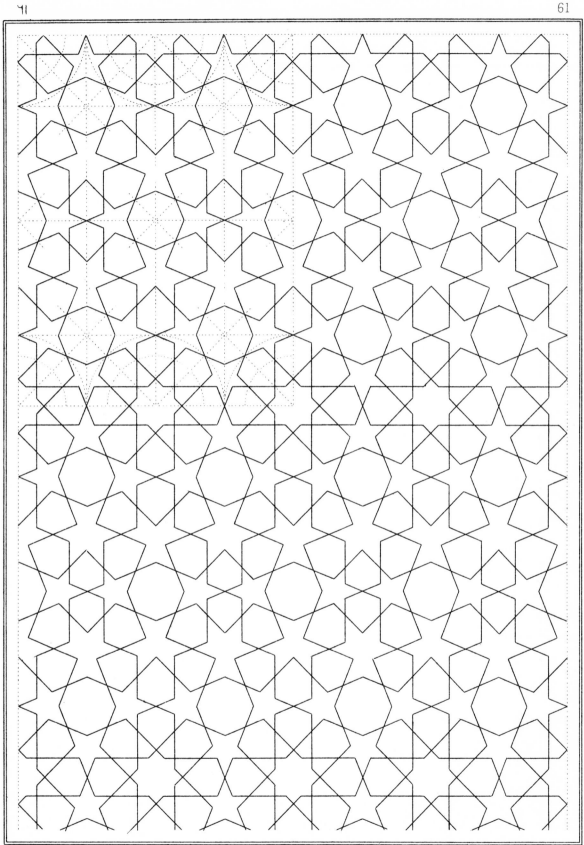

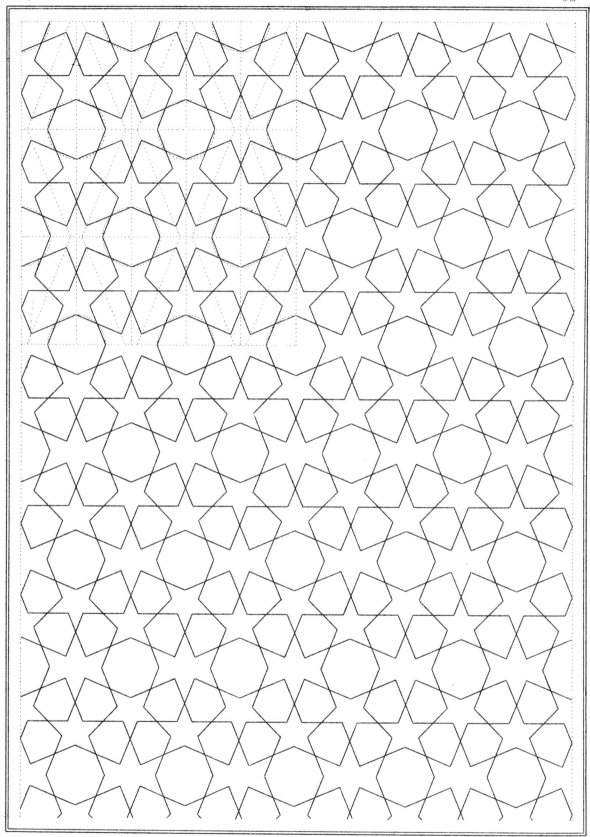

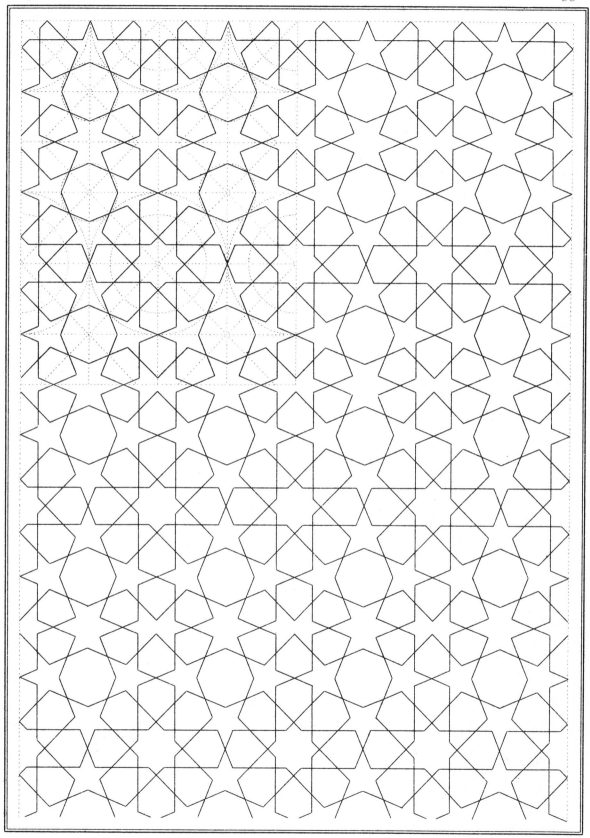

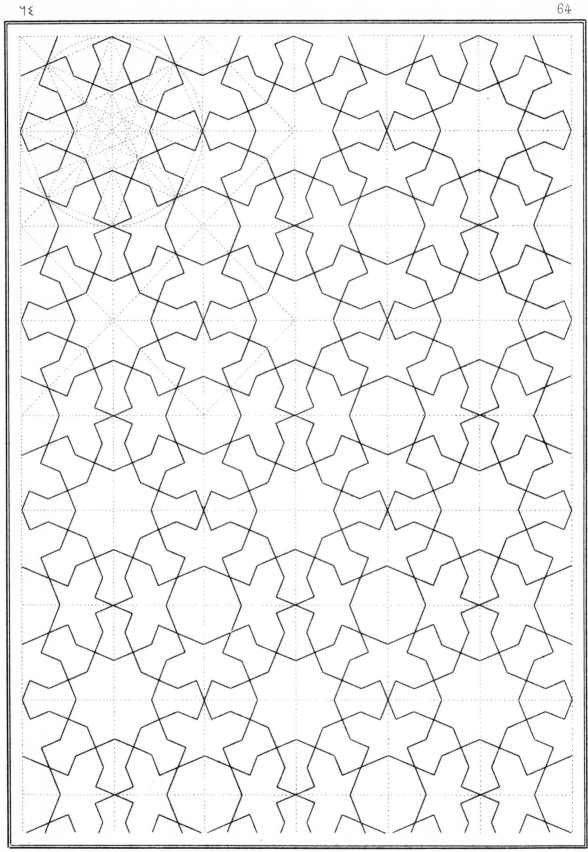

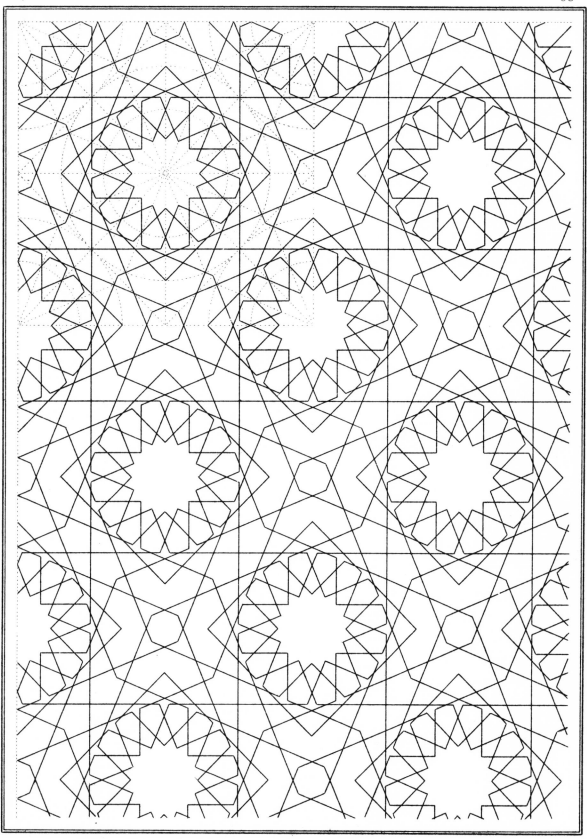

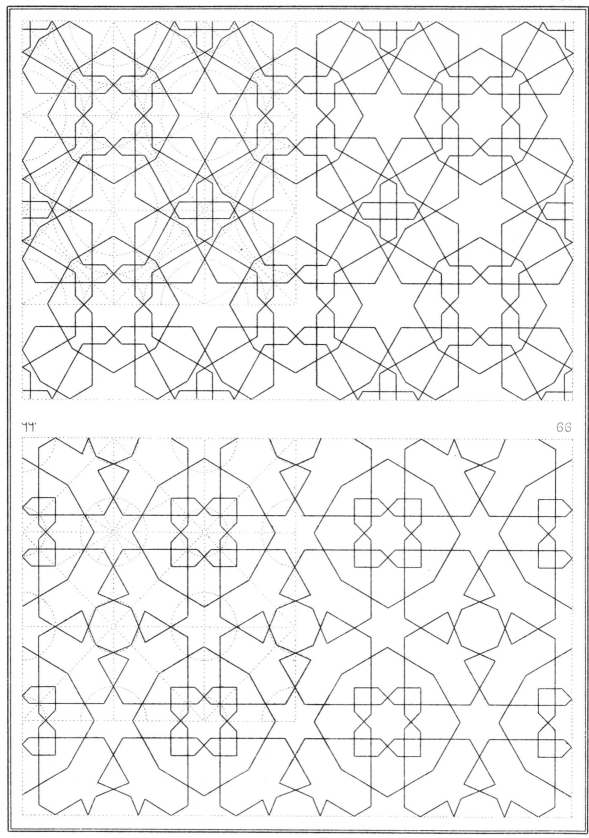

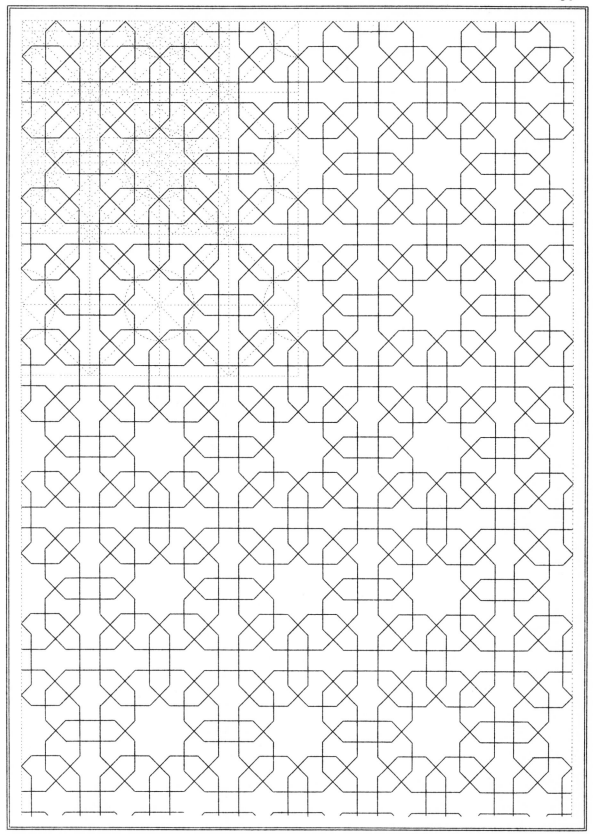

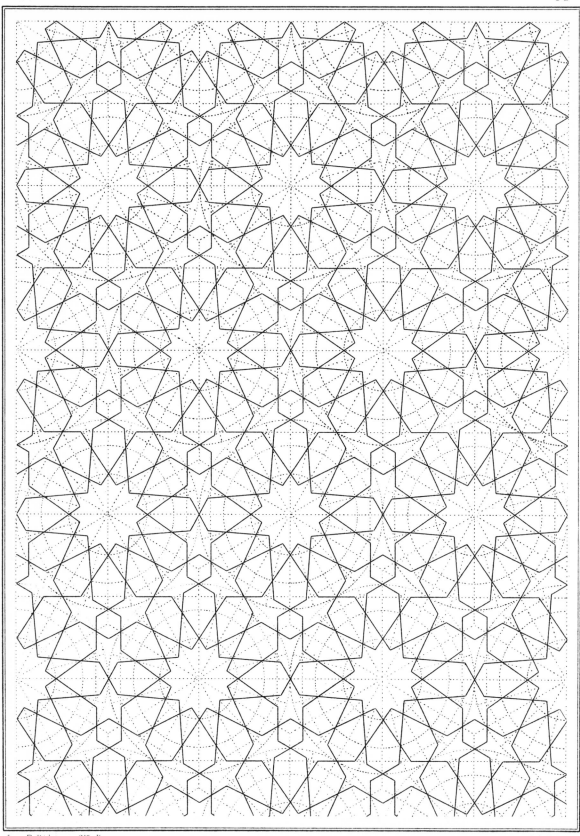

Imp F Didot et C¹ᵉ Paris
J. Sulpis sc.

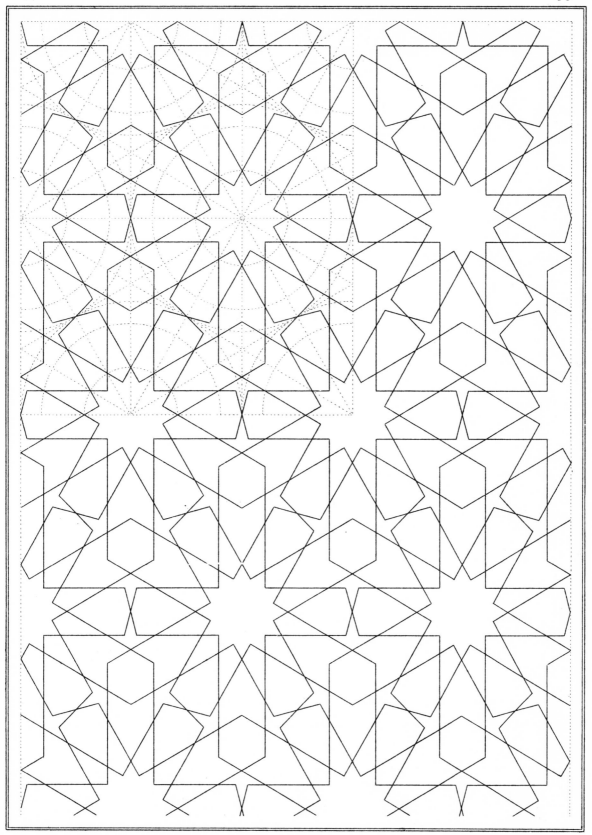

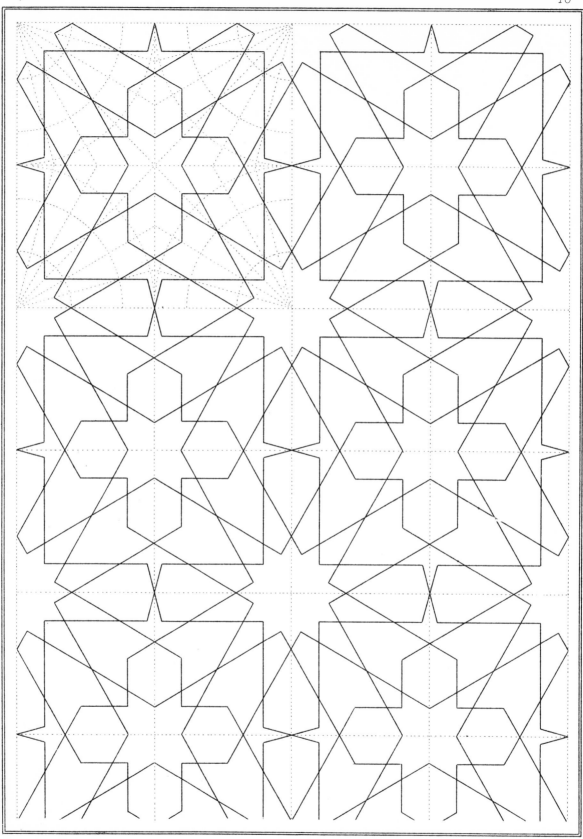

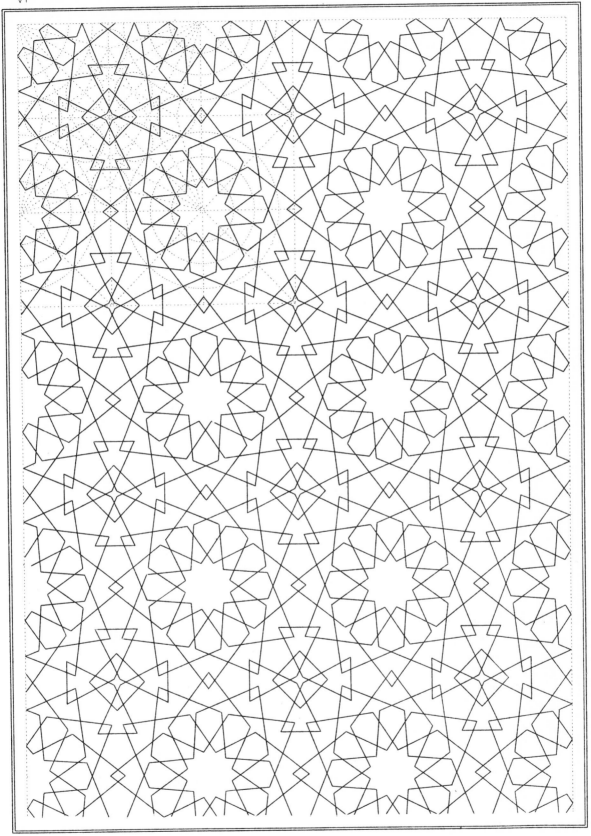

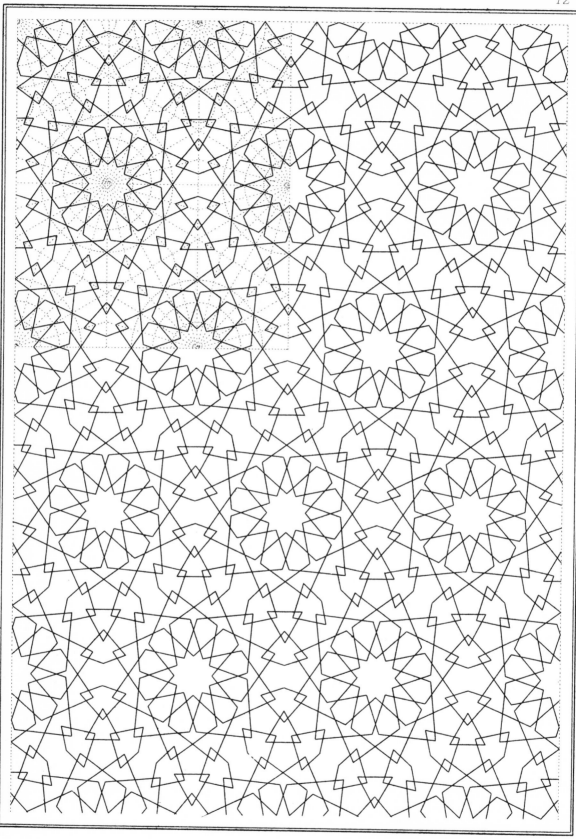

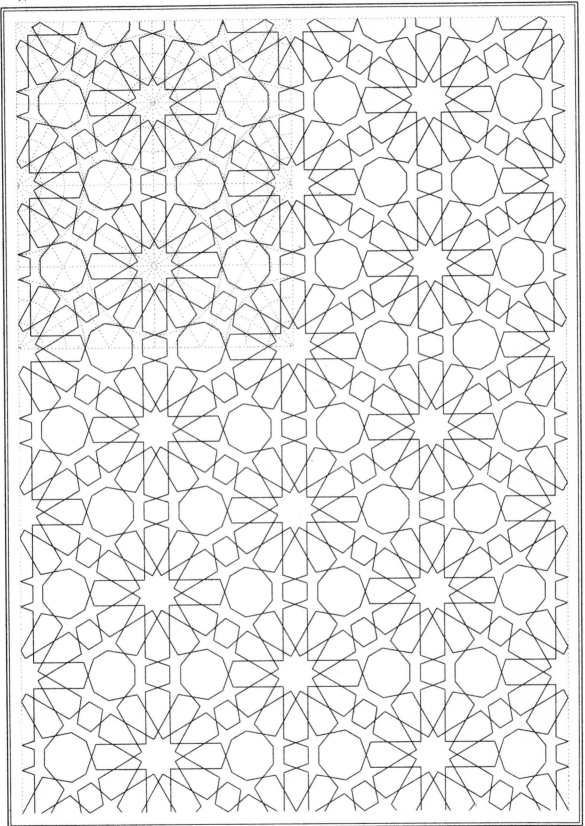

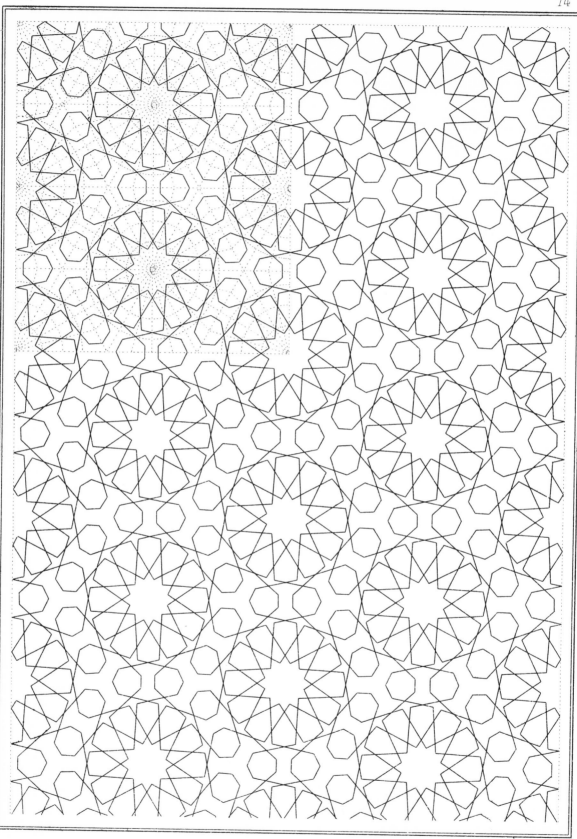

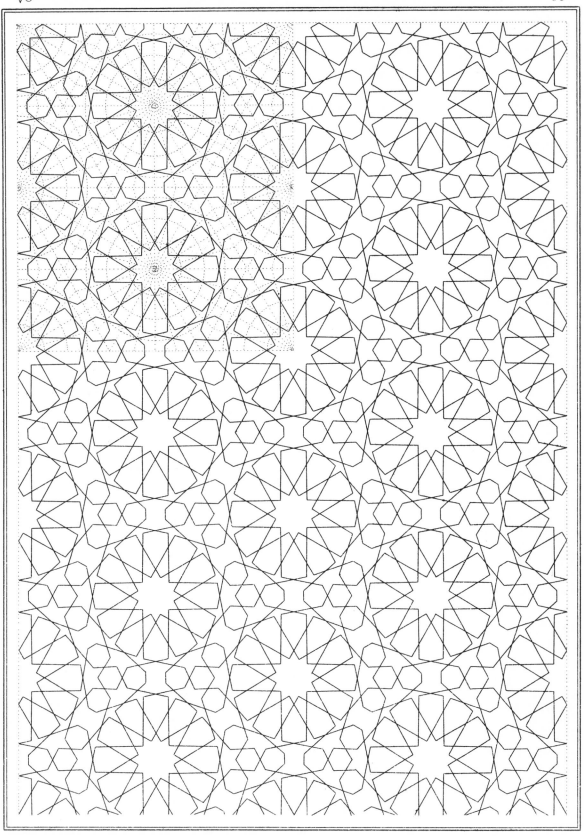

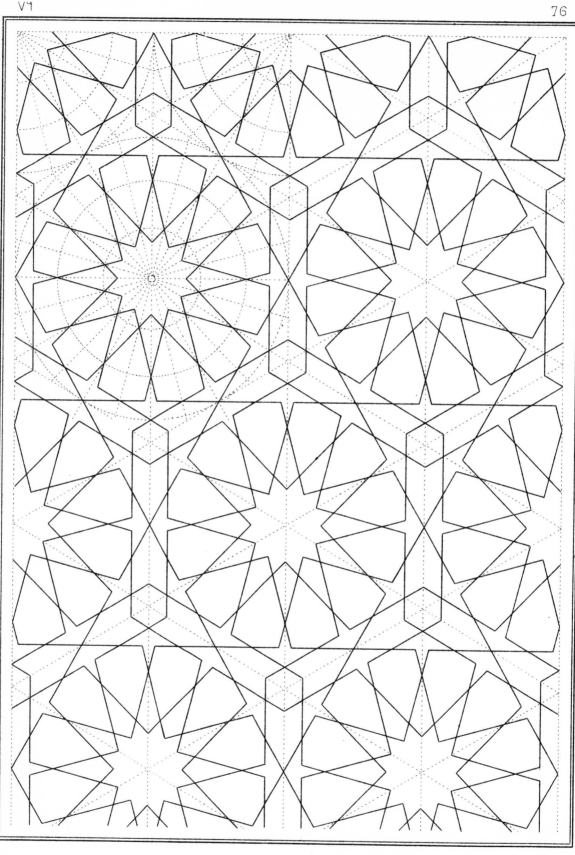

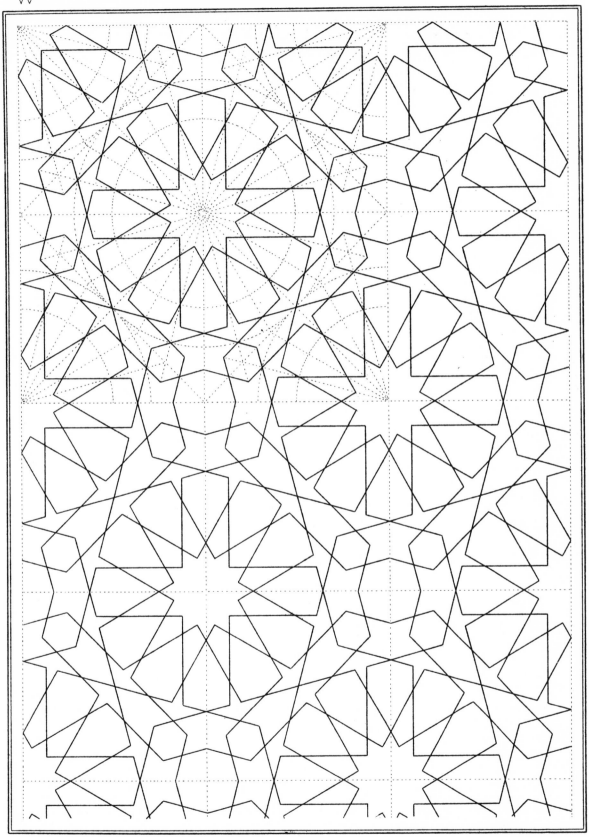

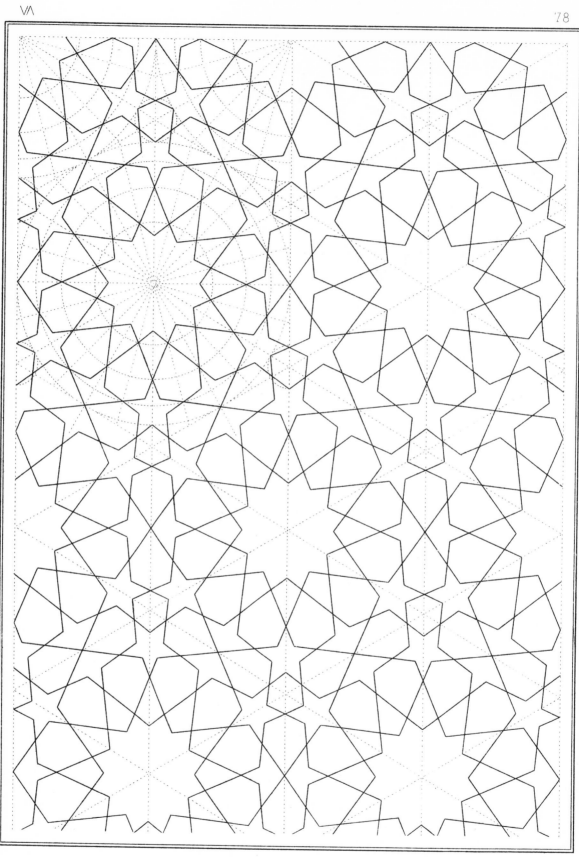

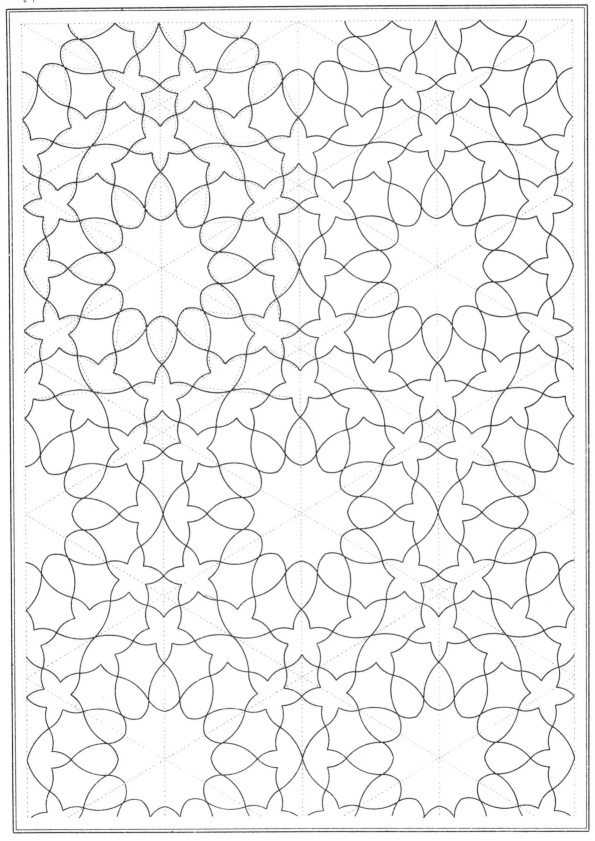

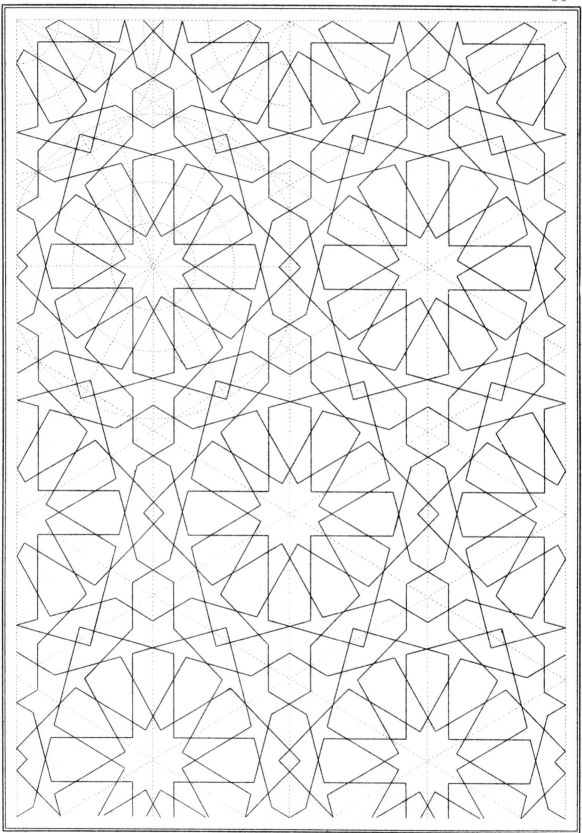

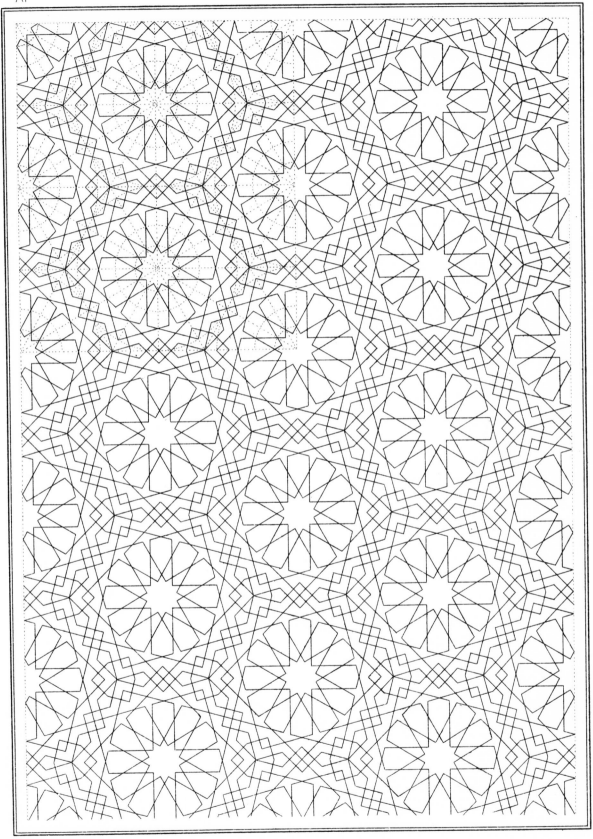

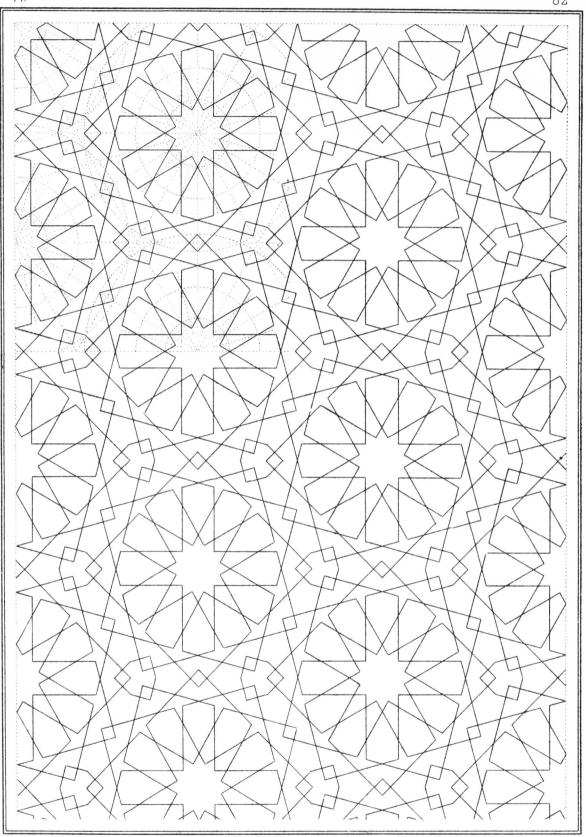

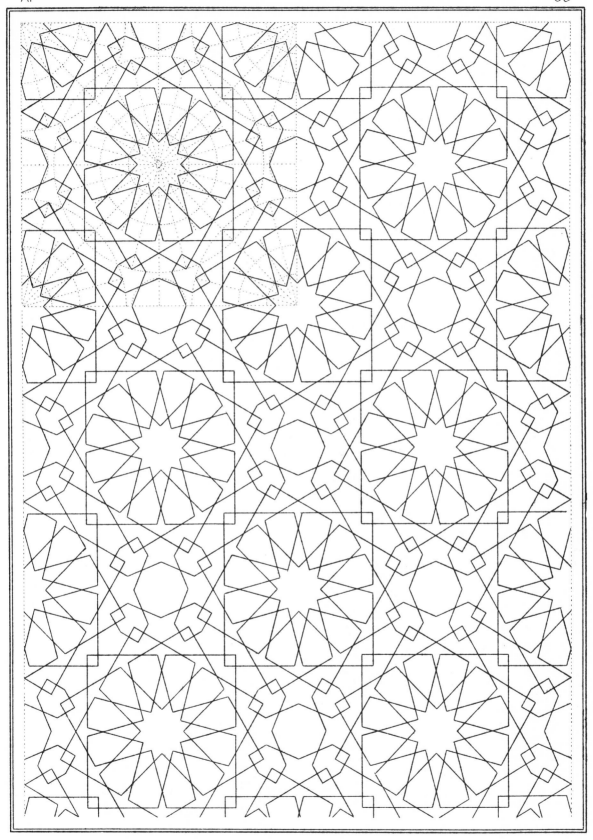

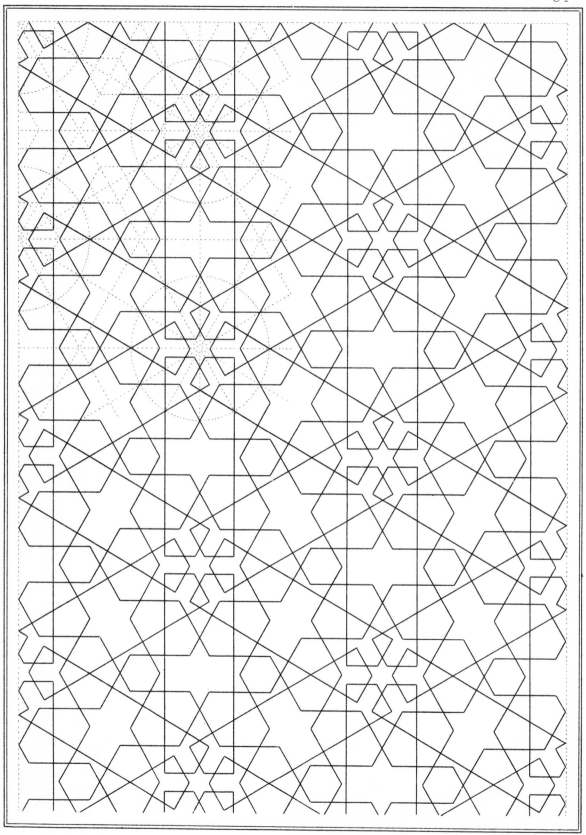

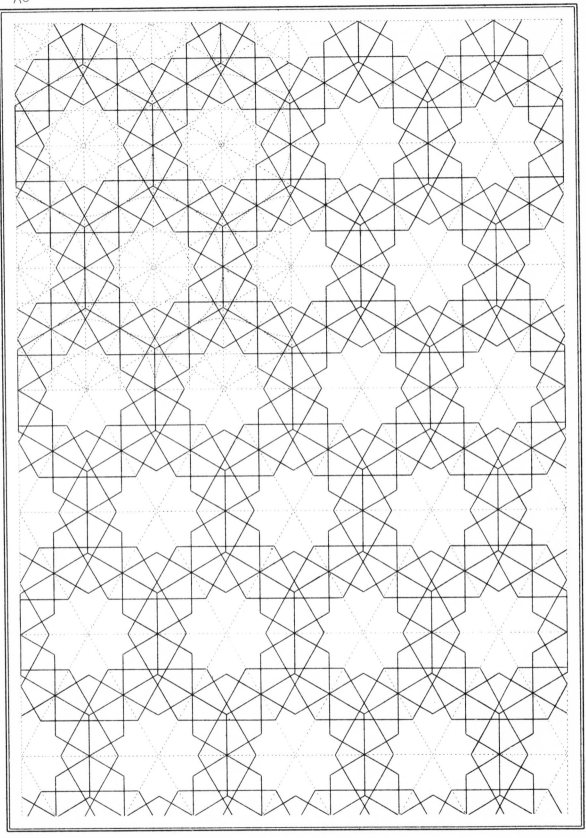

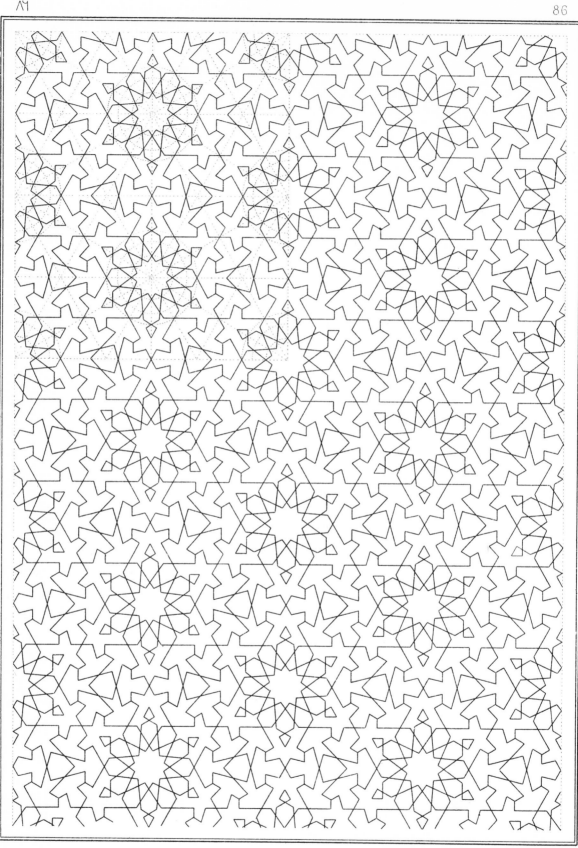

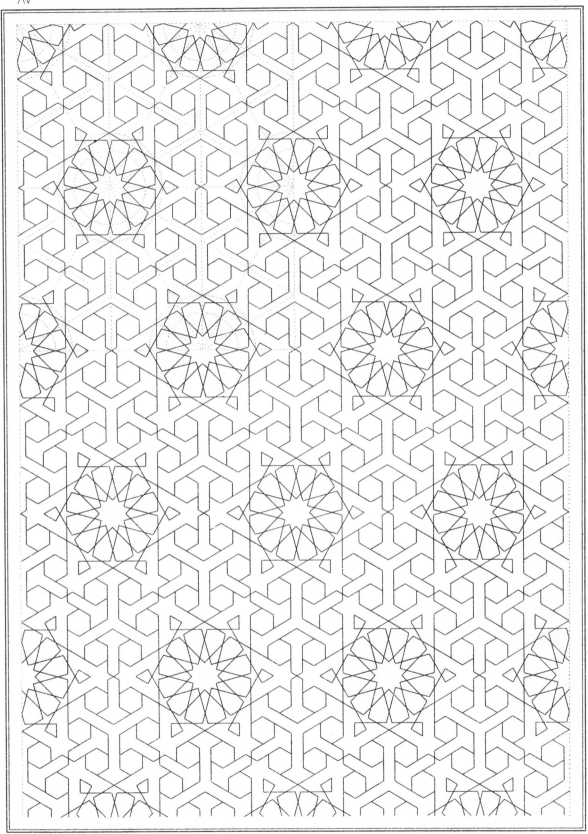

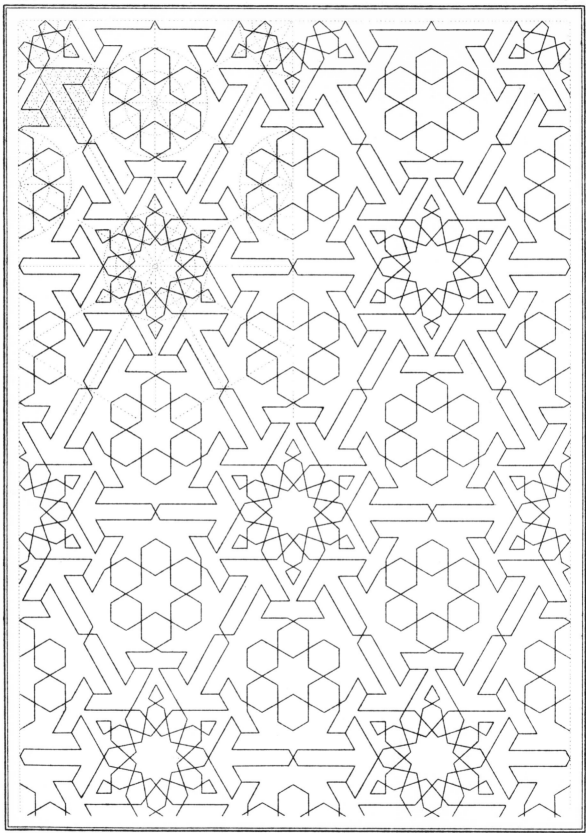

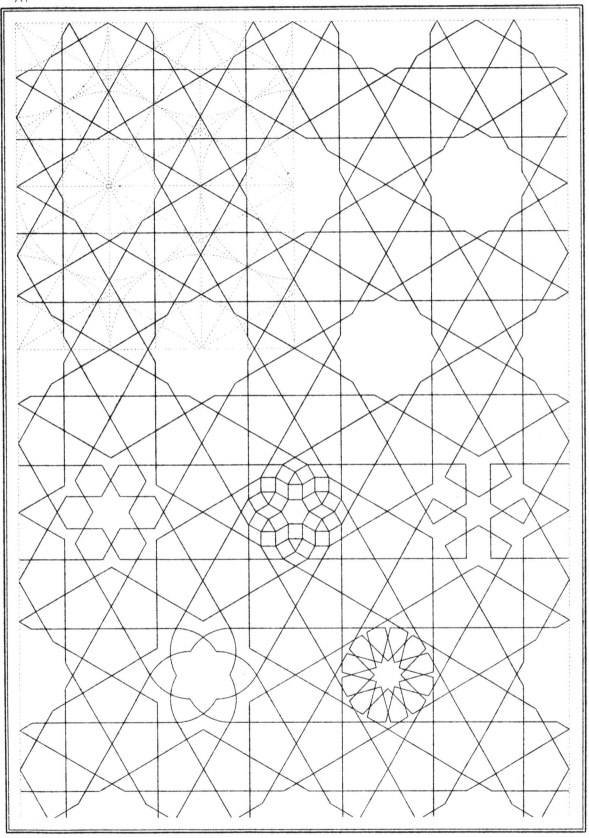

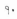

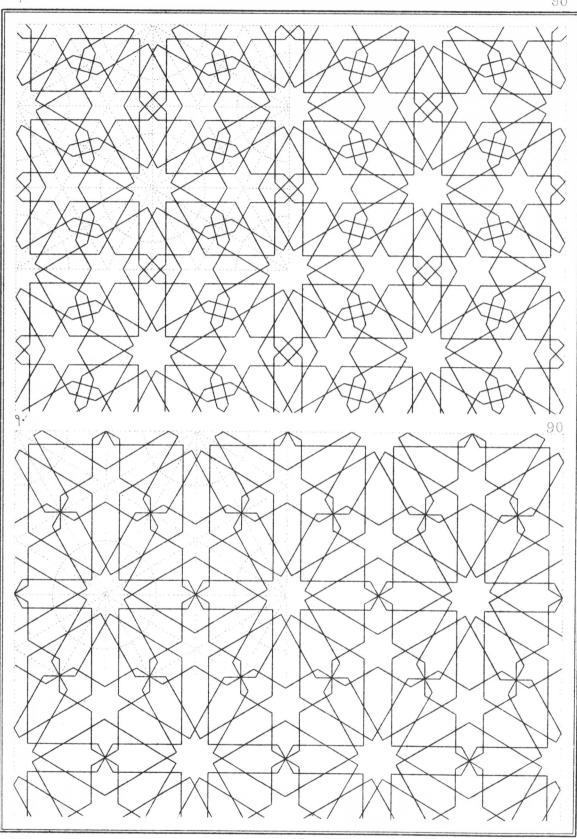

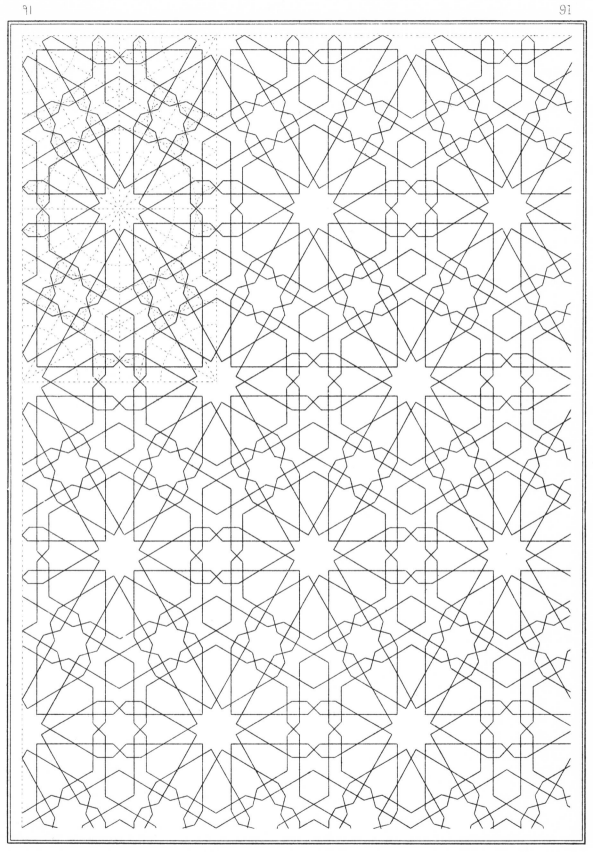

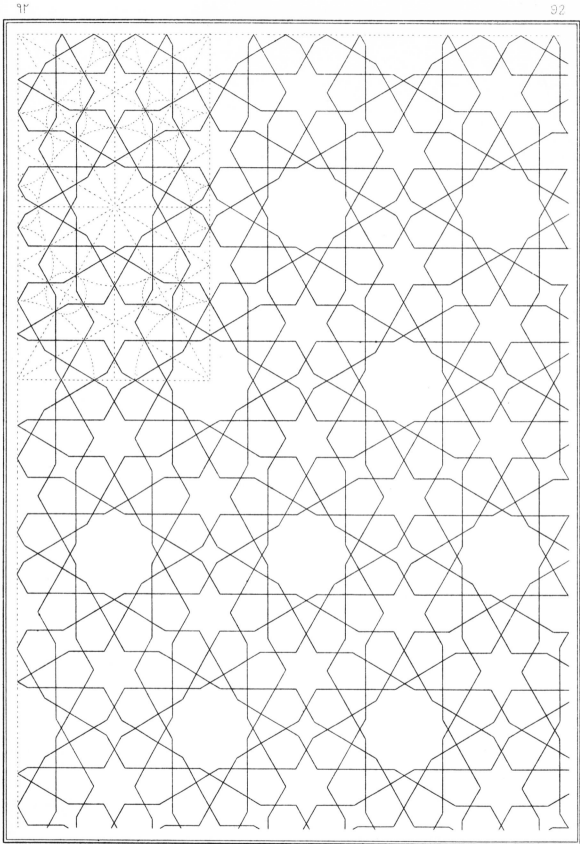

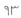

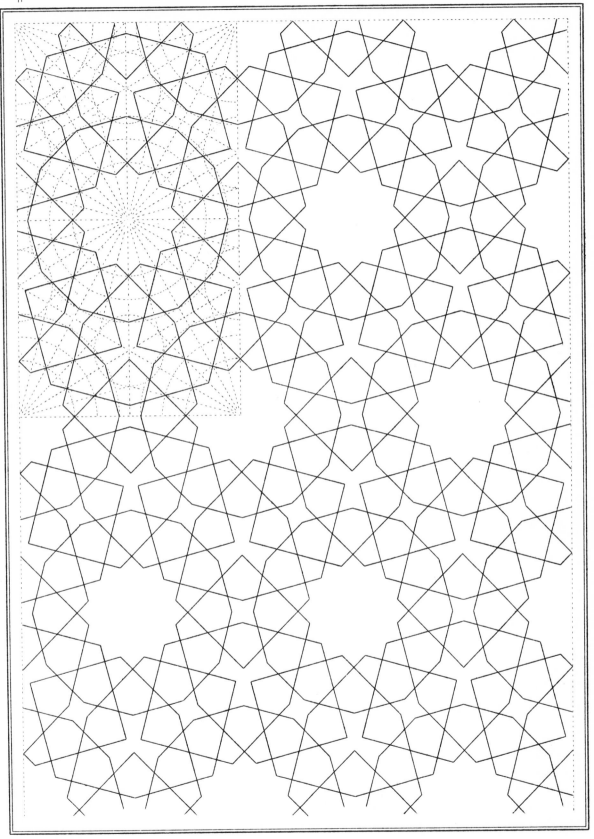

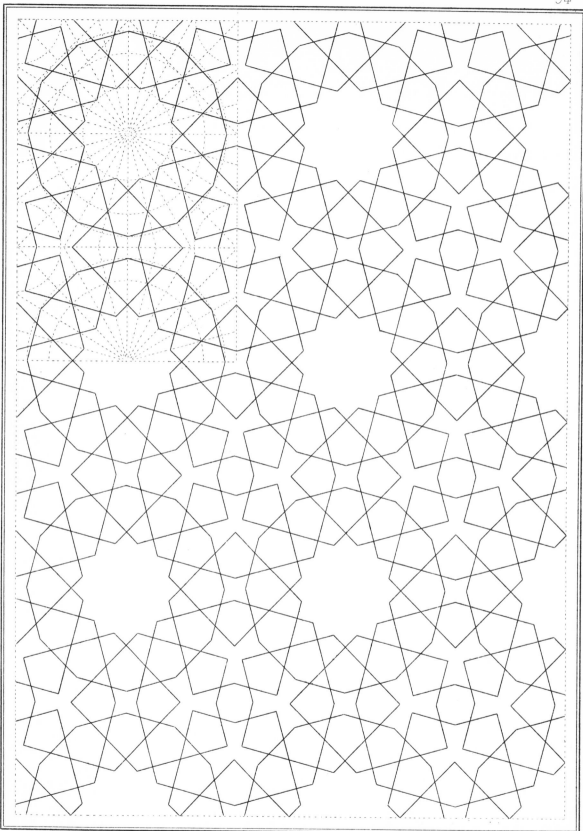

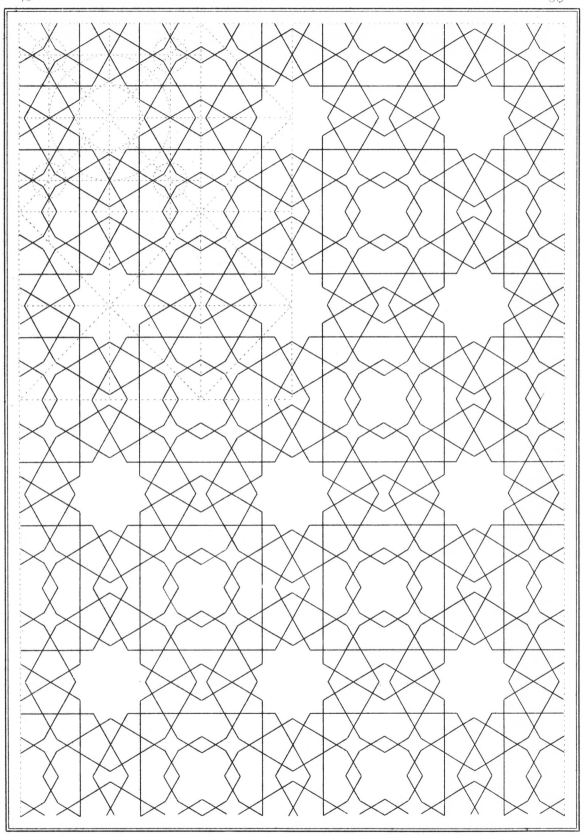

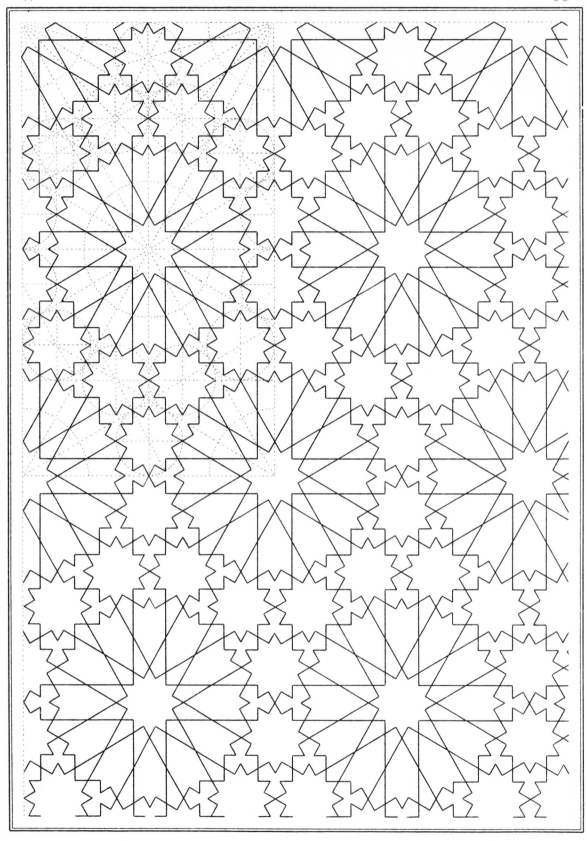

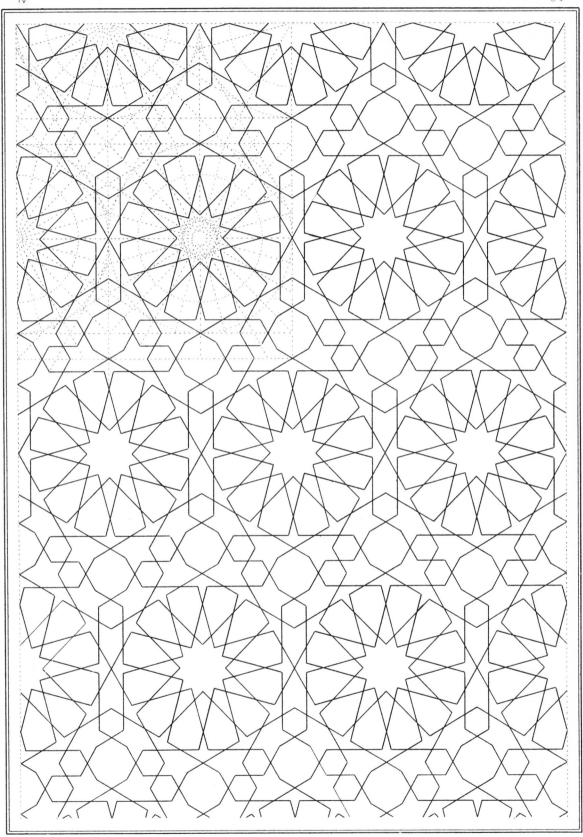

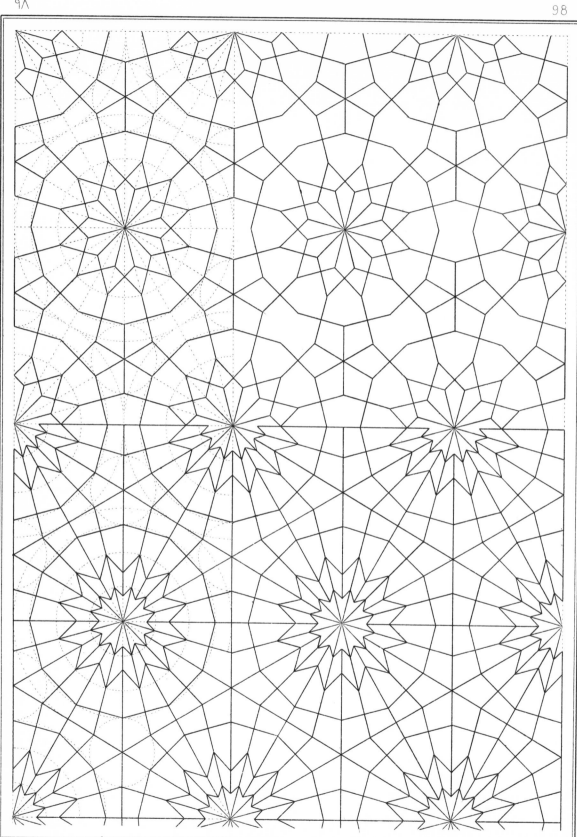

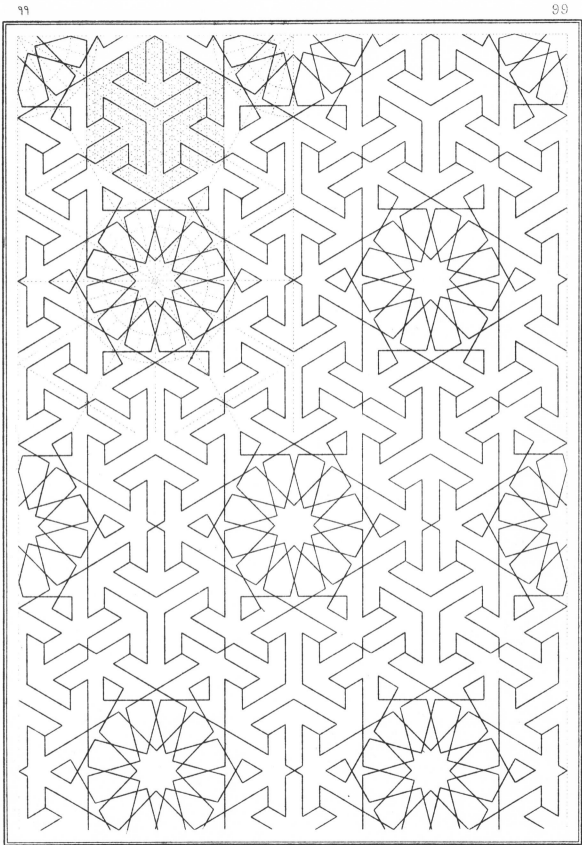

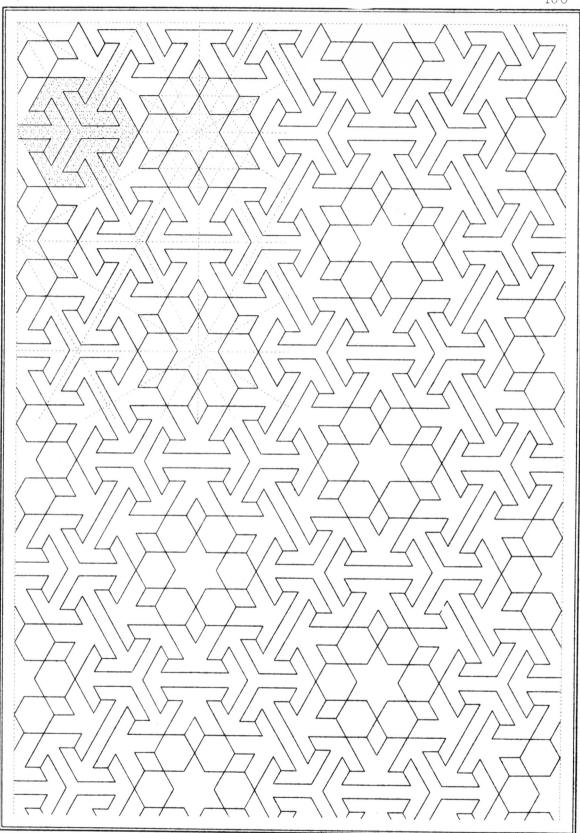

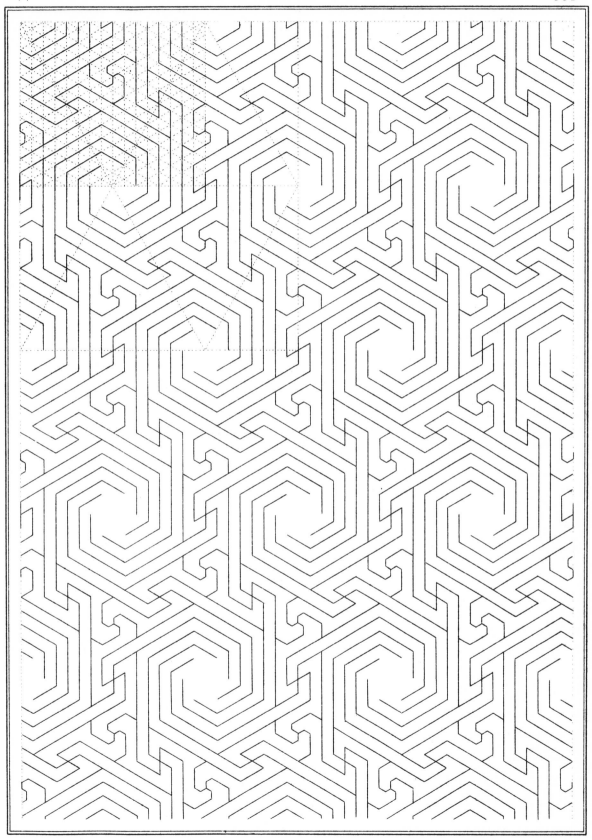

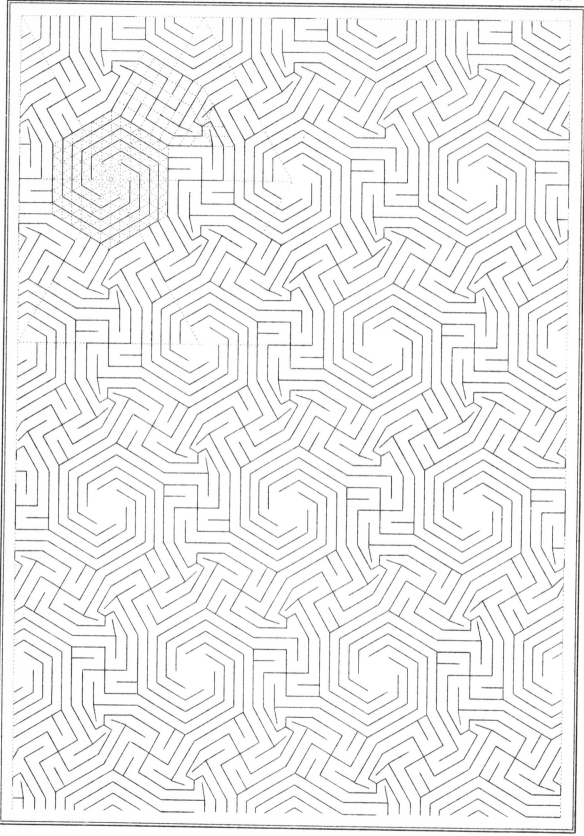

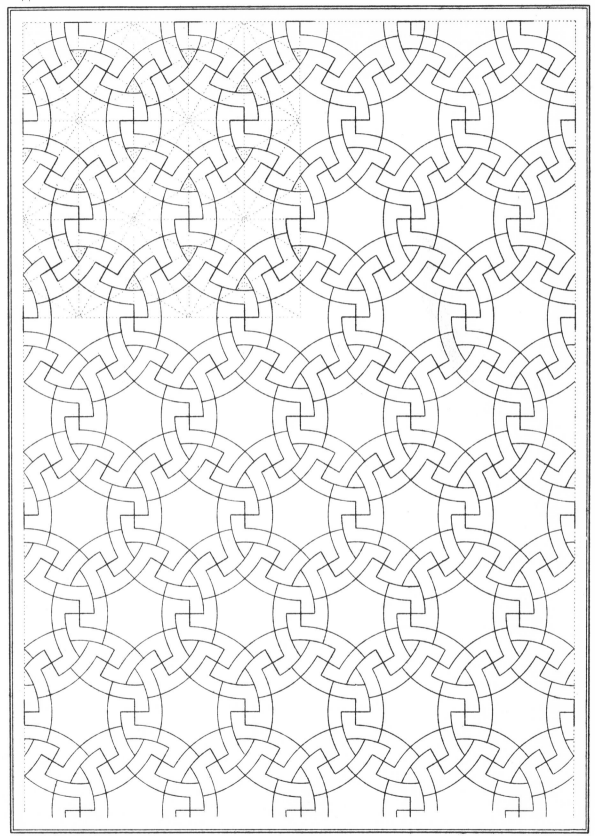

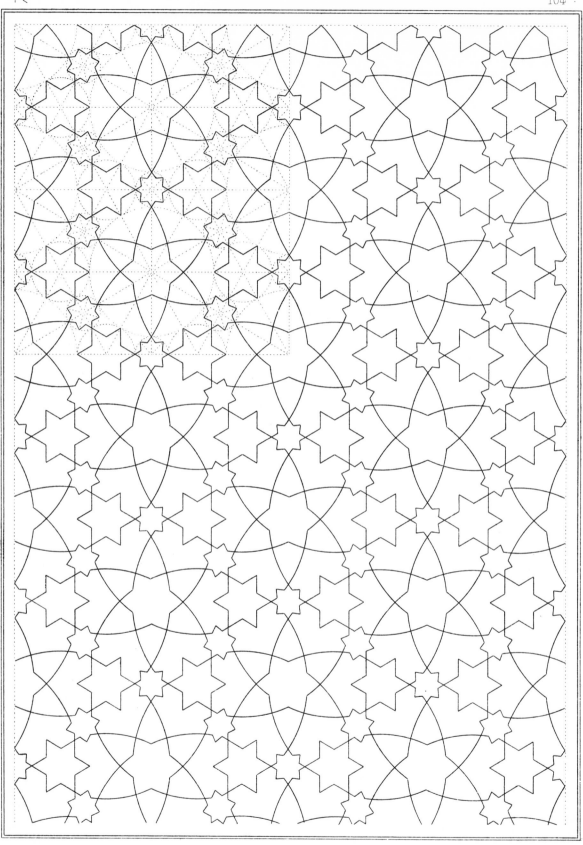

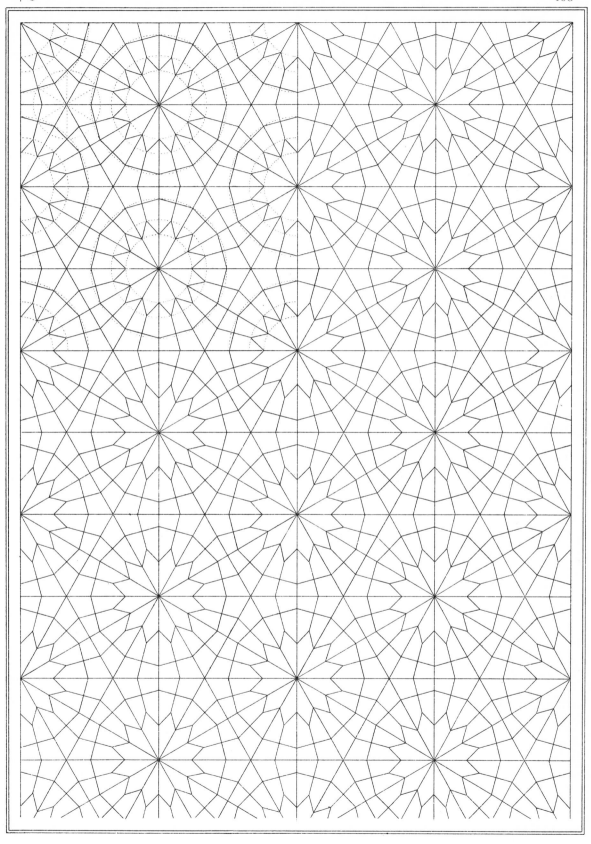

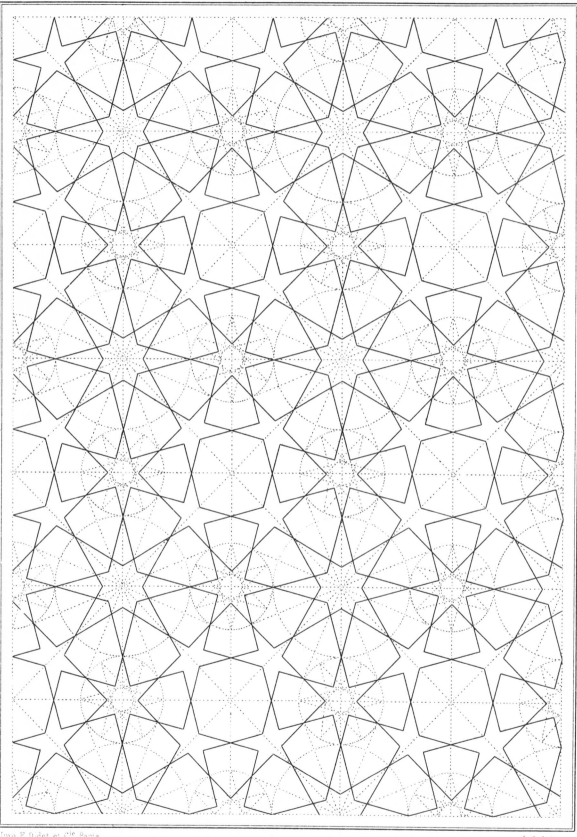

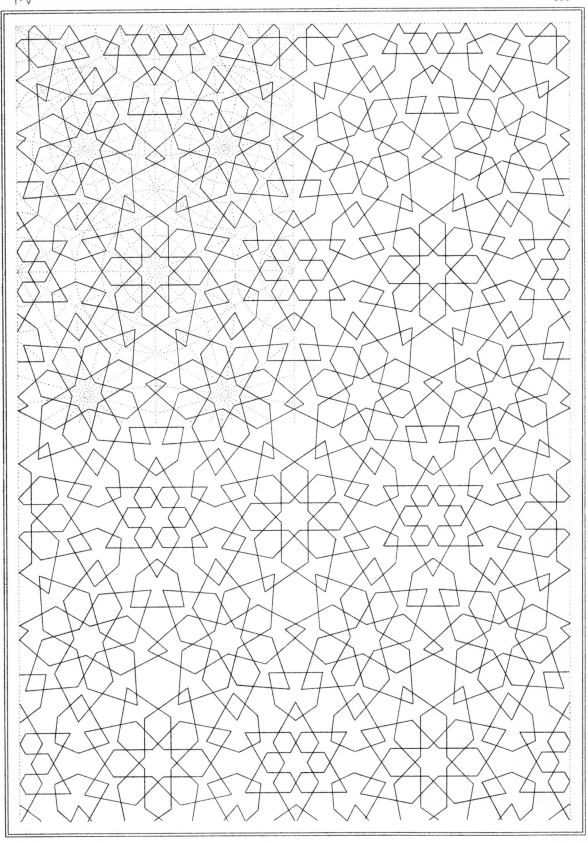

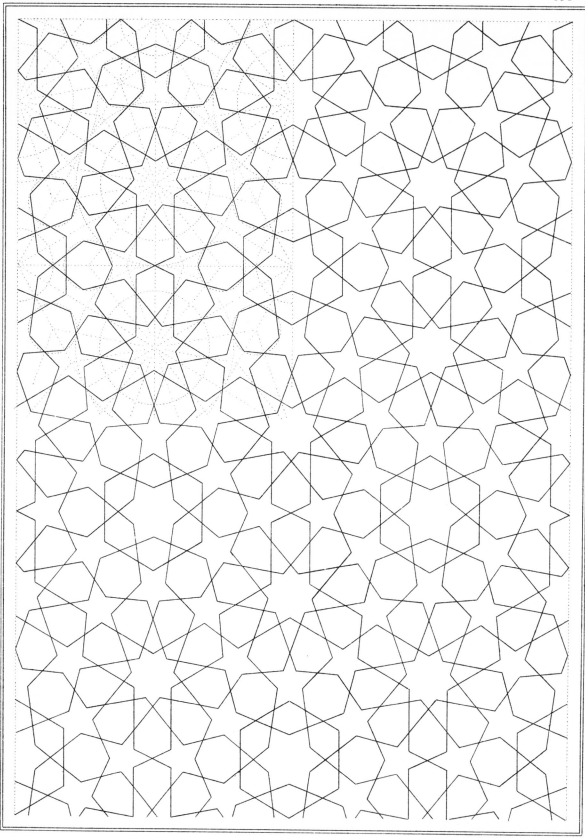

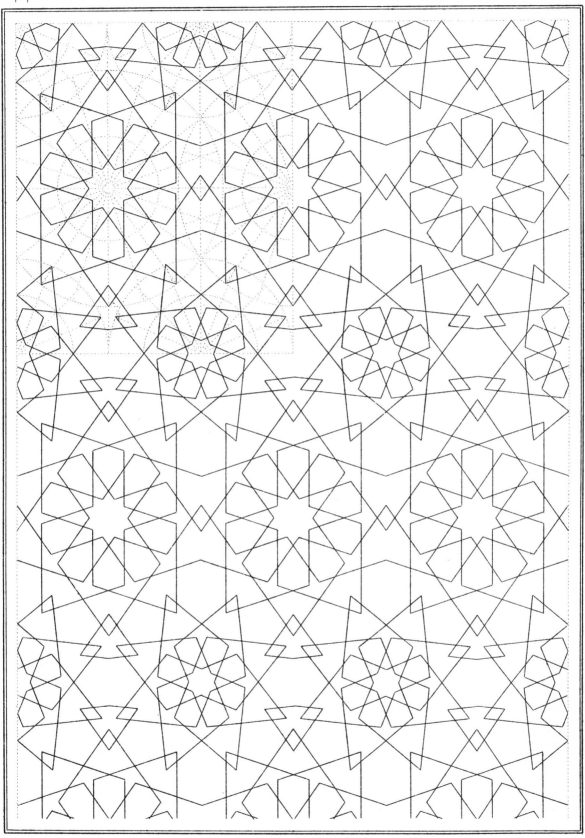

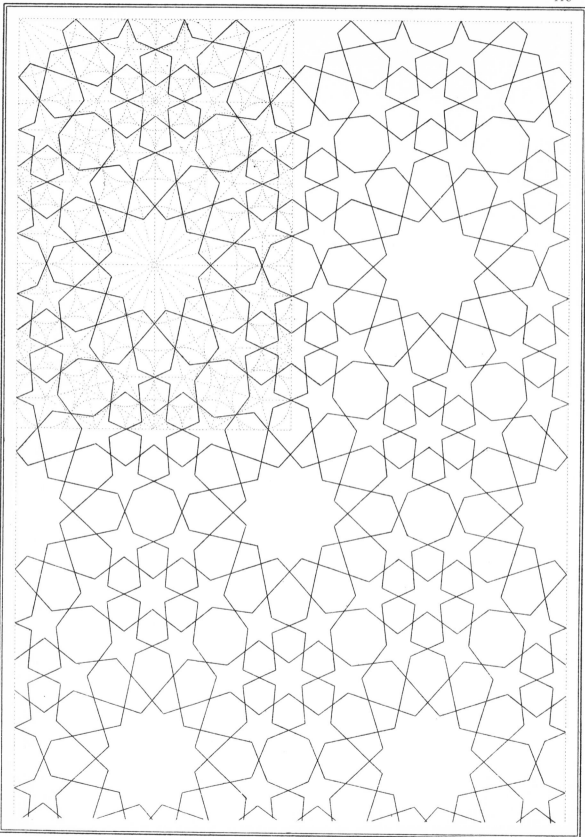

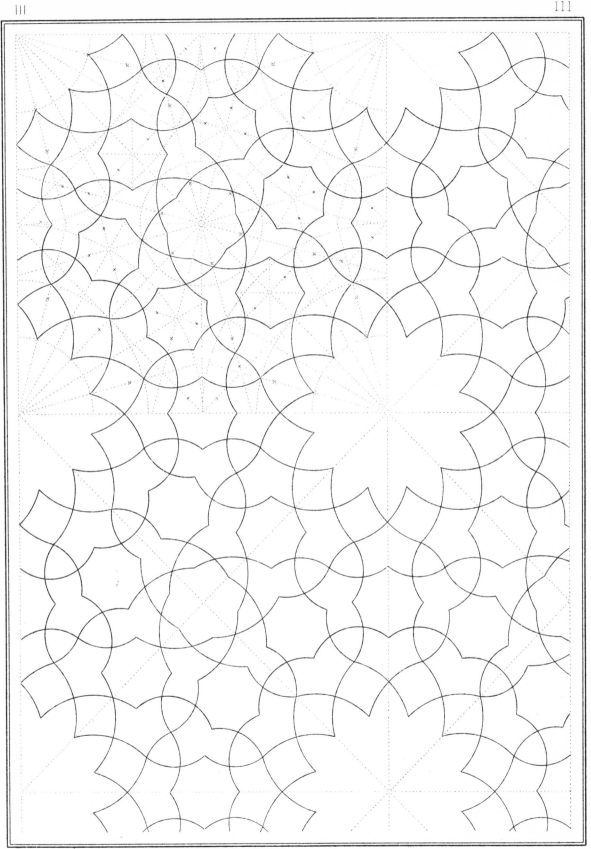

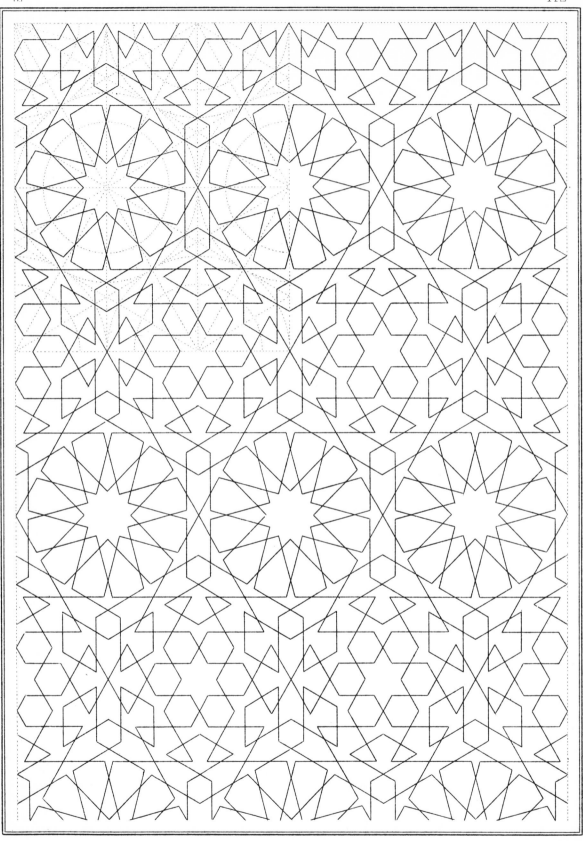

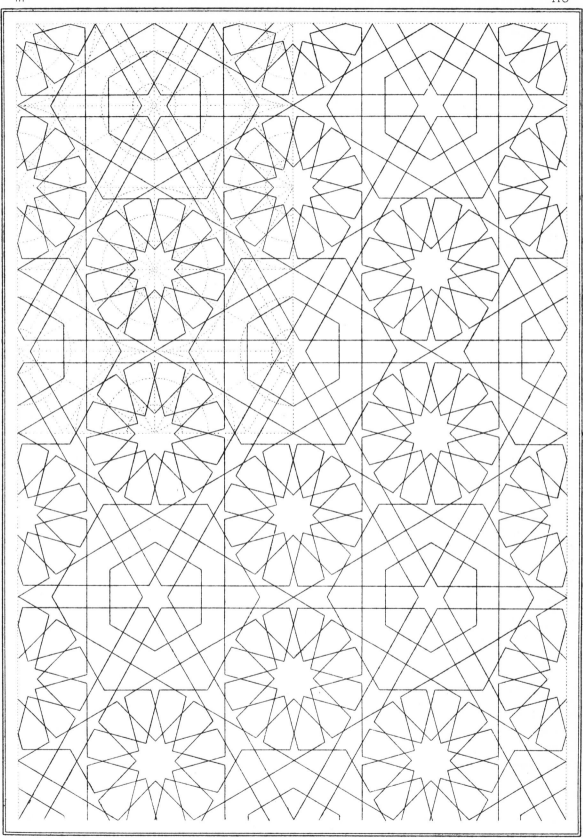

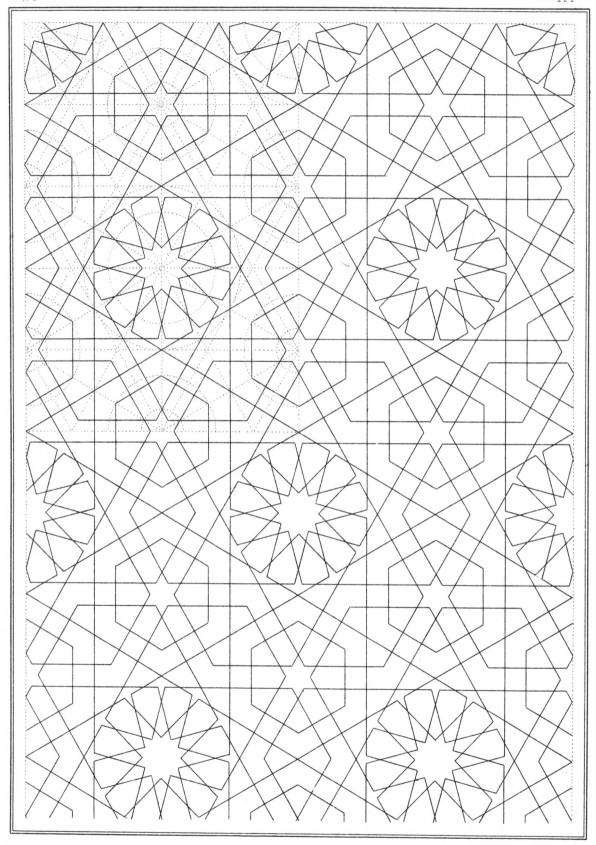

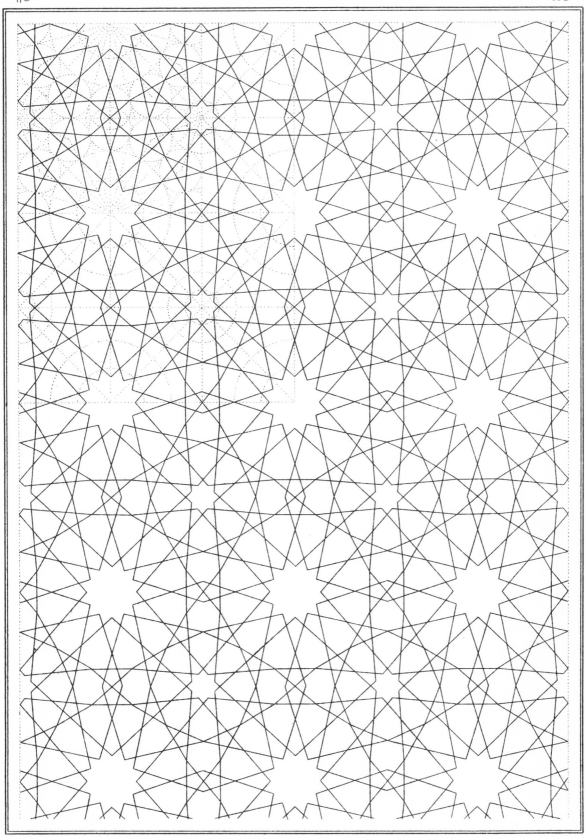

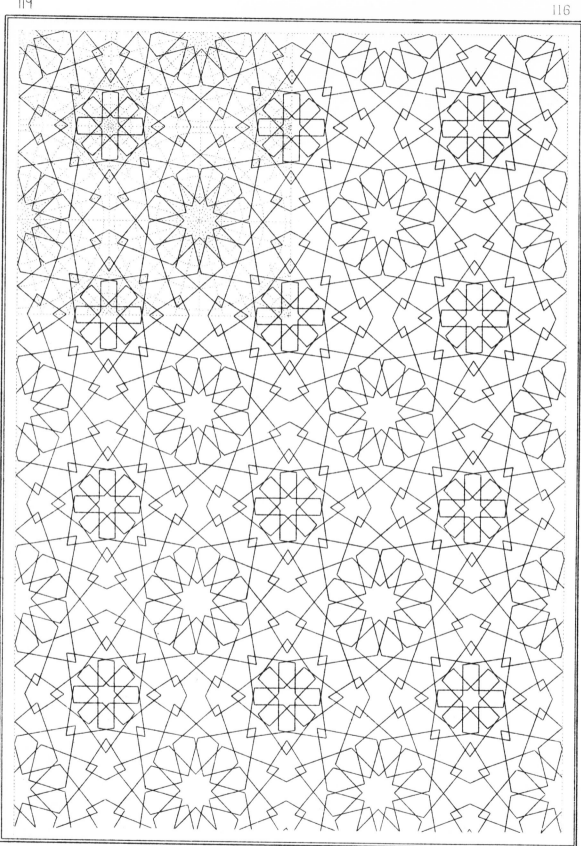

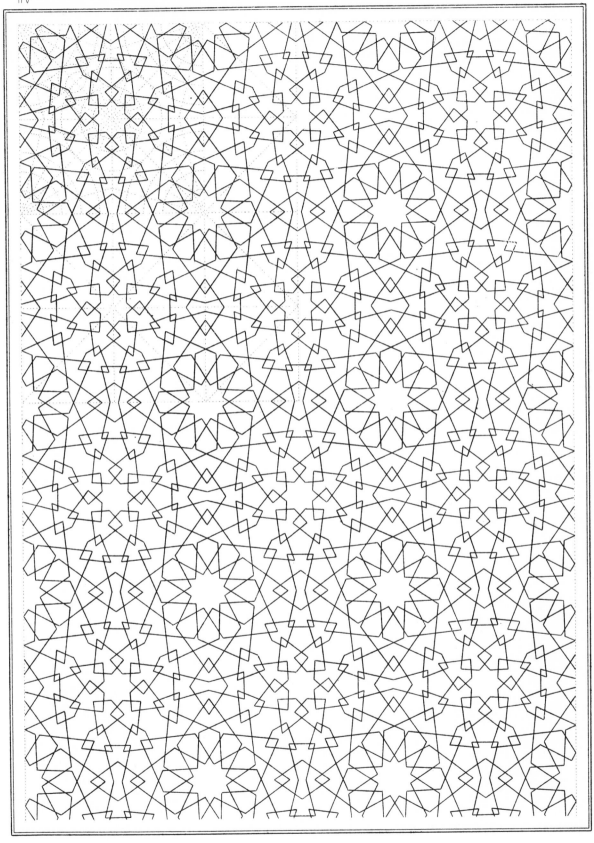

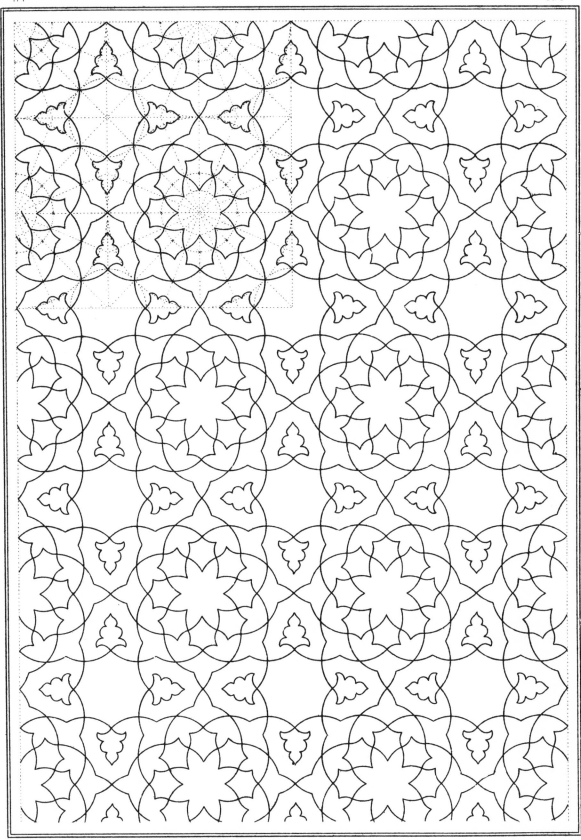

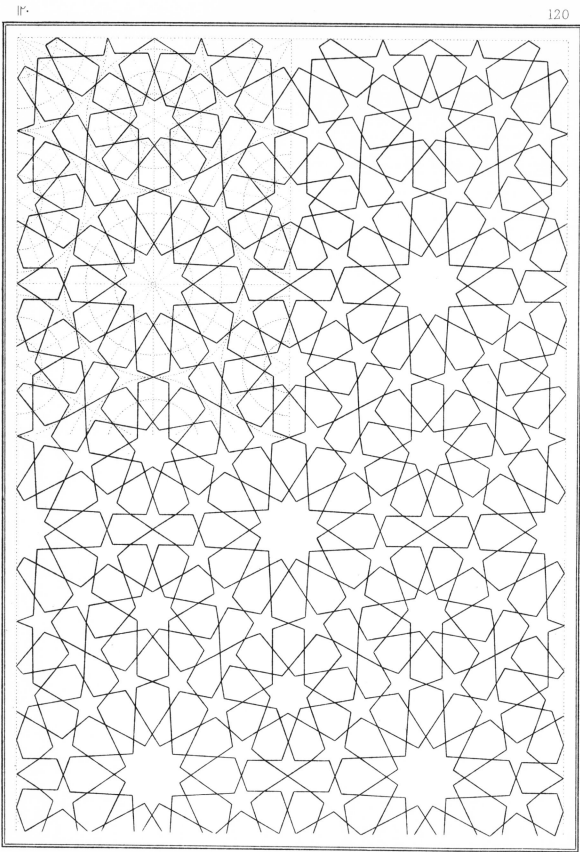

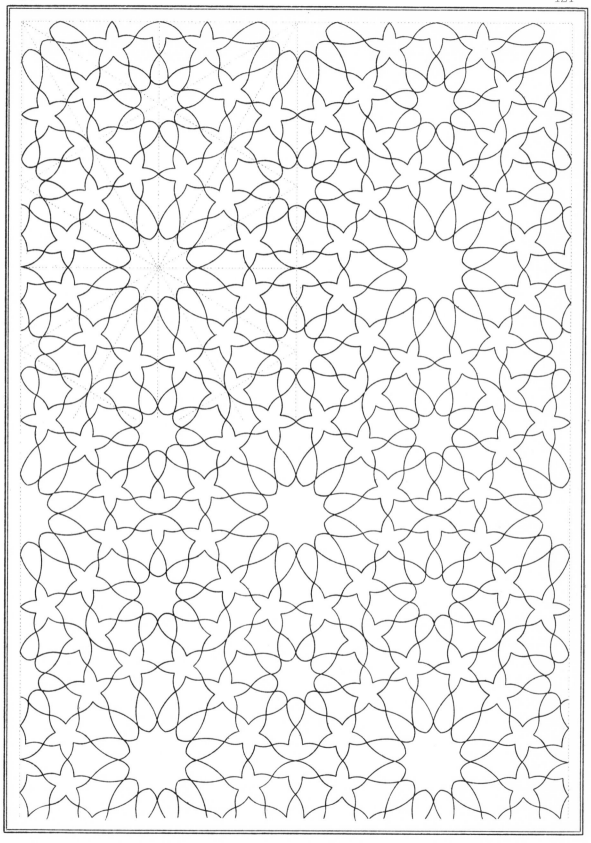

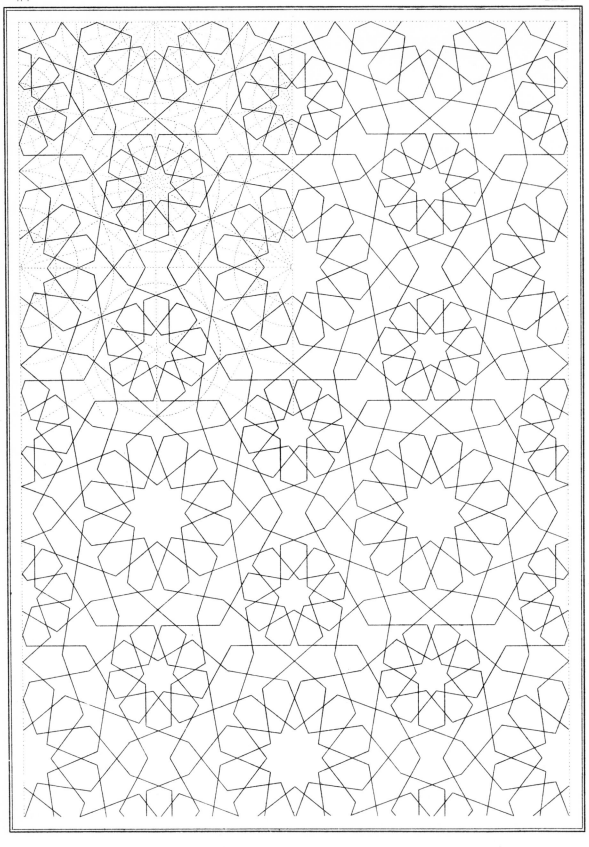

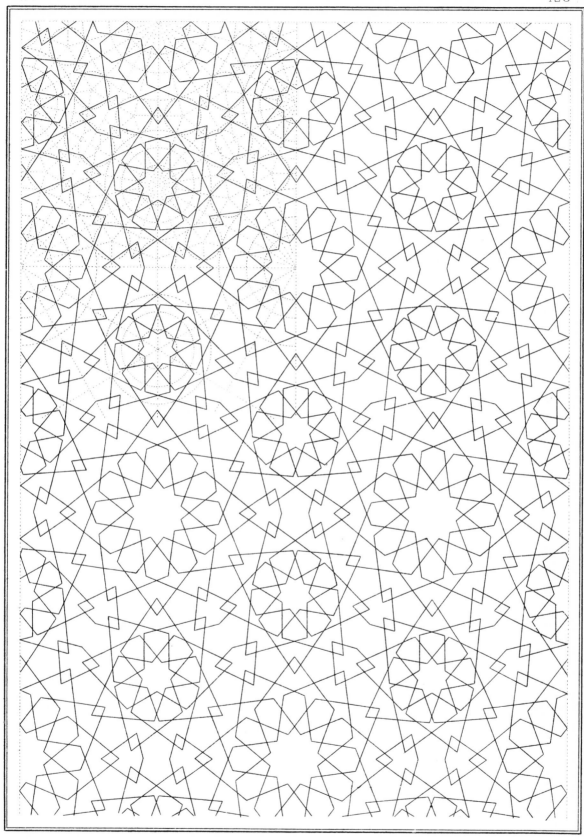

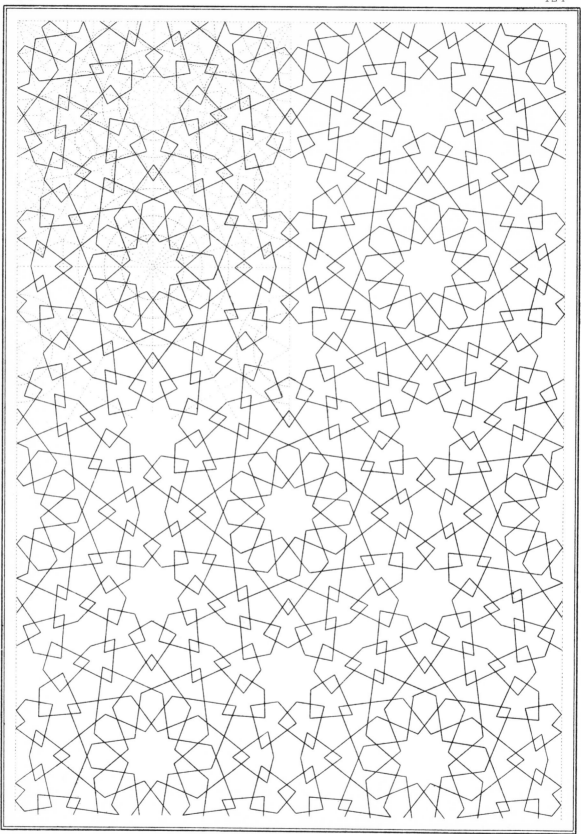

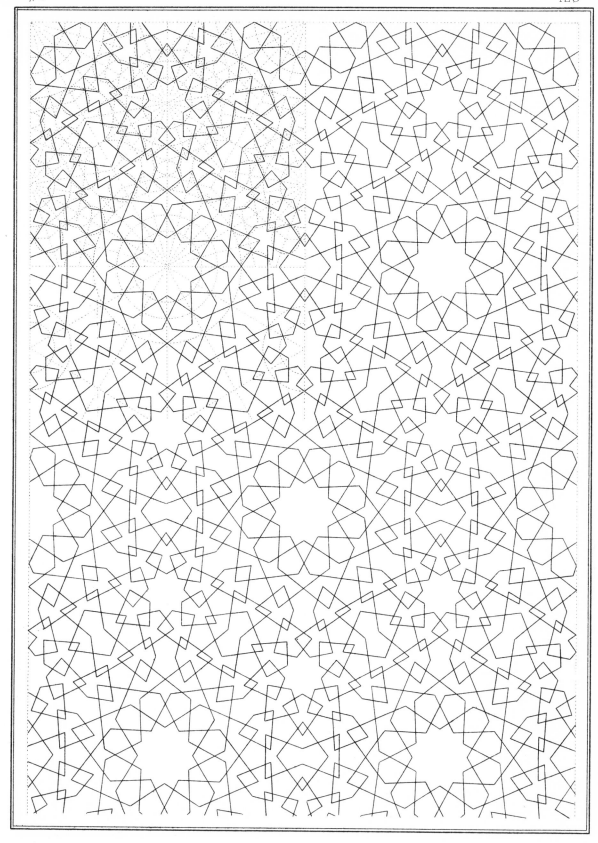

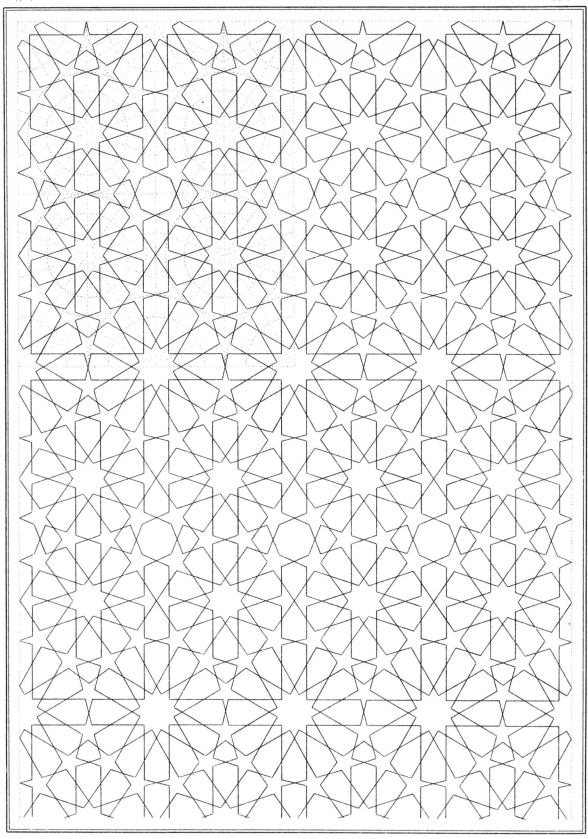

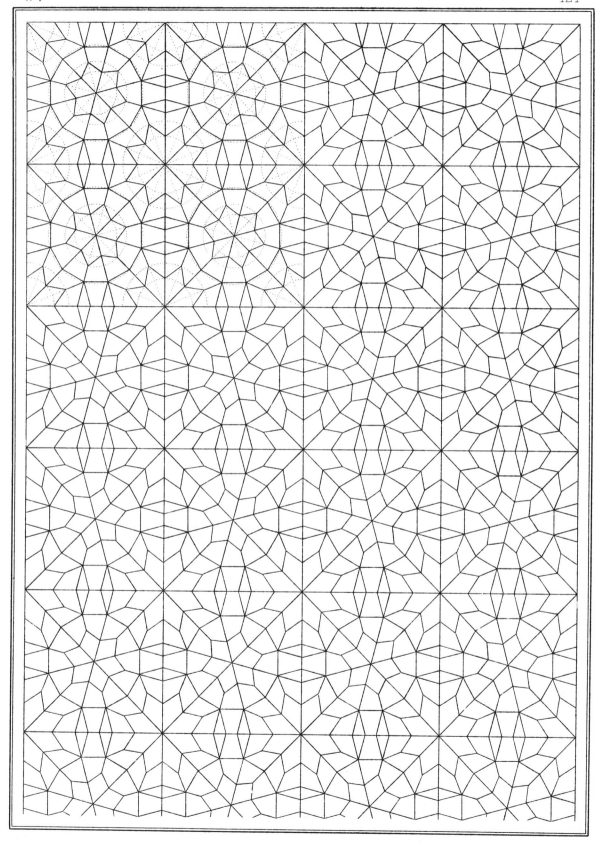

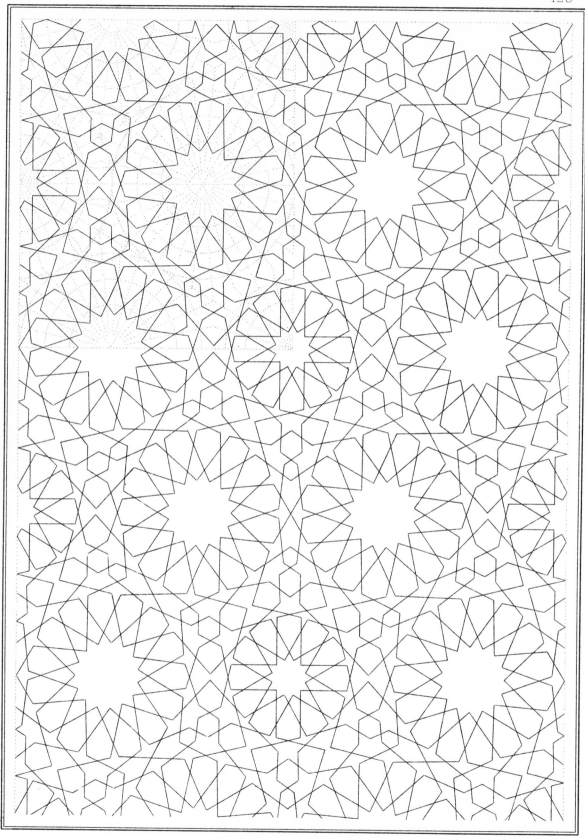

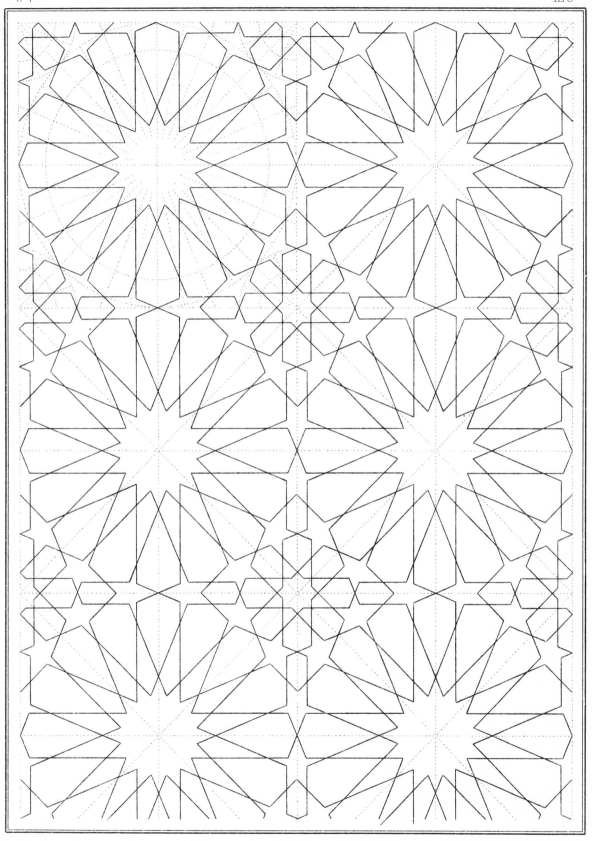

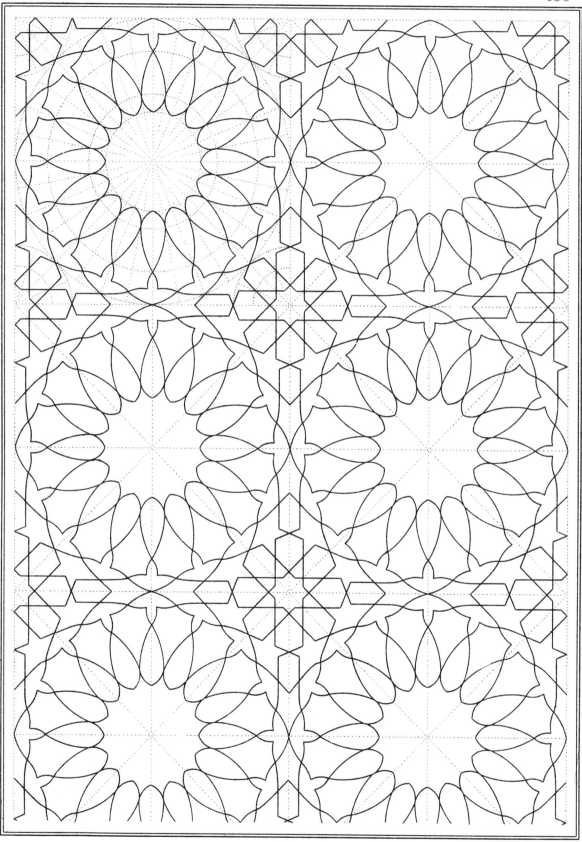

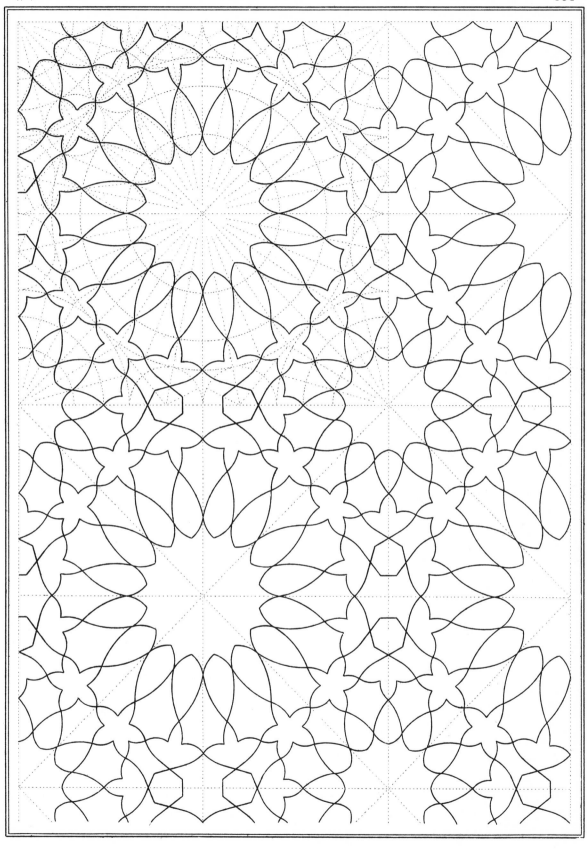

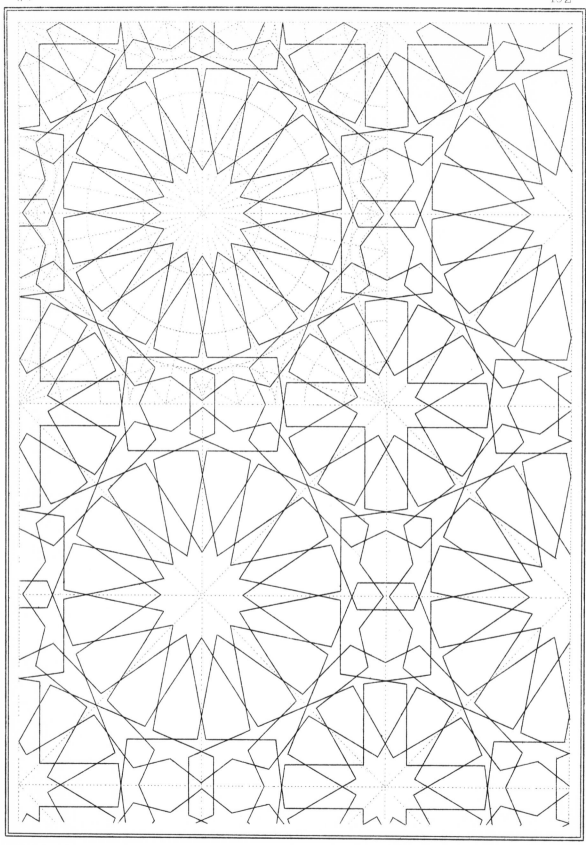

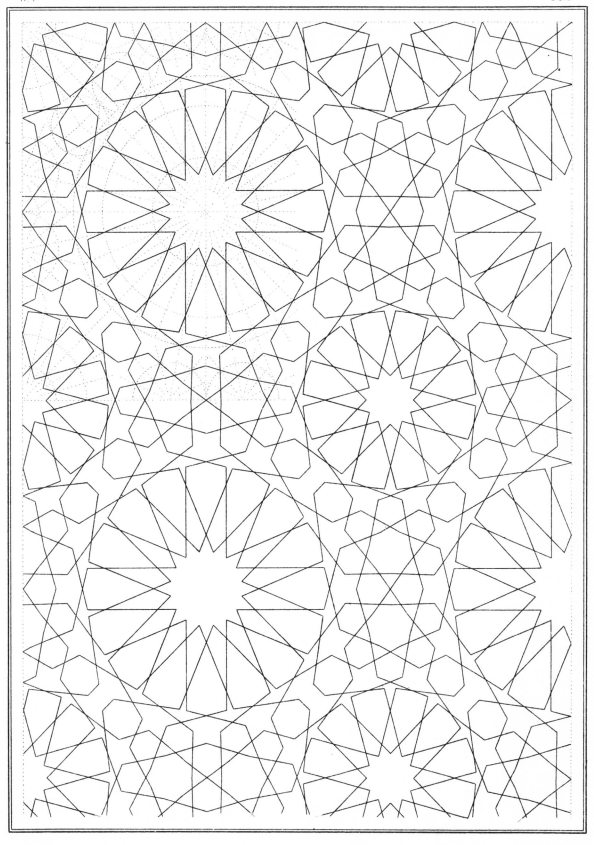

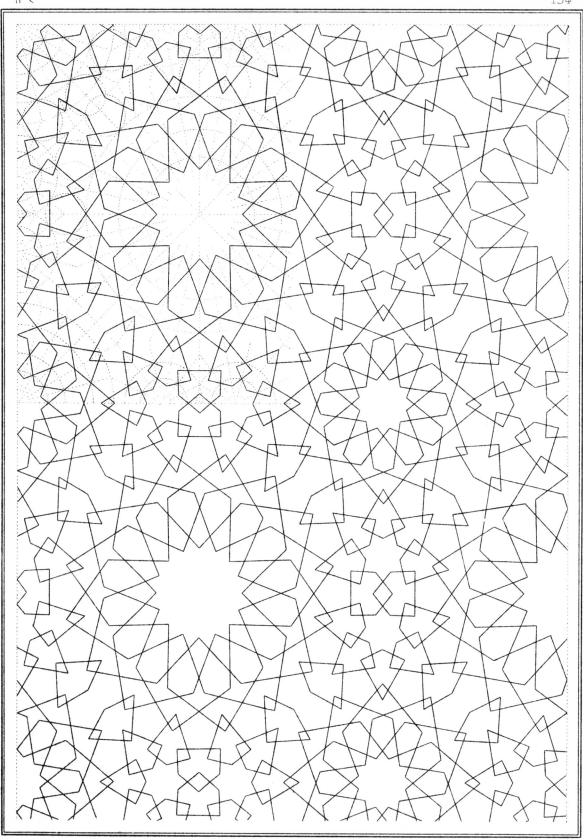

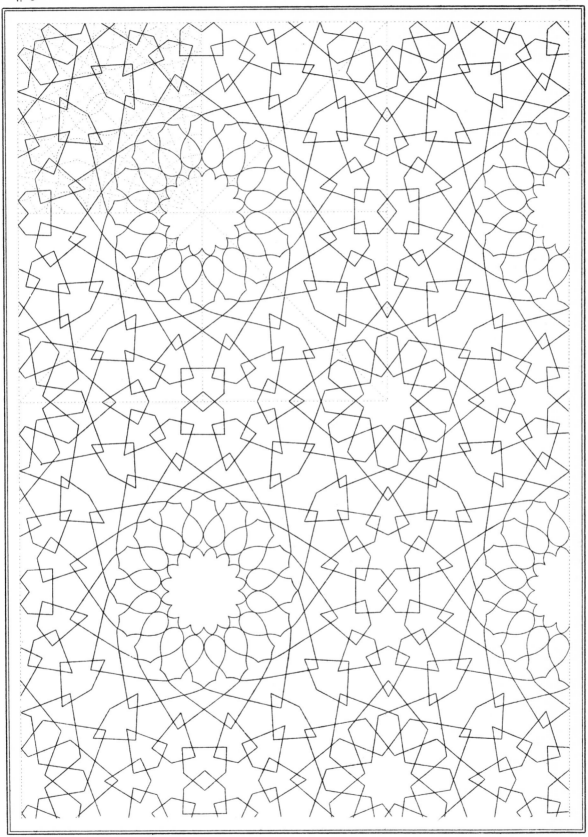

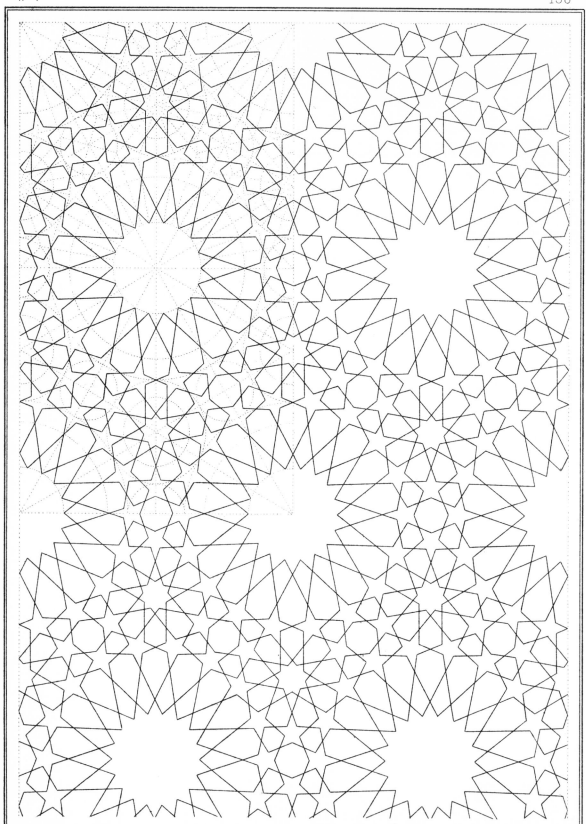

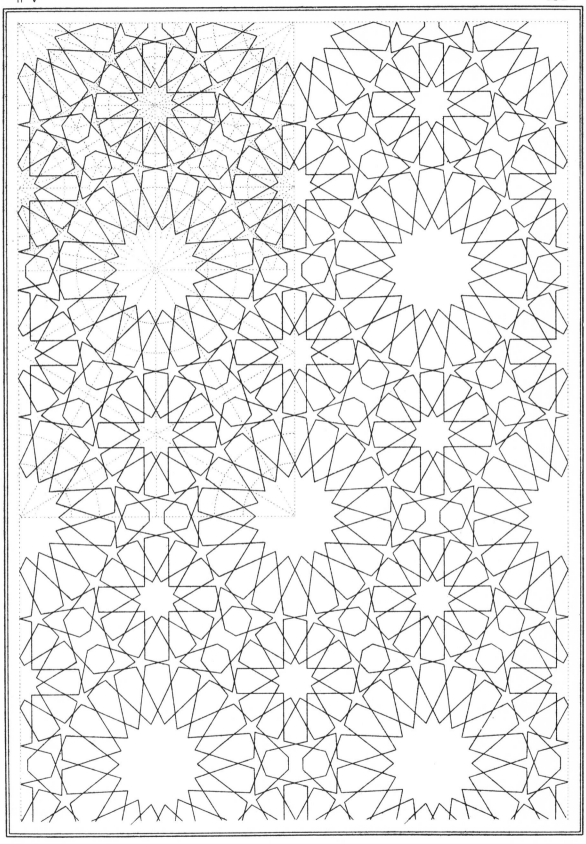

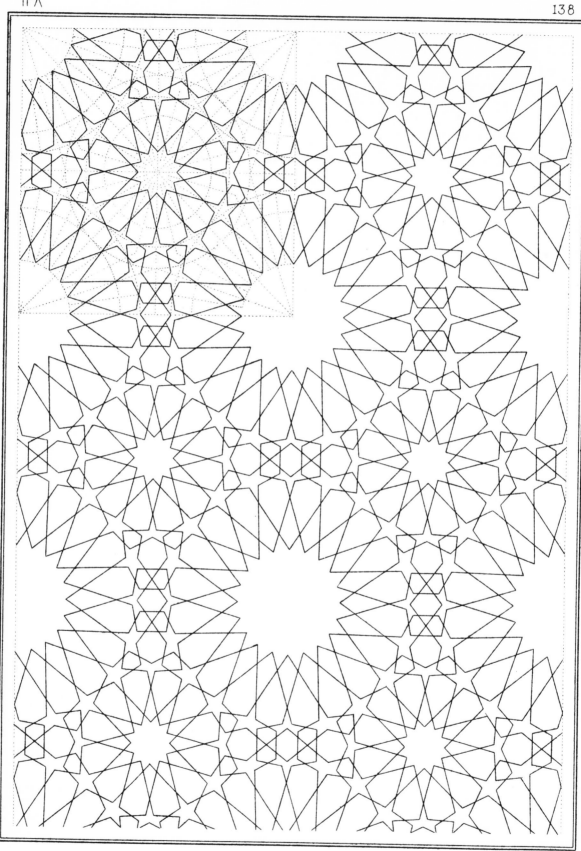

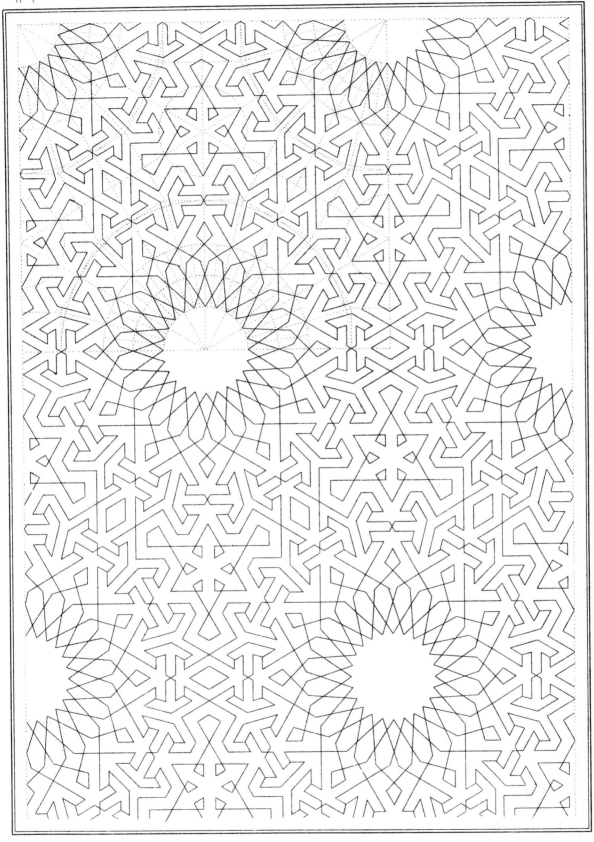

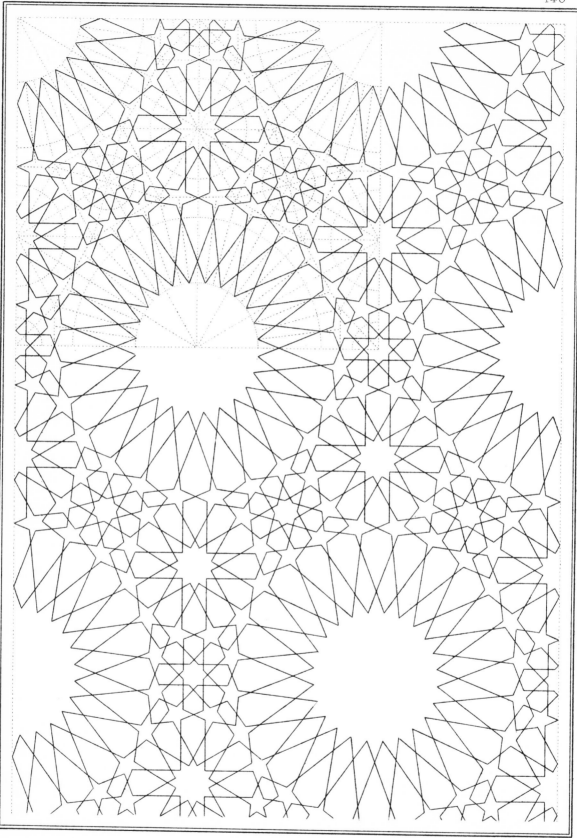

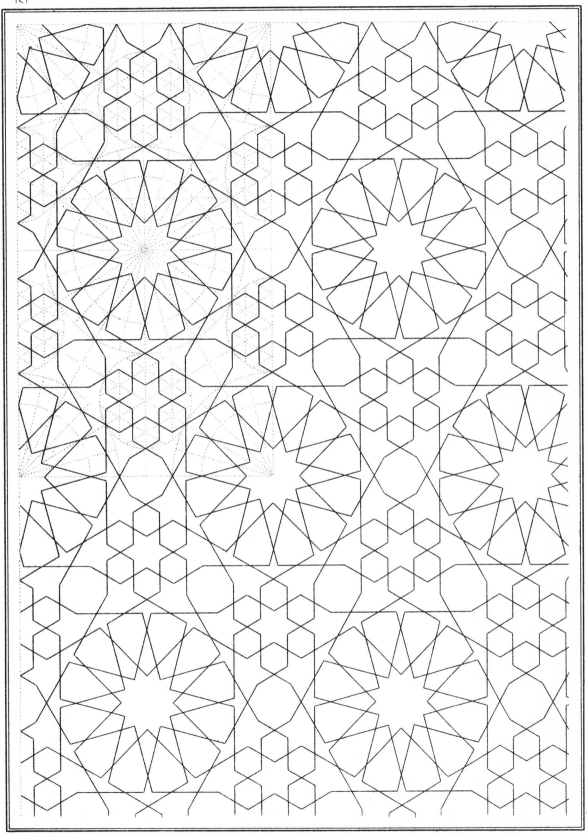

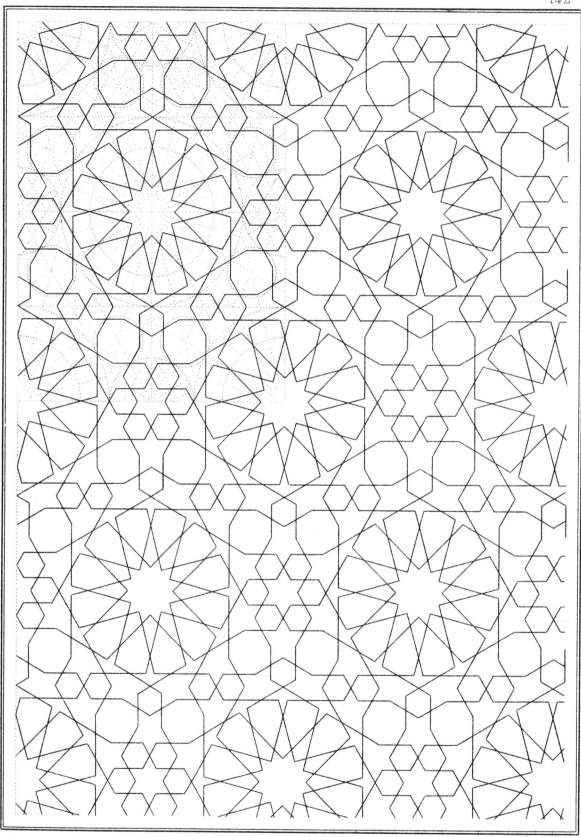

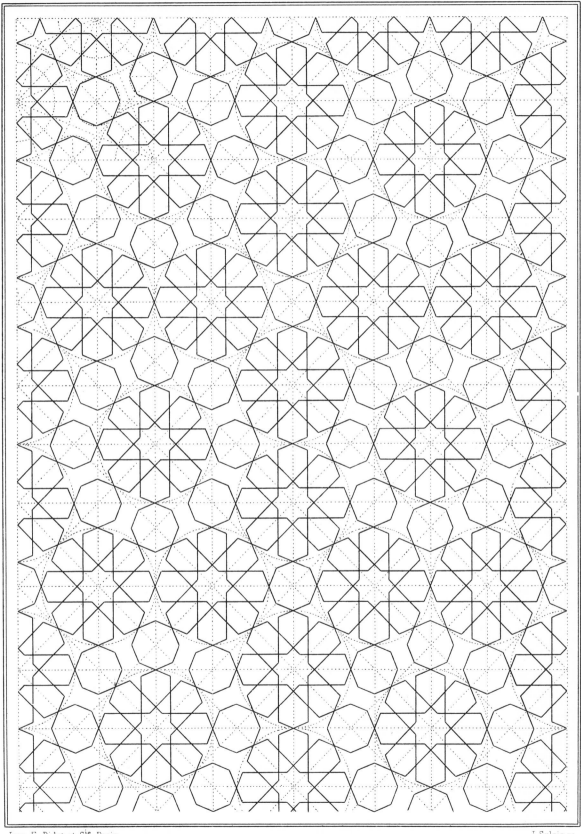

Imp. F. Didot et Cie Paris

J. Sulpis sc

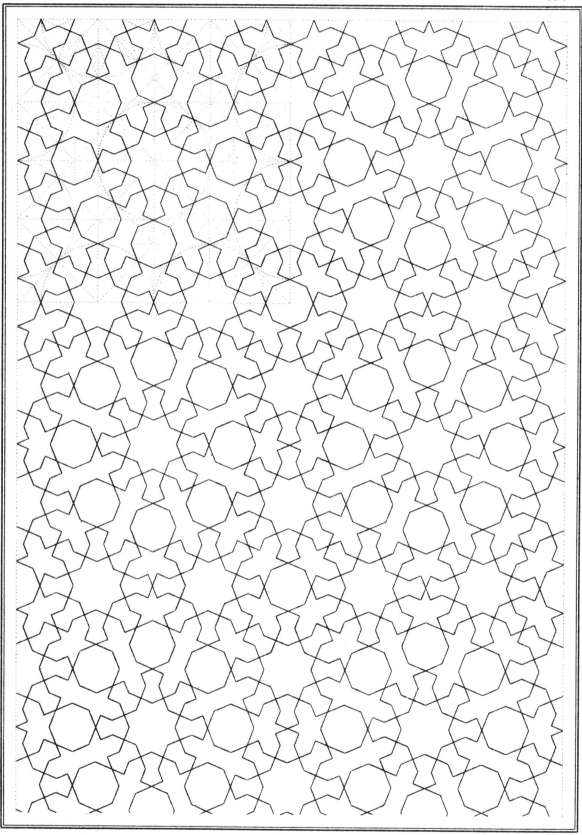

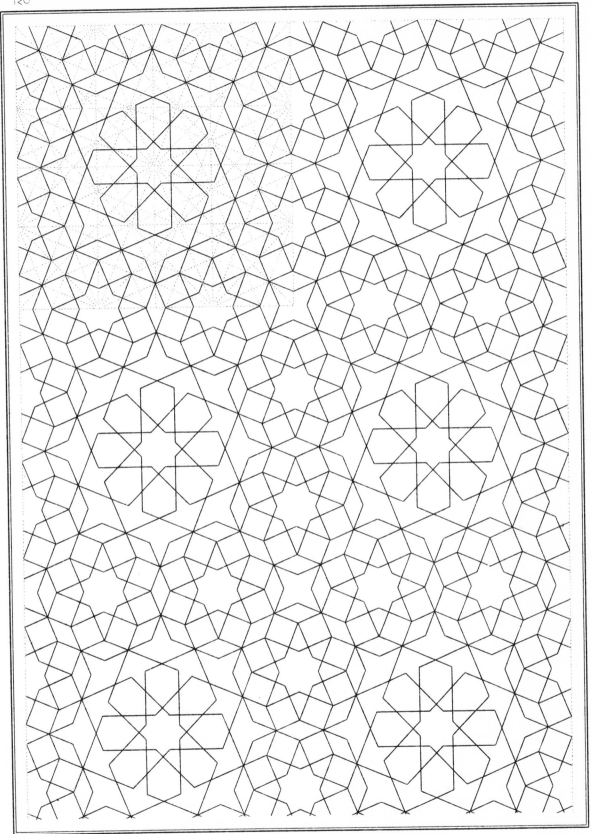

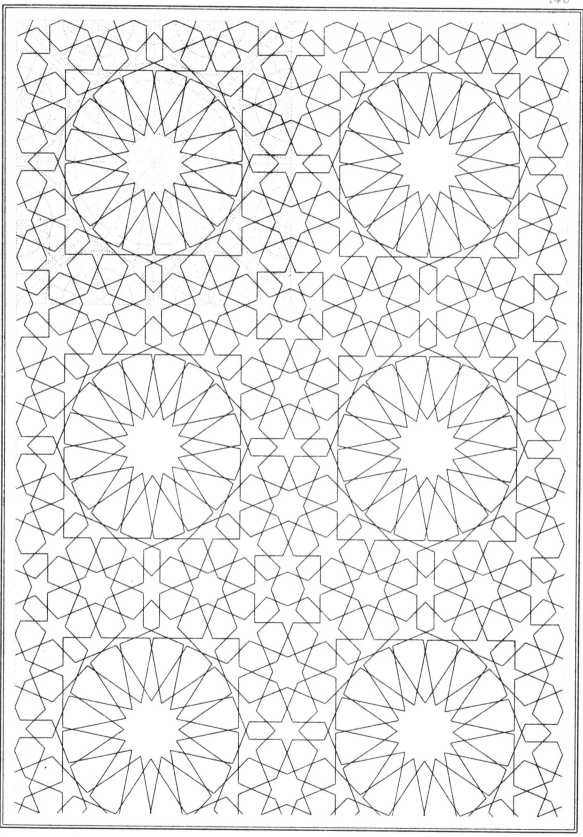

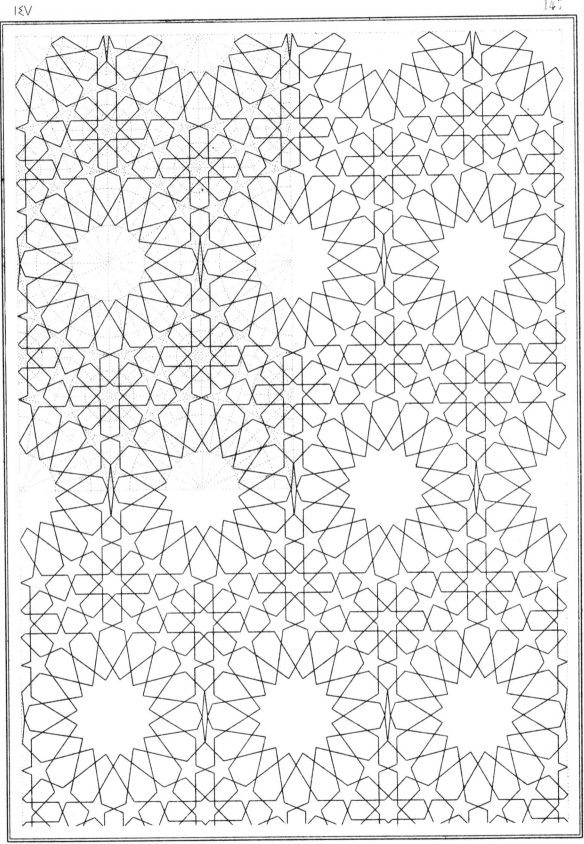

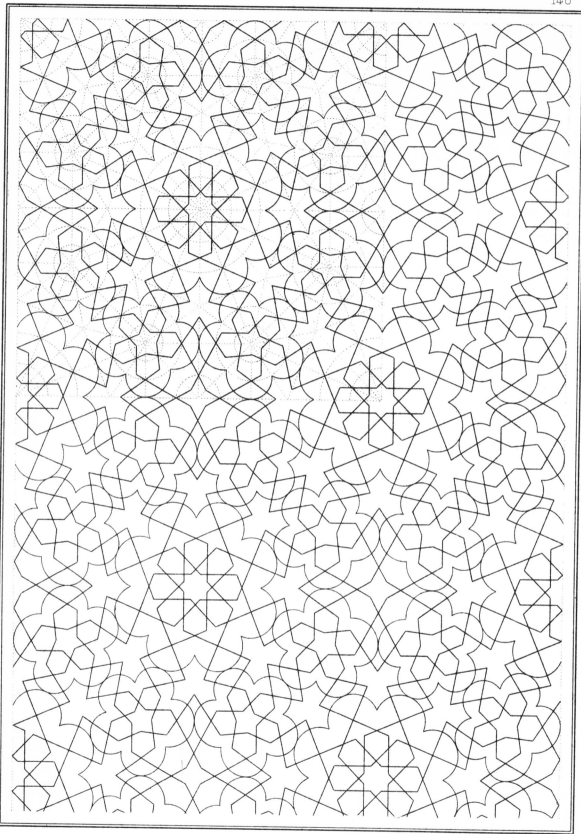

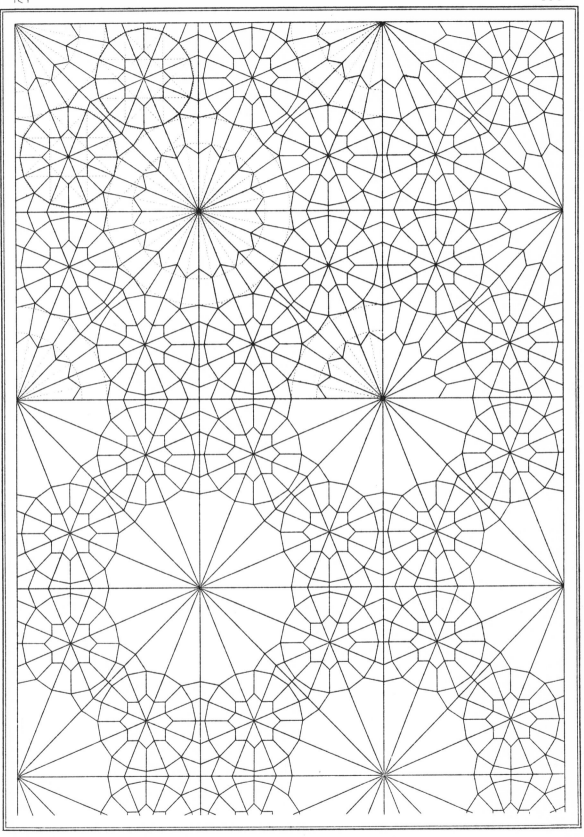

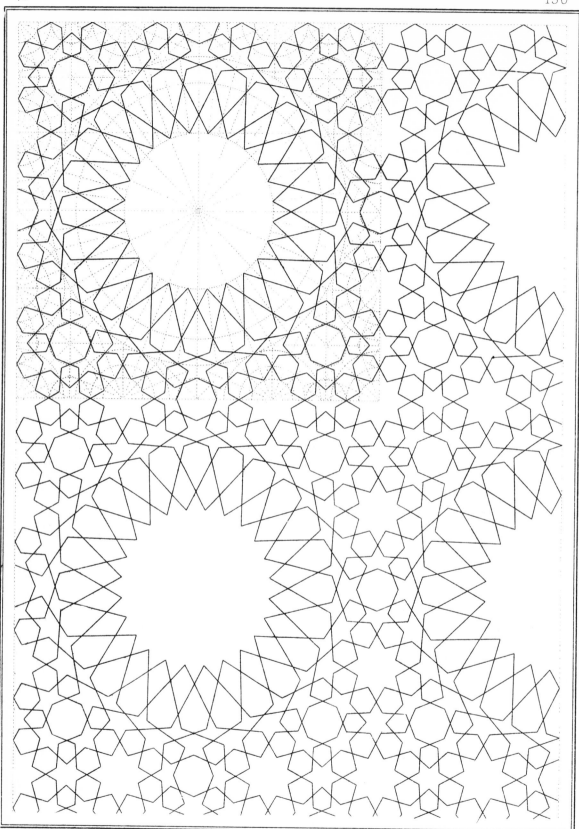

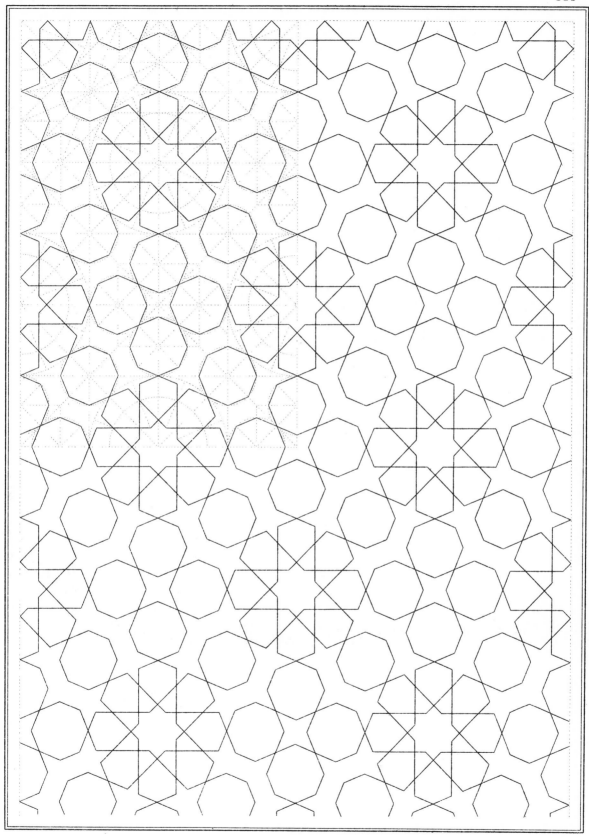

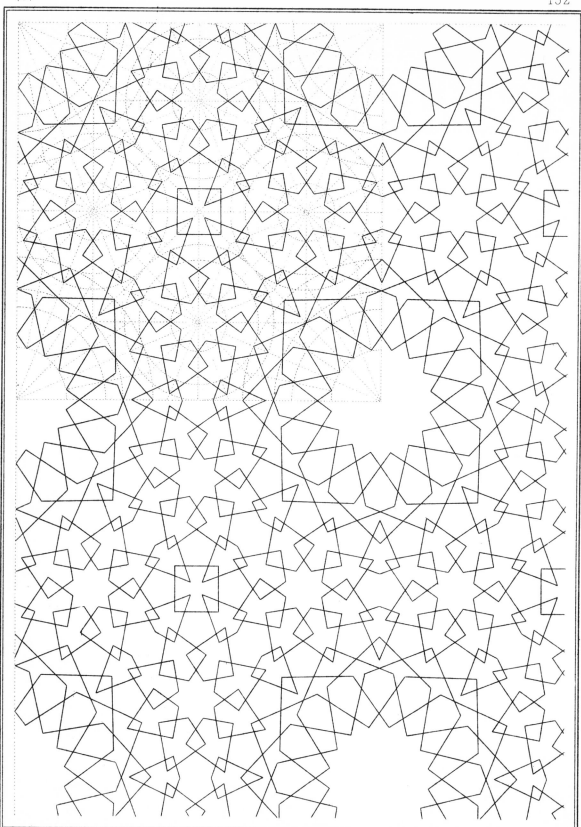

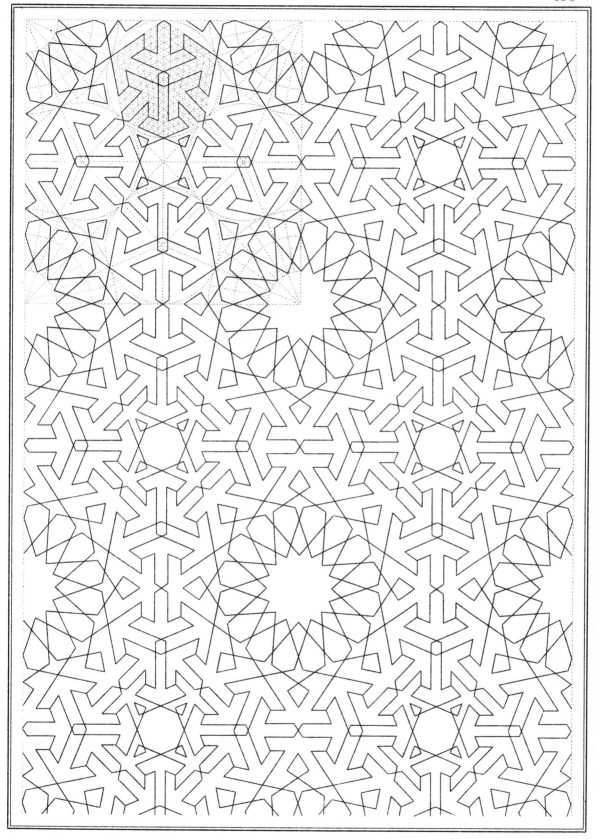

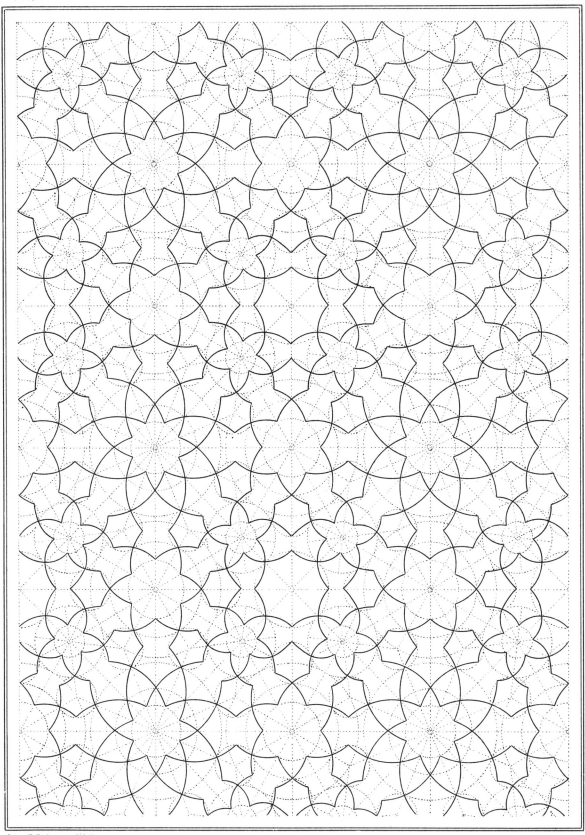

Imp. F Didot et Cie Paris

J. Sulpis sc.

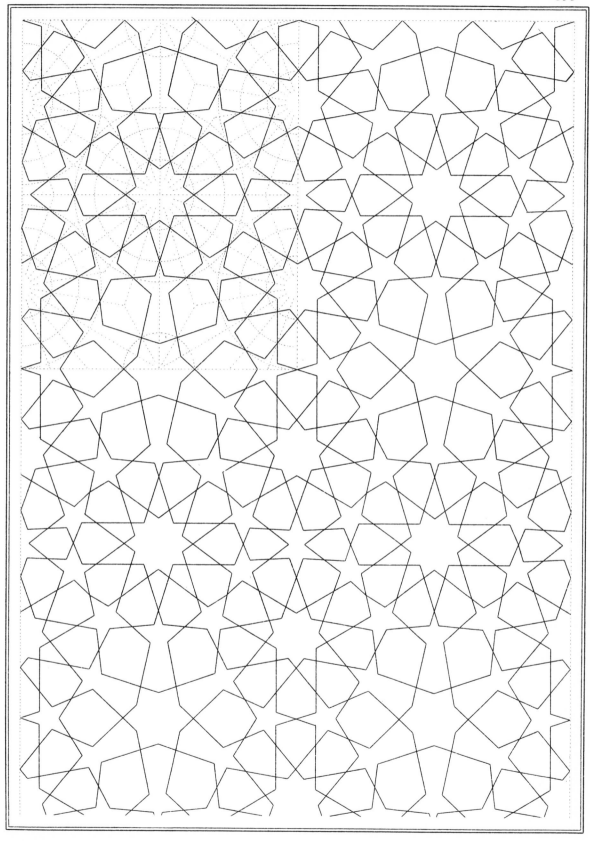

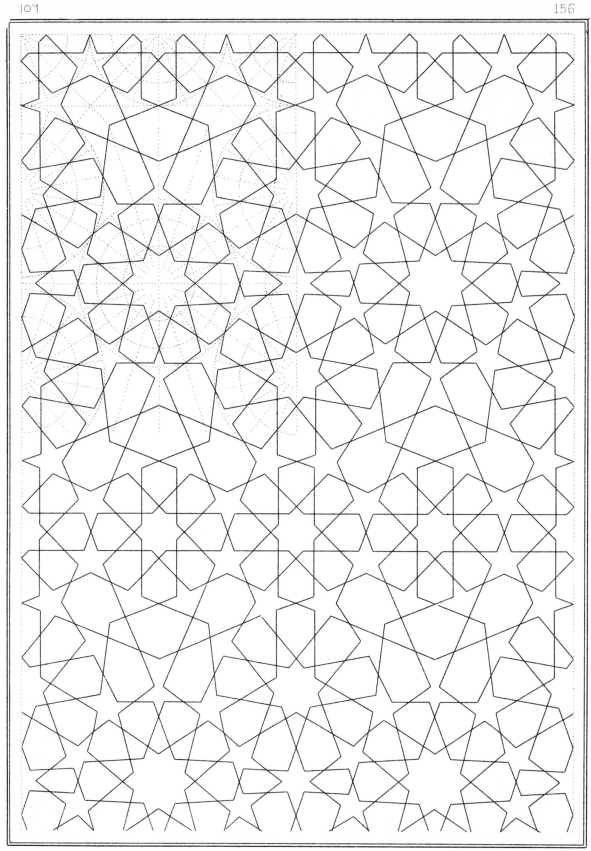

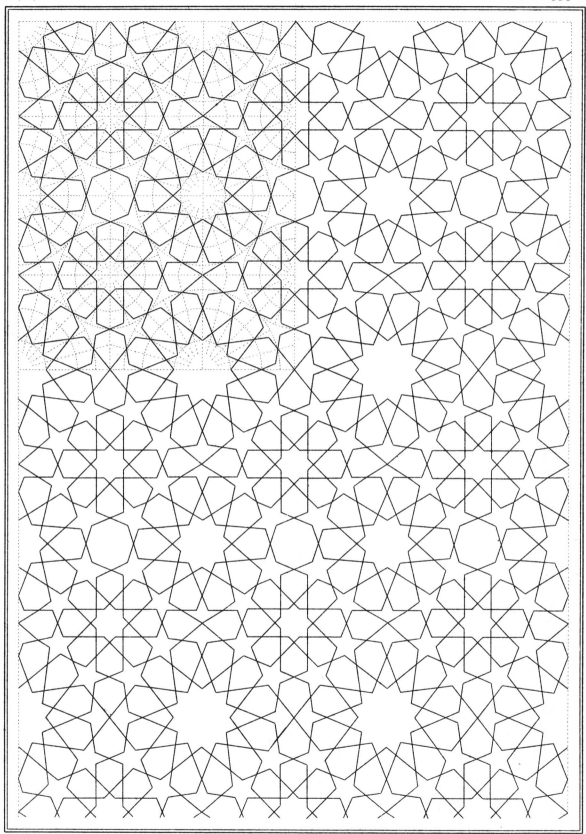

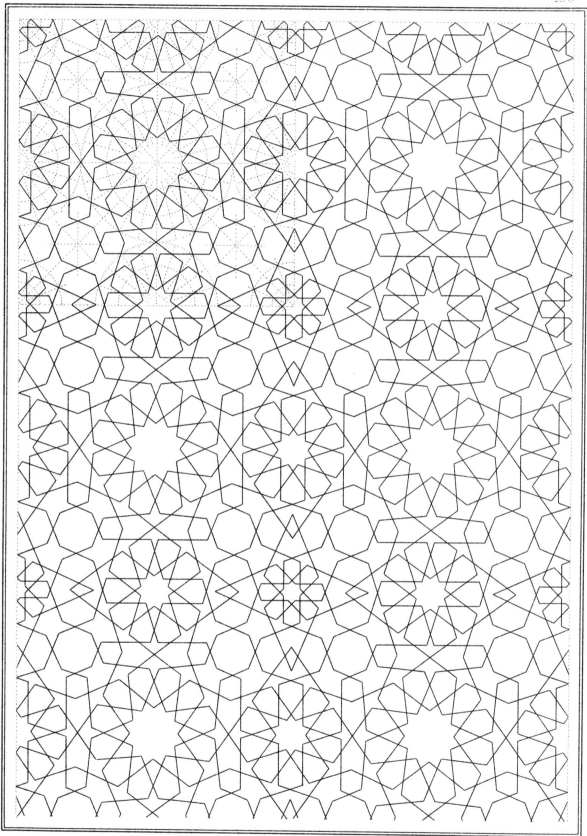

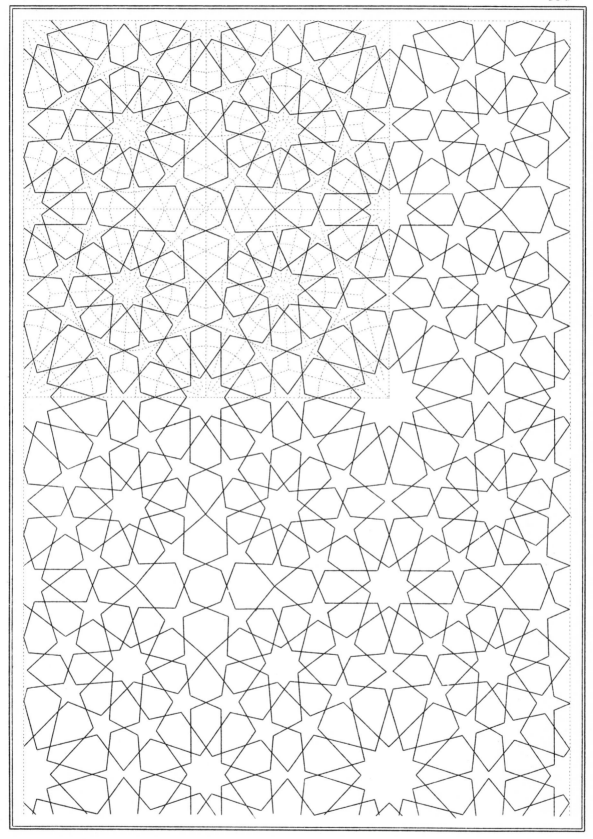

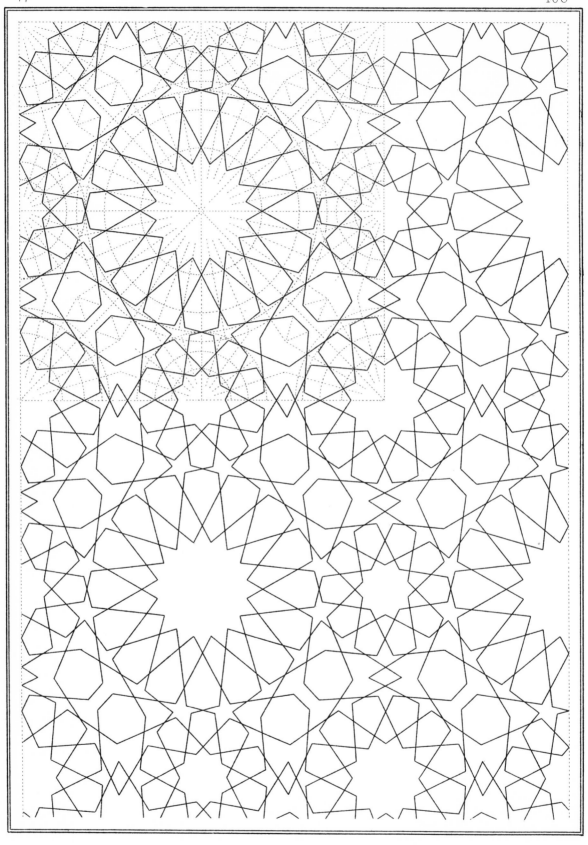

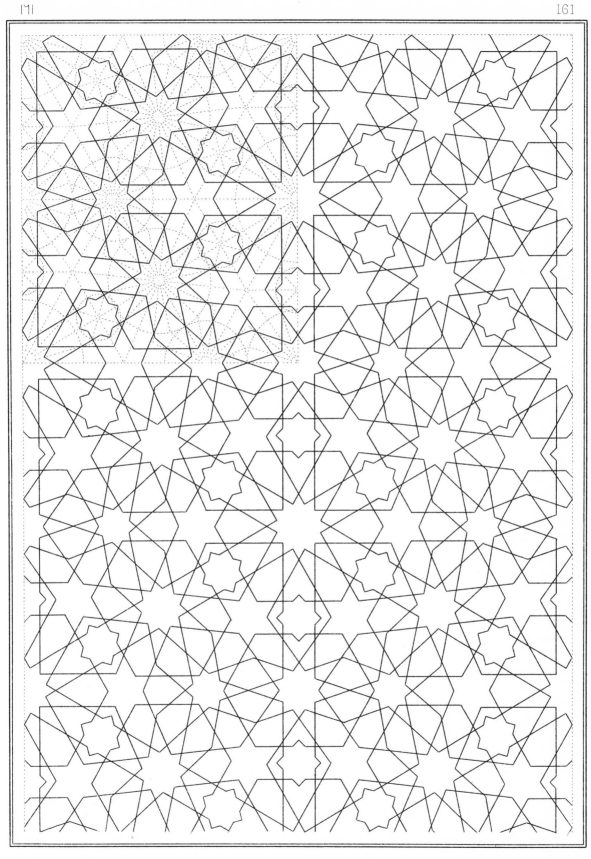

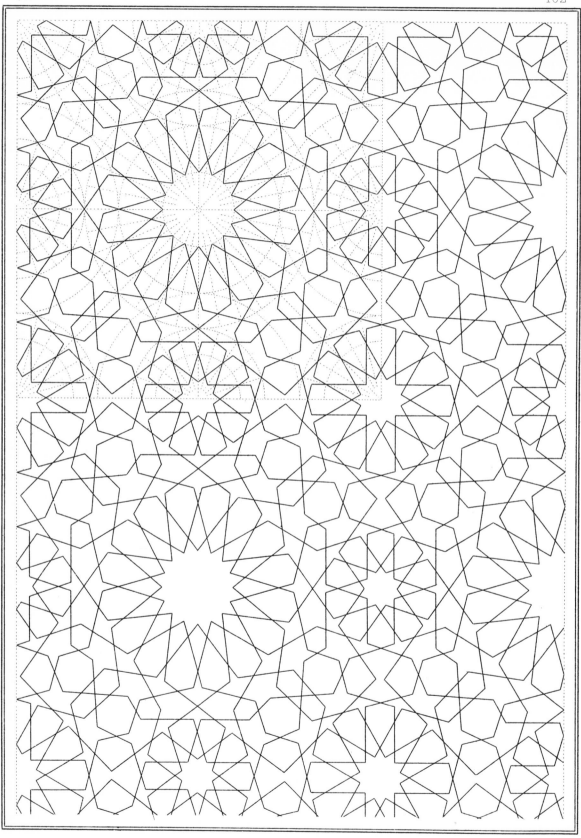

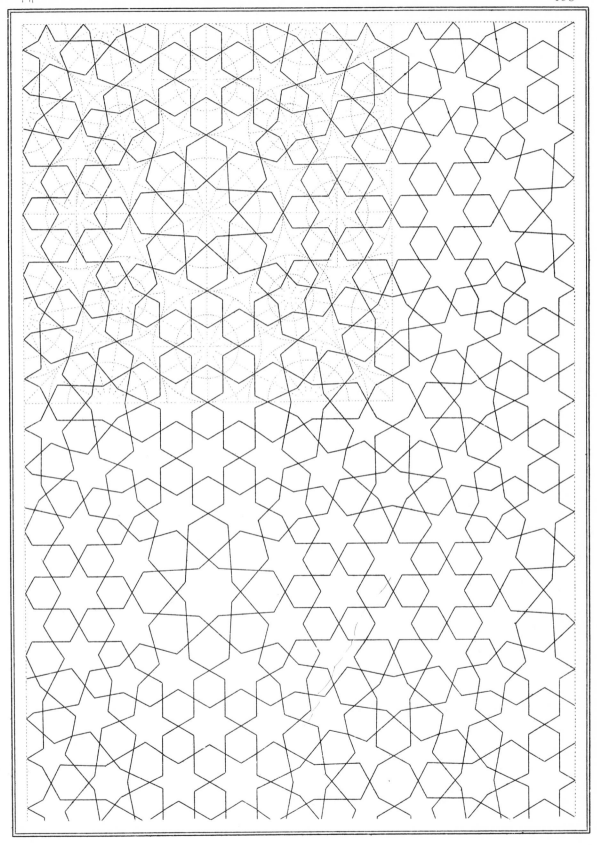

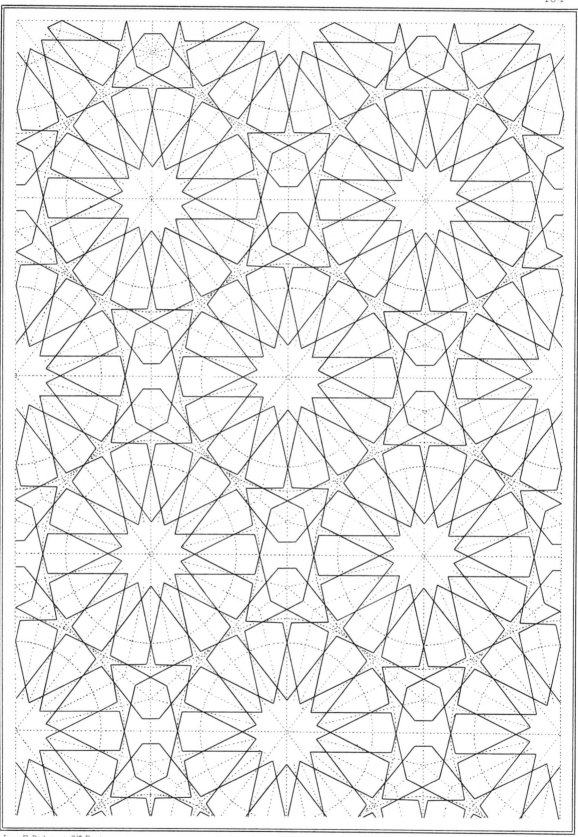

Imp F Didot et Cⁱᵉ Paris

J. Sulpis sc

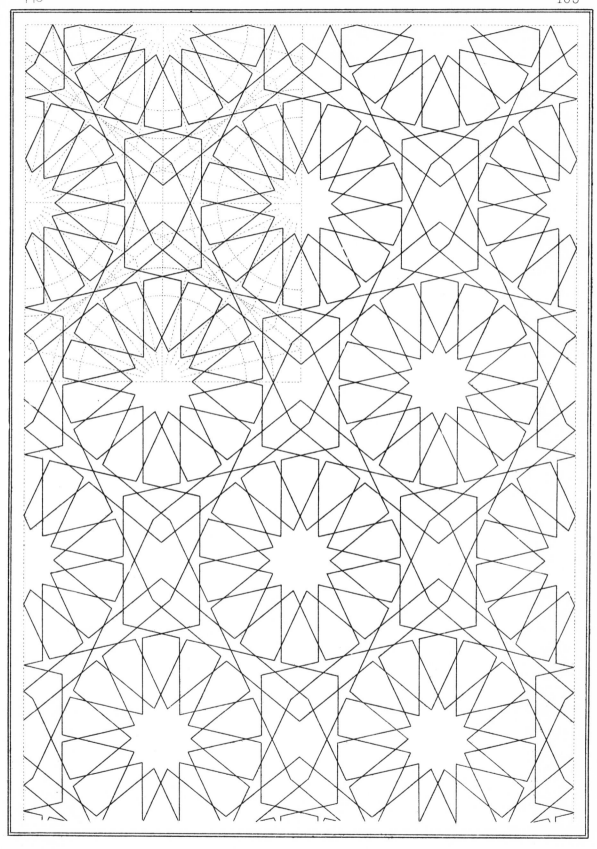

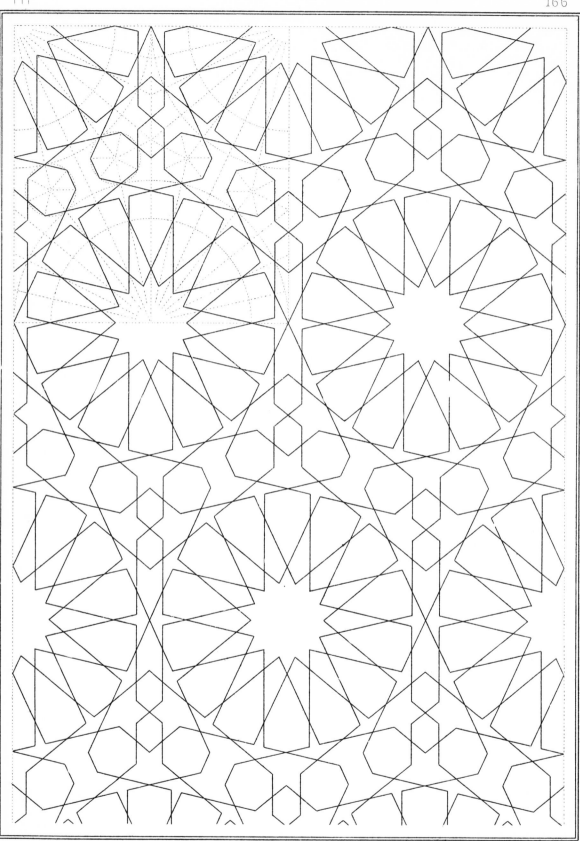

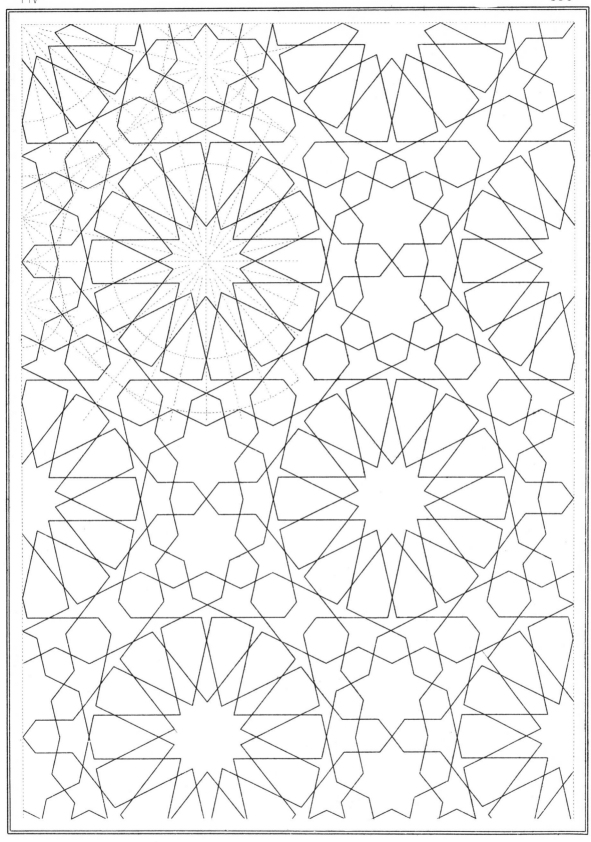

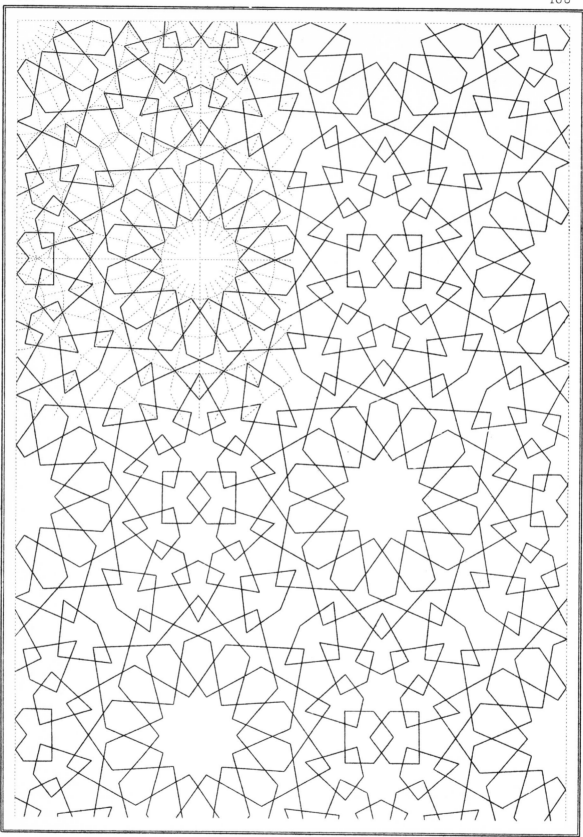

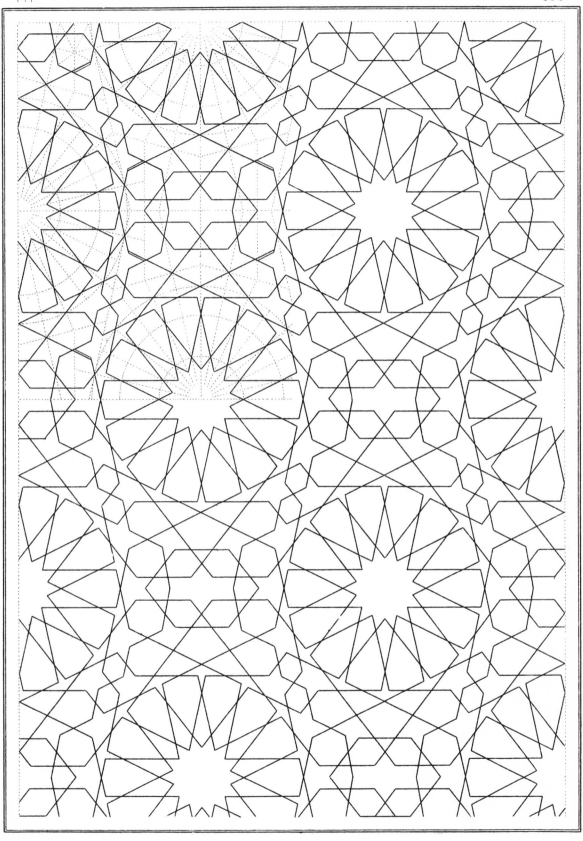

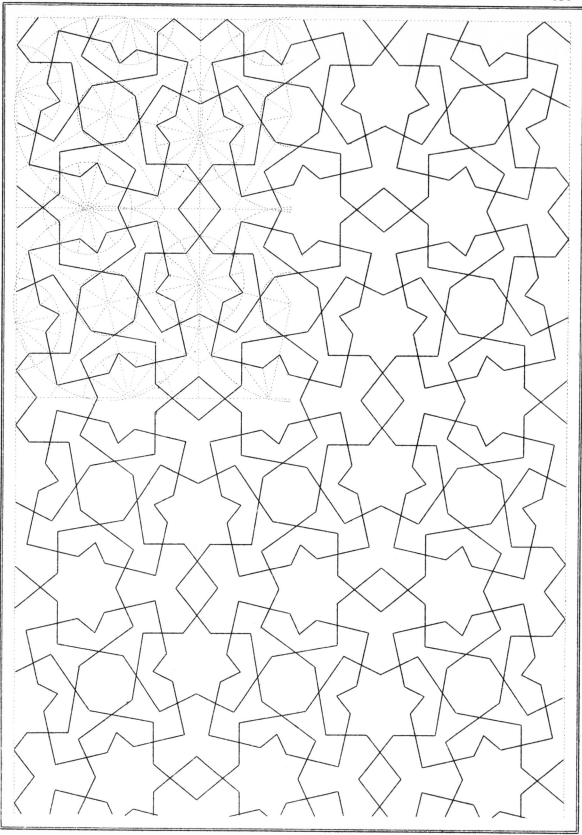

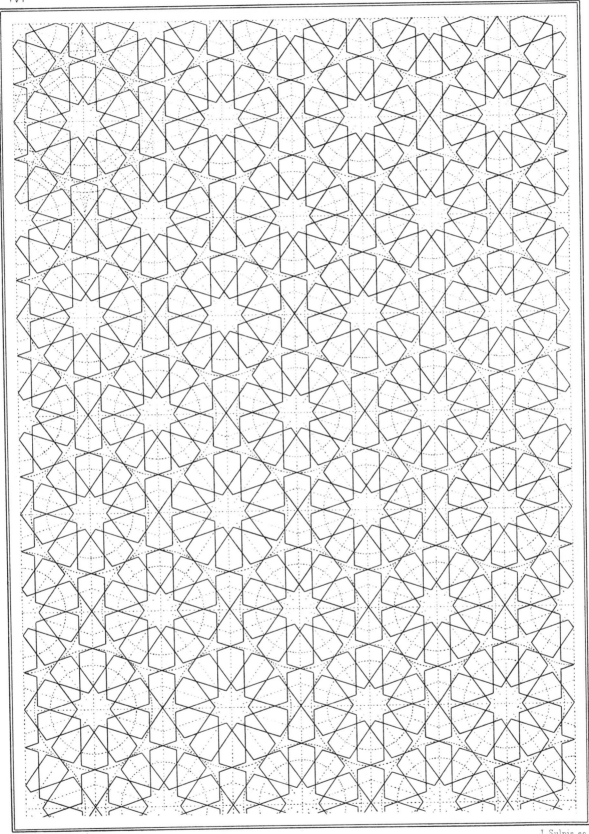

Imp.F Didot et Cⁱᵉ Paris

J. Sulpis sc

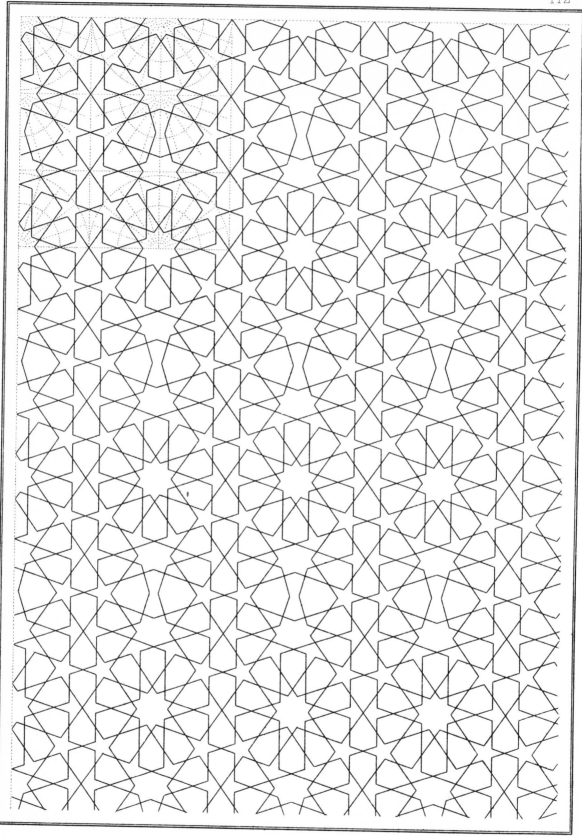

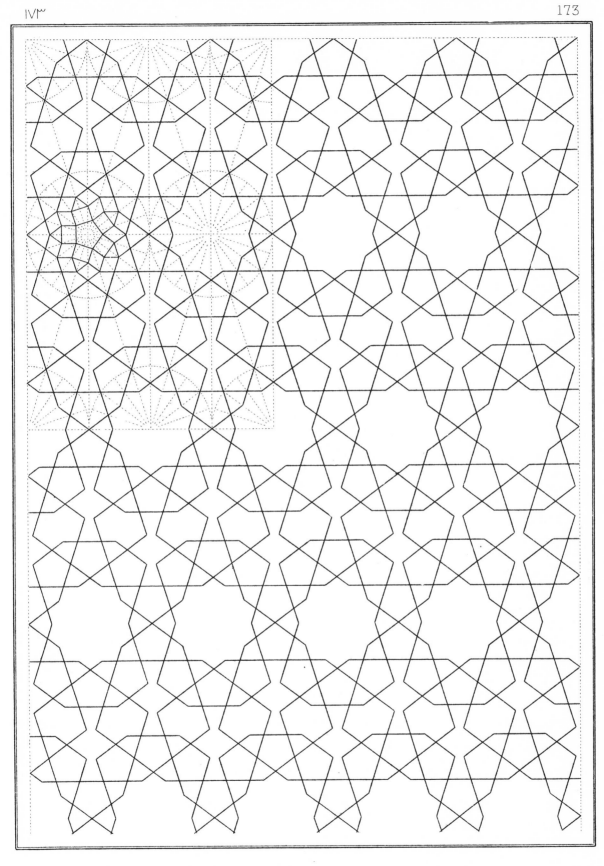

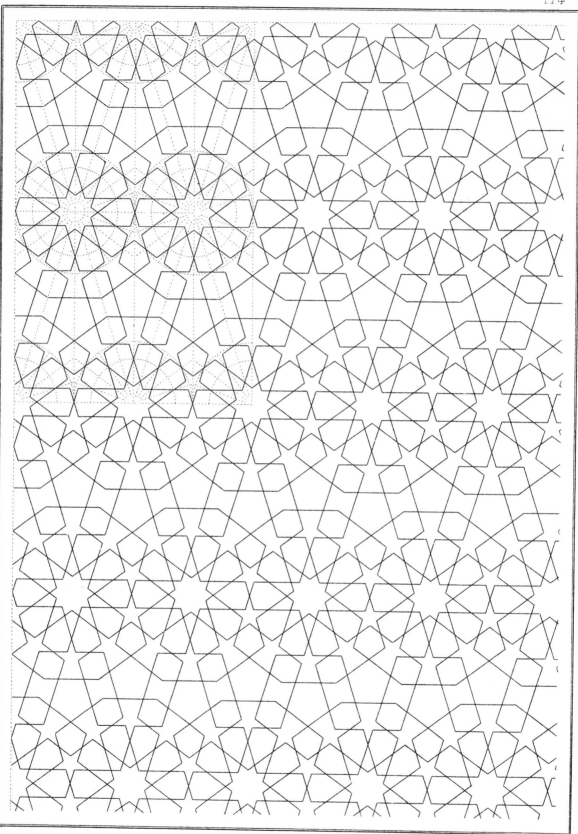

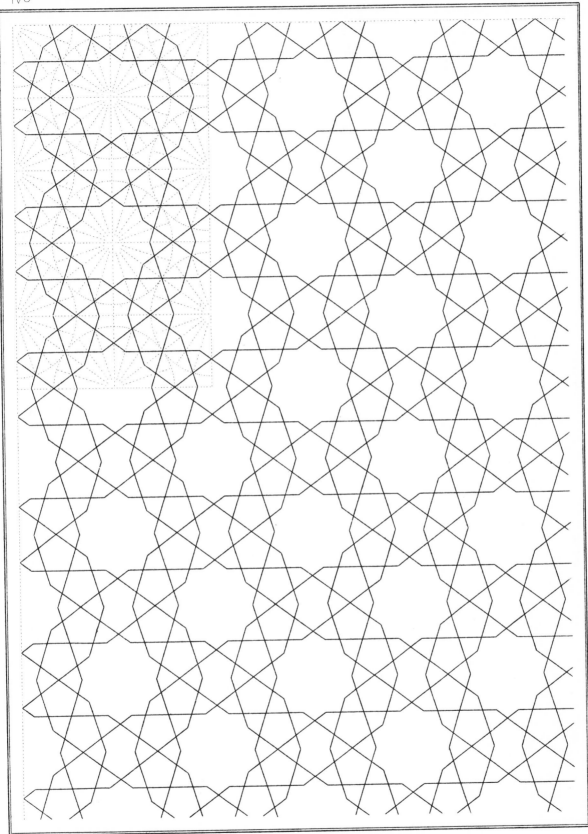

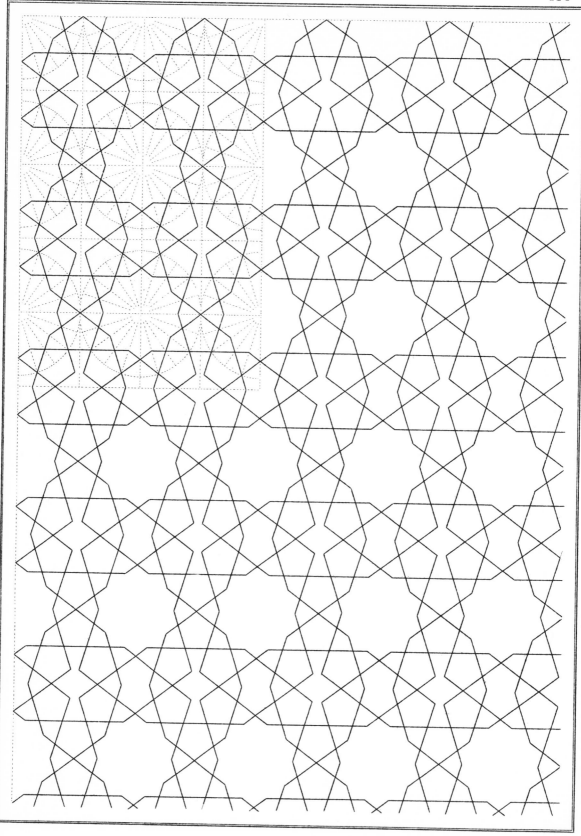

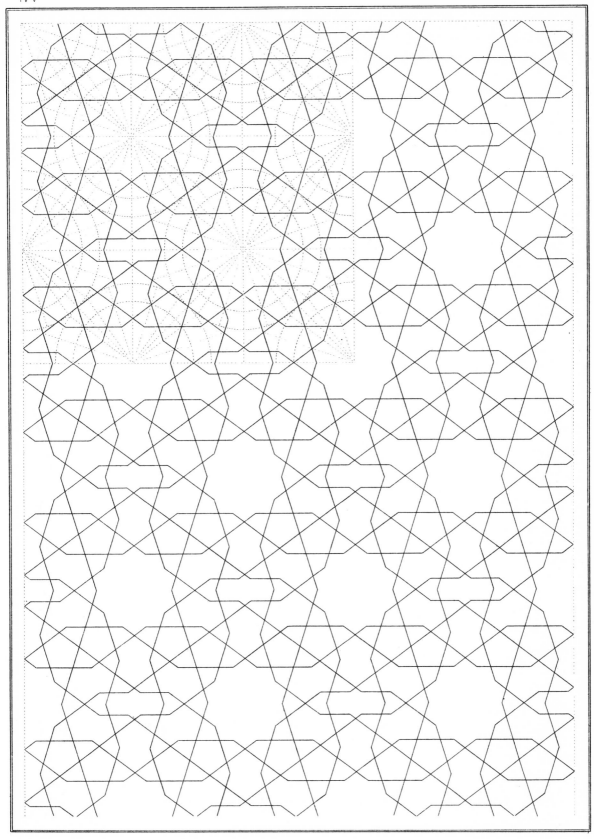

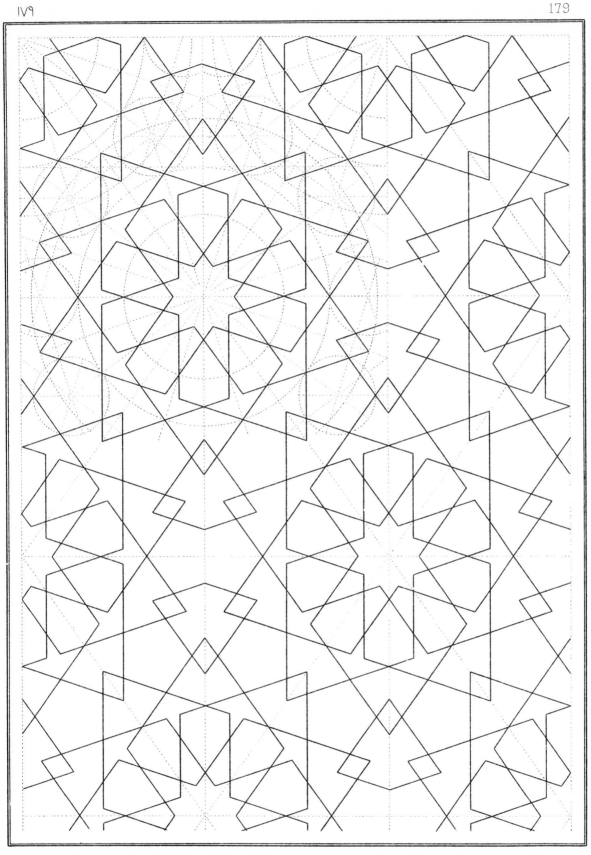

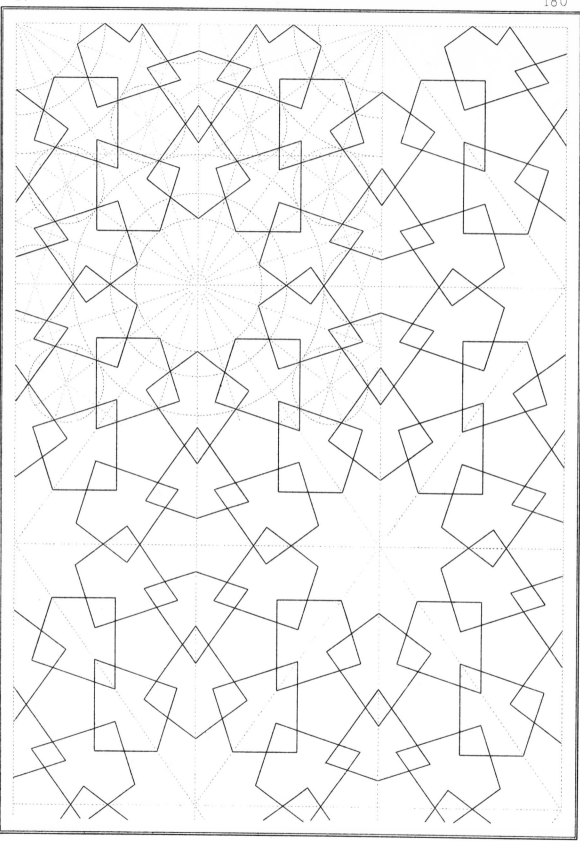

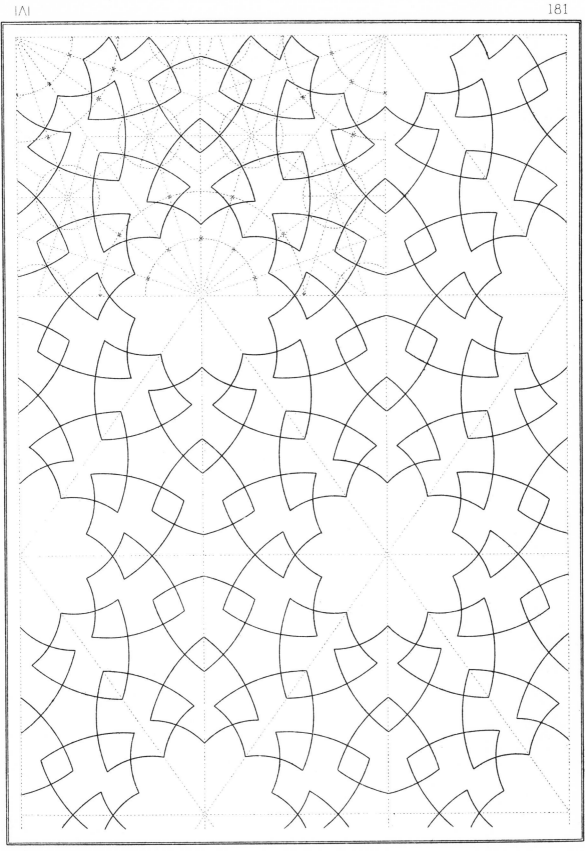

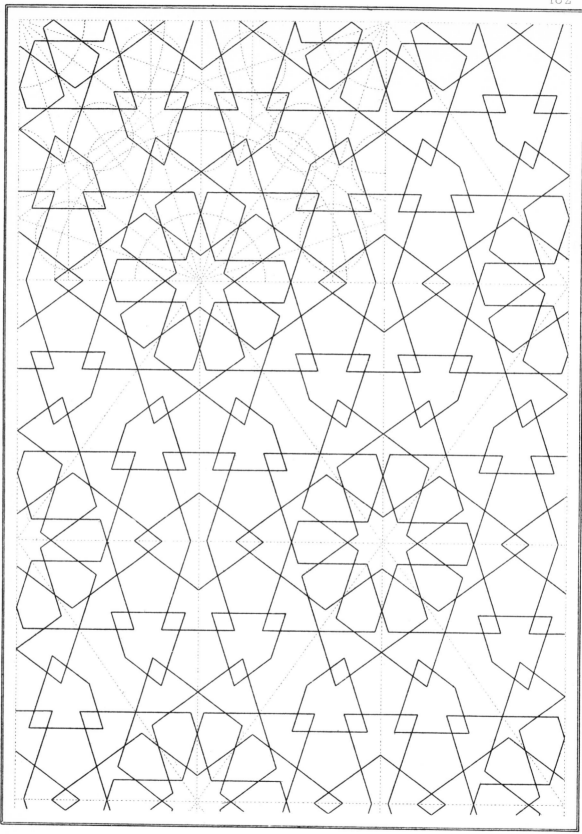

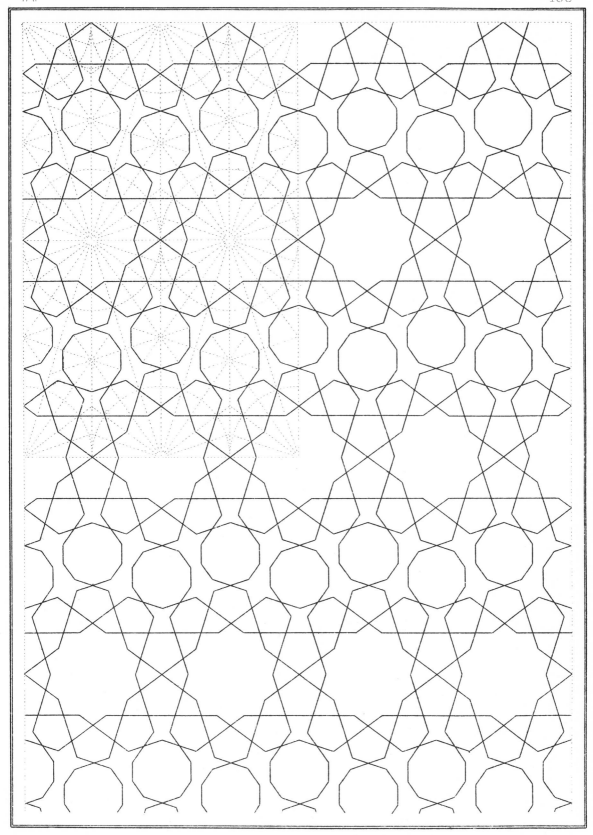

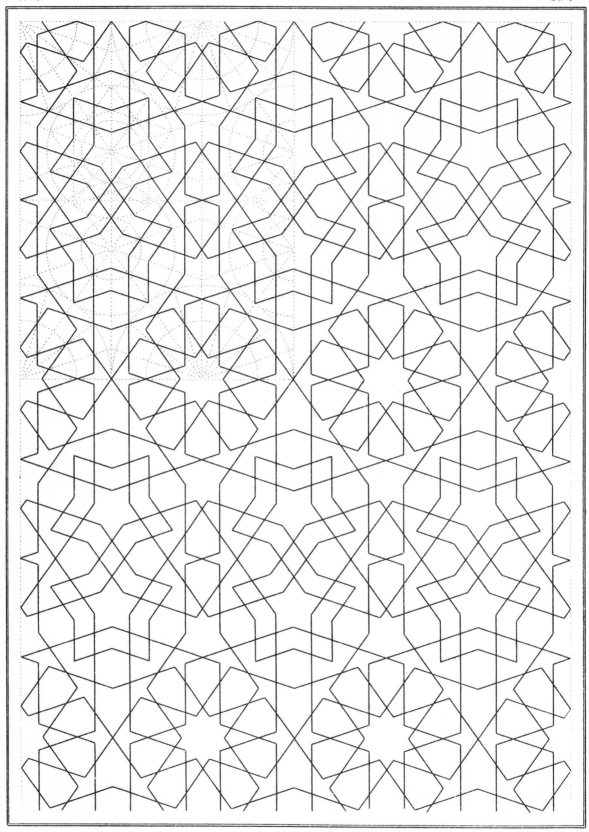

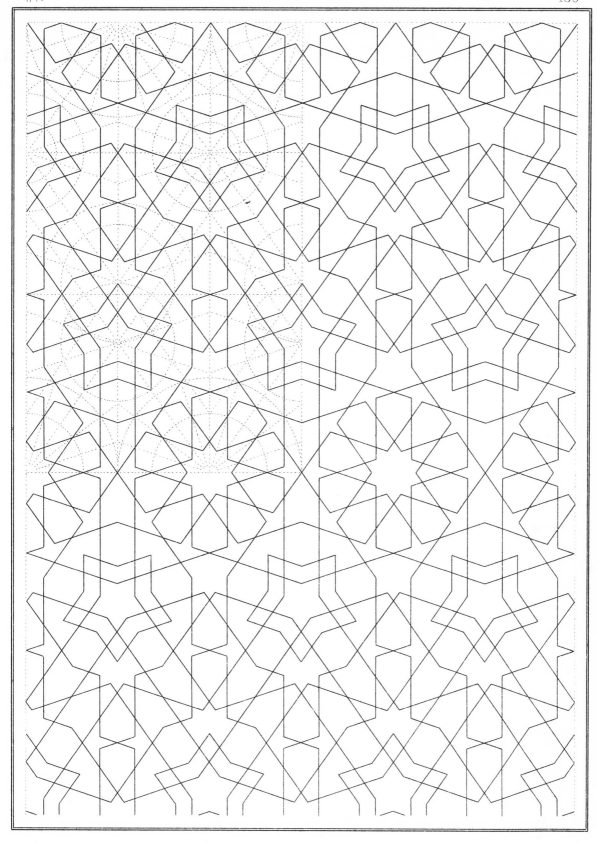

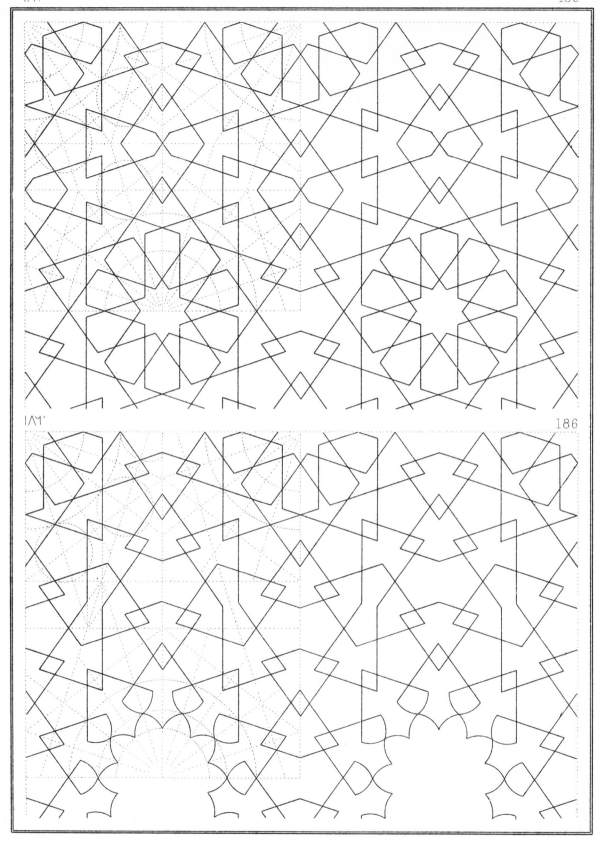

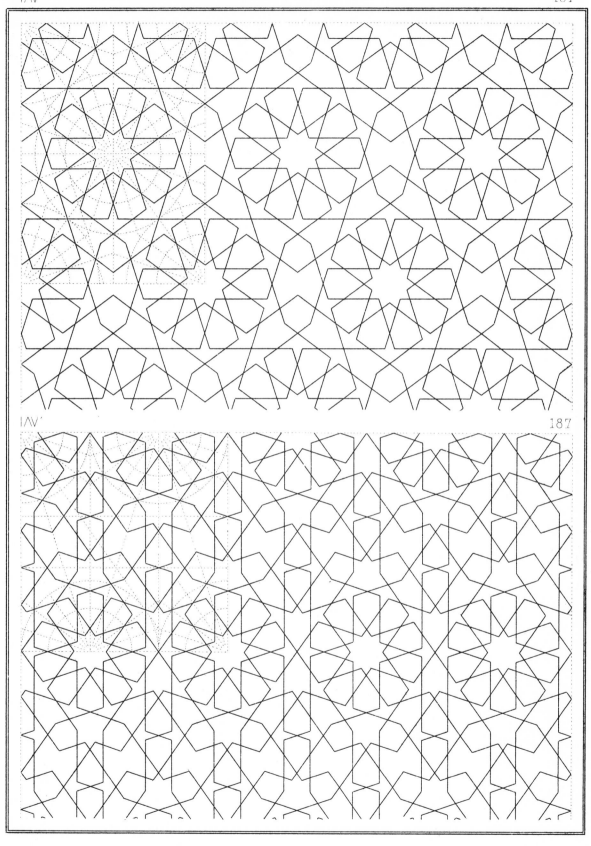

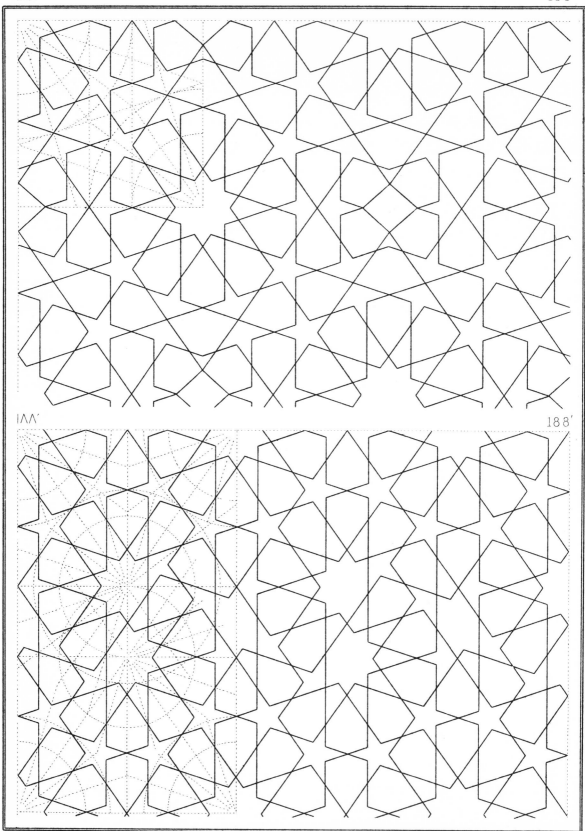

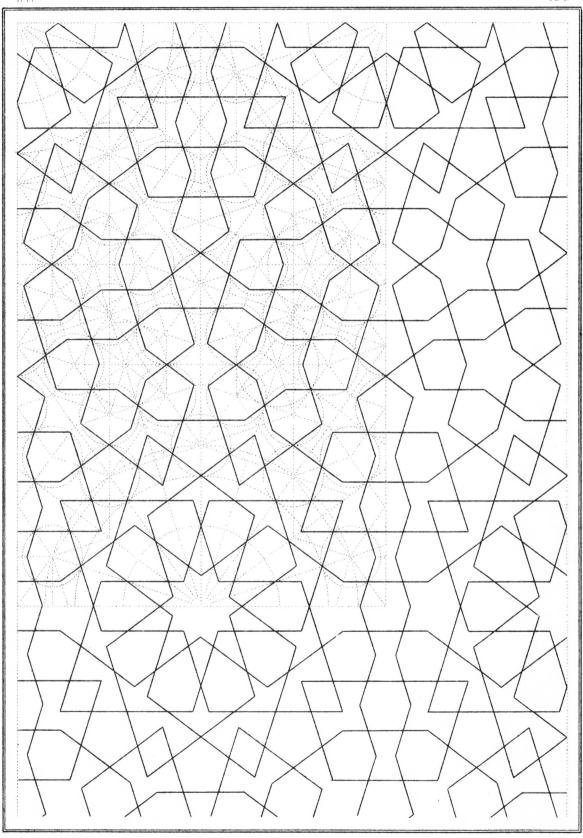

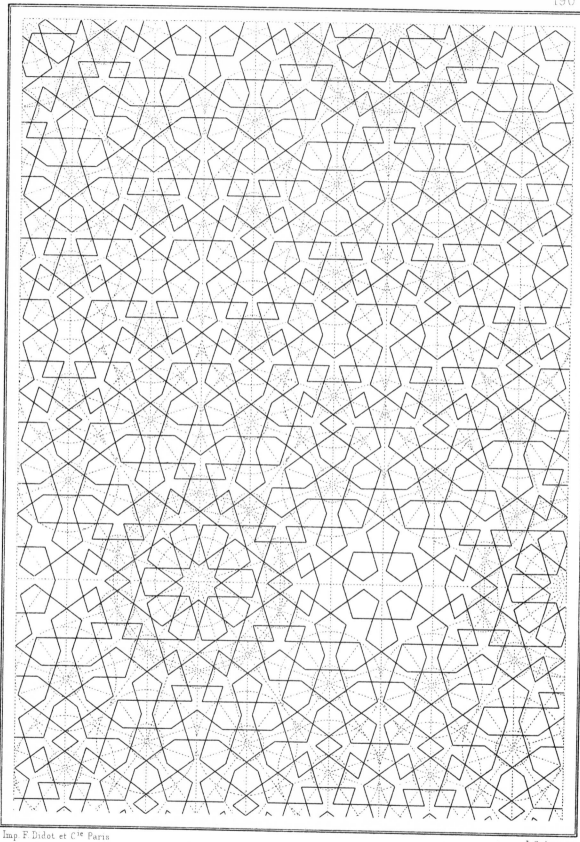

Imp. F. Didot et C^ie Paris

J. Sulpis sc.

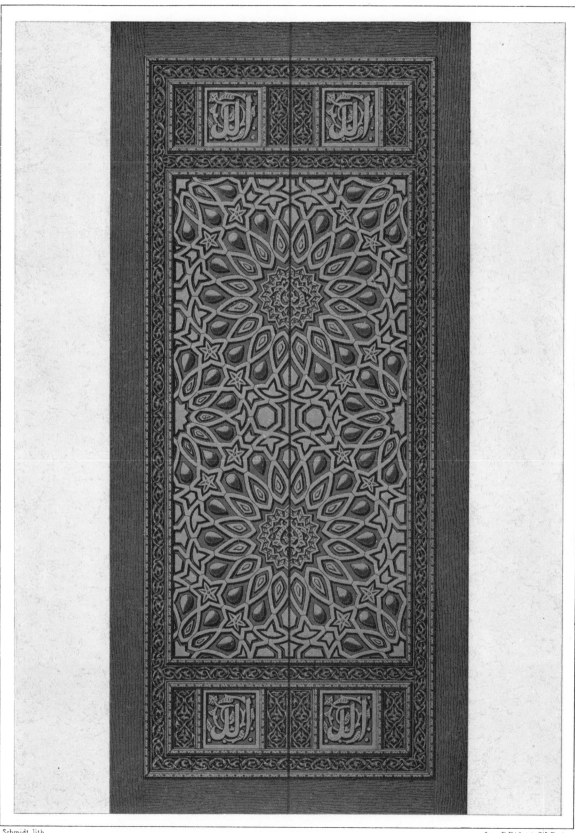

Schmidt, lith.

Imp. F. Didot & C^ie, Paris.

Bronze

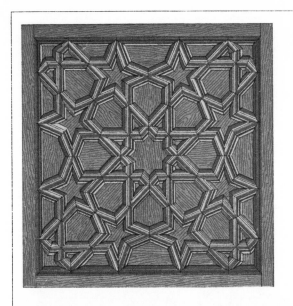
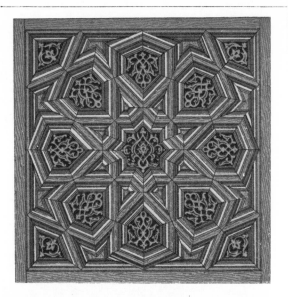
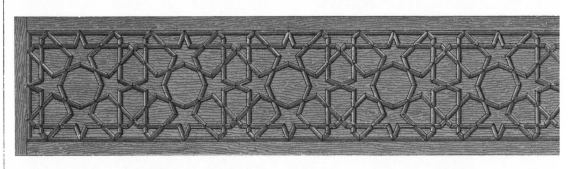
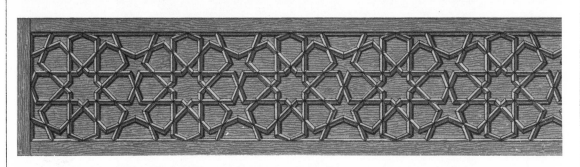
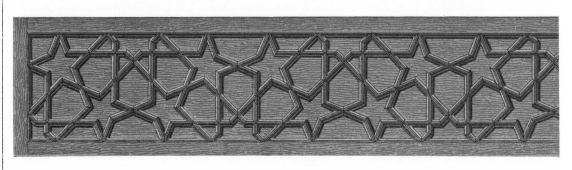

Schmidt, lith.

Imp. F. Didot & Cie, Paris.

Woodwork

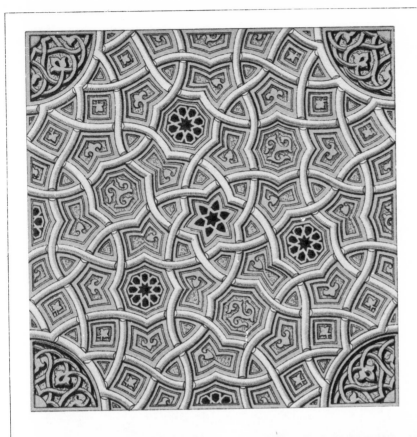
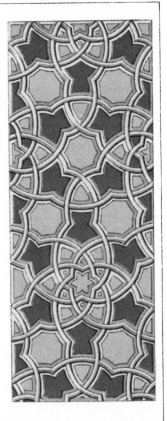
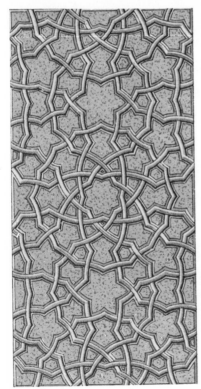
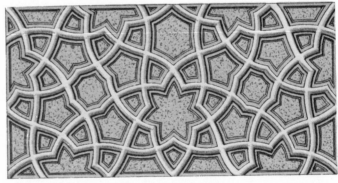
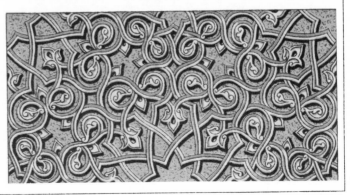

Schmidt, lith.

Imp. F. Didot & Cie, Paris

Carving

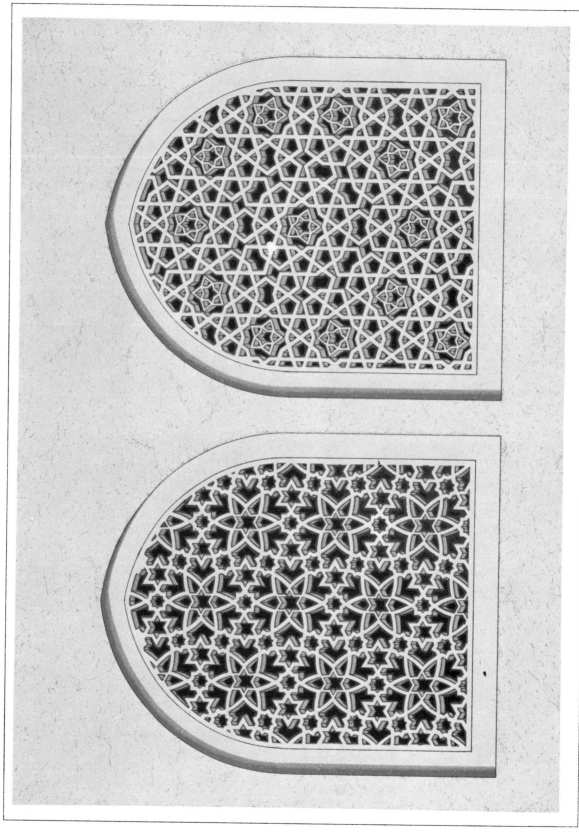

Imp. F. Didot & C.ie Paris.

Schmidt. lith.

Openwork Windows

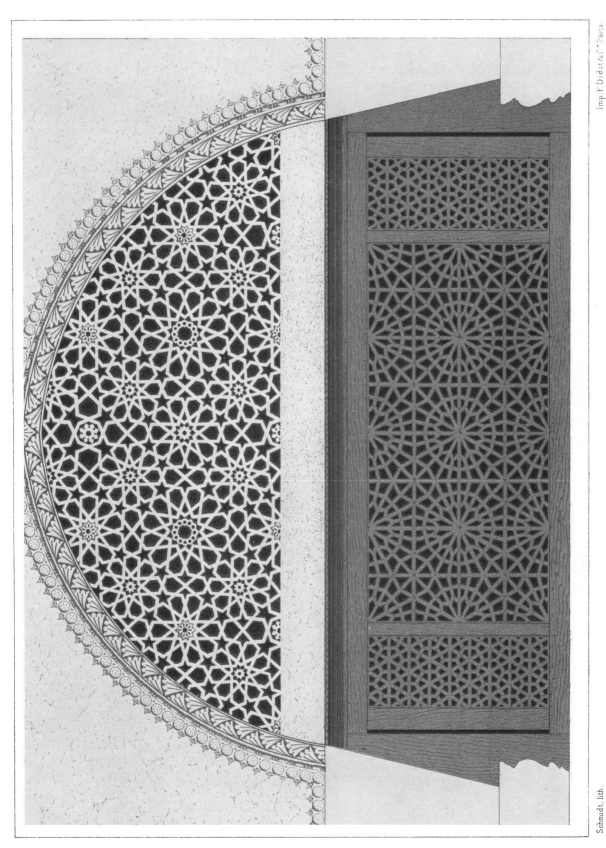

Schmidt, lith.

Imp. F. Didot & C.ⁱᵉ Paris.

Openwork Arch and Trellis

Pl. VI

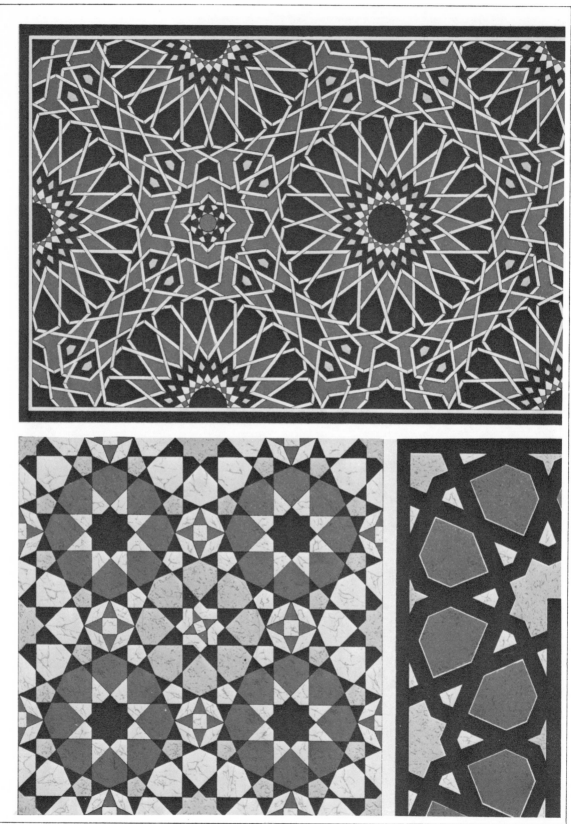

Schmidt, lith.

Imp. F. Didot & Cie, Paris.

Mosaics

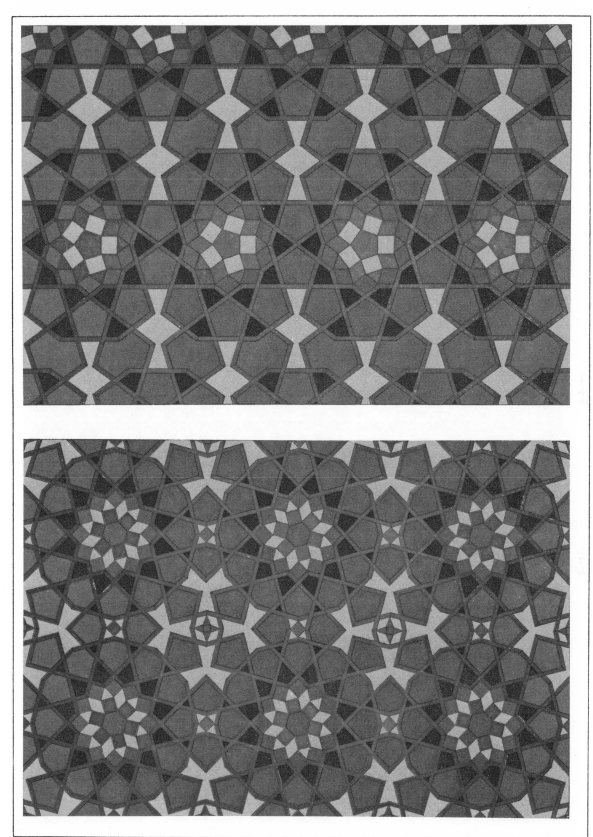

Schmidt lith.

Imp. F. Didot & Cie, Paris.

Mosaics

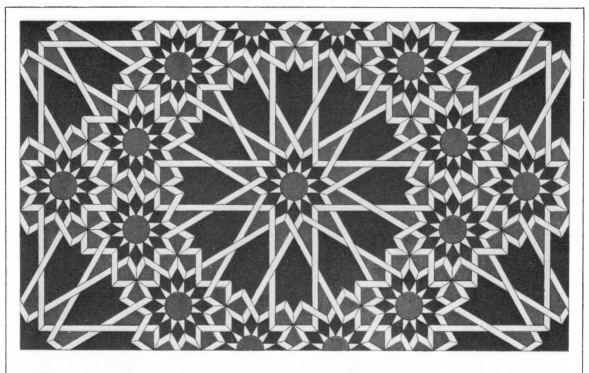

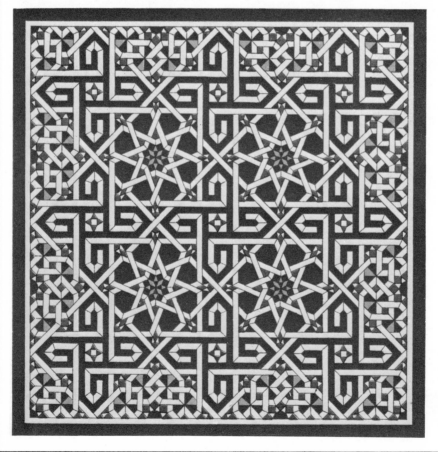

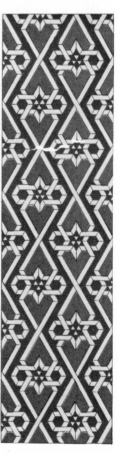

Schmidt, lith.

Imp. F. Didot & Cie, Paris.

Mosaics

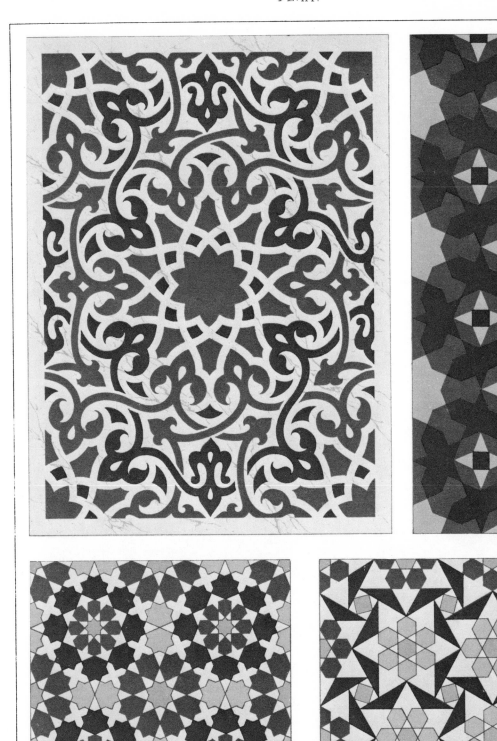

Schmidt, lith.

Imp. F. Didot & C.ie, Paris.

Inlaid Work

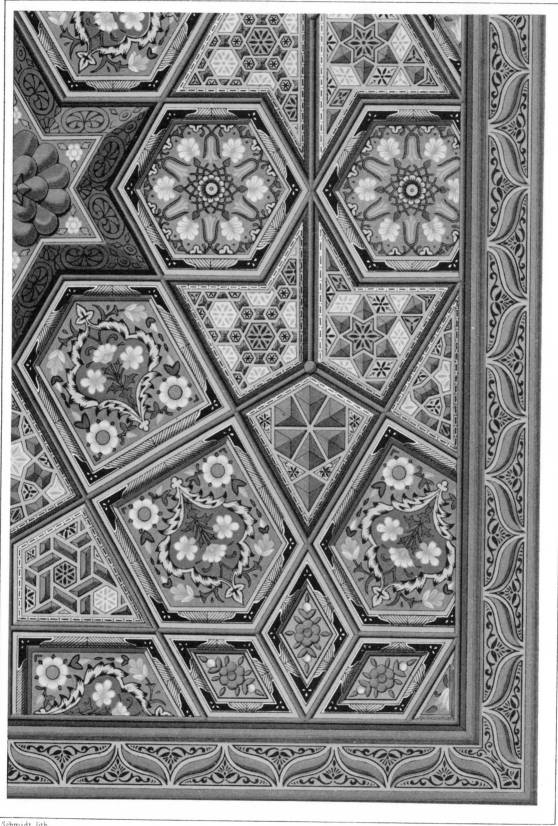

Schmidt, lith.

Imp. F.Didot & C.ⁱᵉ Paris.

Ceiling